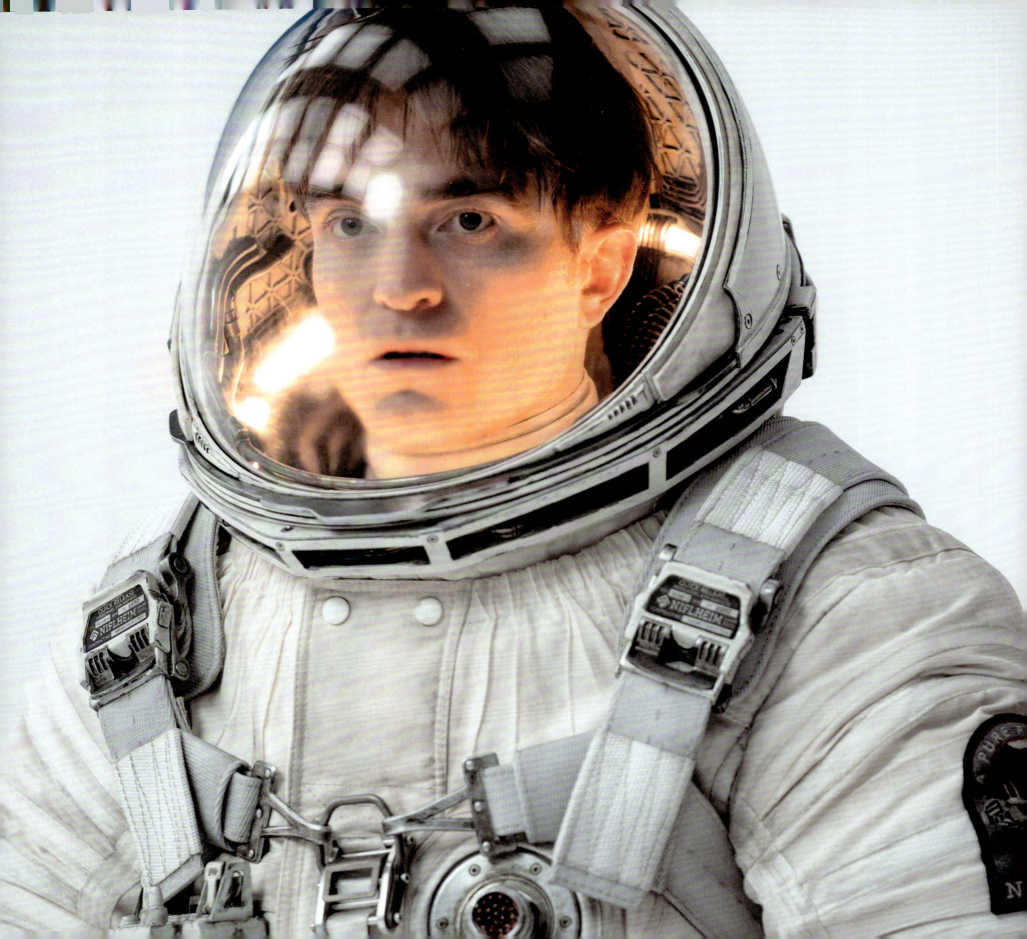

THE ART AND MAKING OF

MICKEY 17

SIMON WARD

Foreword by
BONG JOON HO

INSIGHT
EDITIONS

SAN RAFAEL • LOS ANGELES • LONDON

RIGHT: The origin of the species: A new Mickey Barnes is created in the human printer.

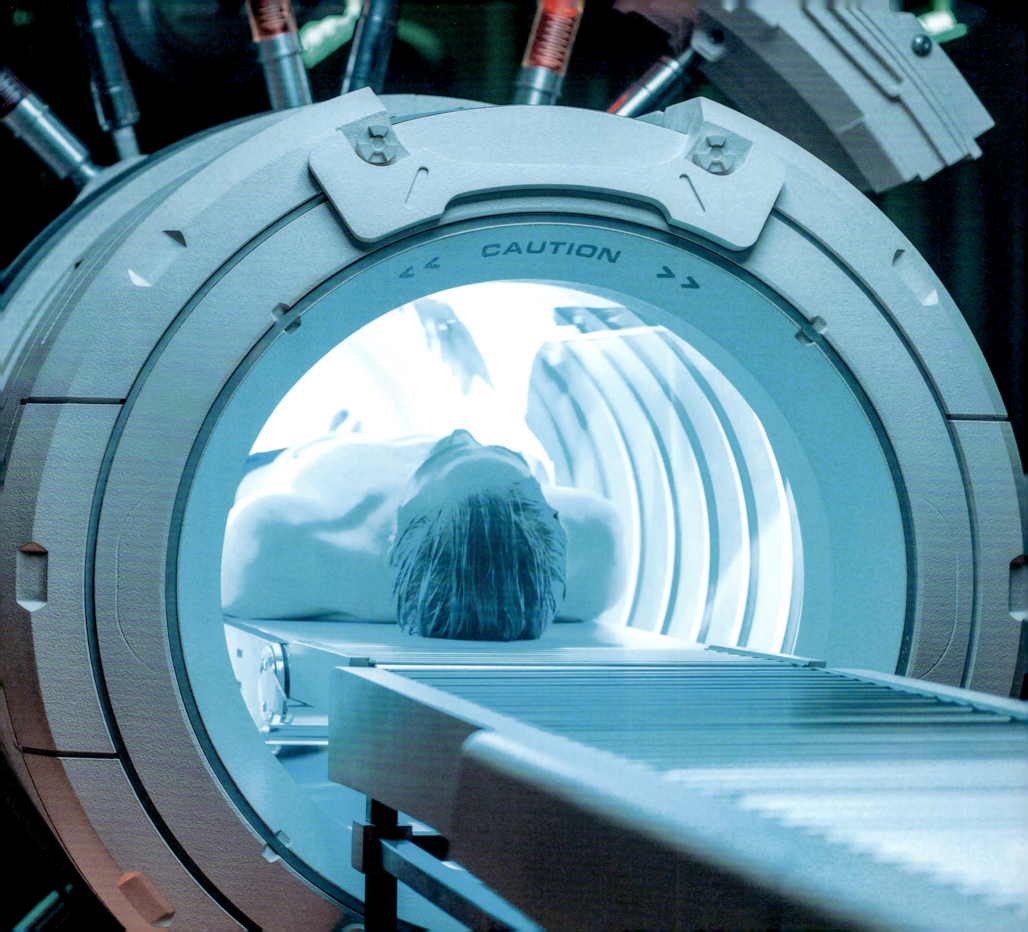

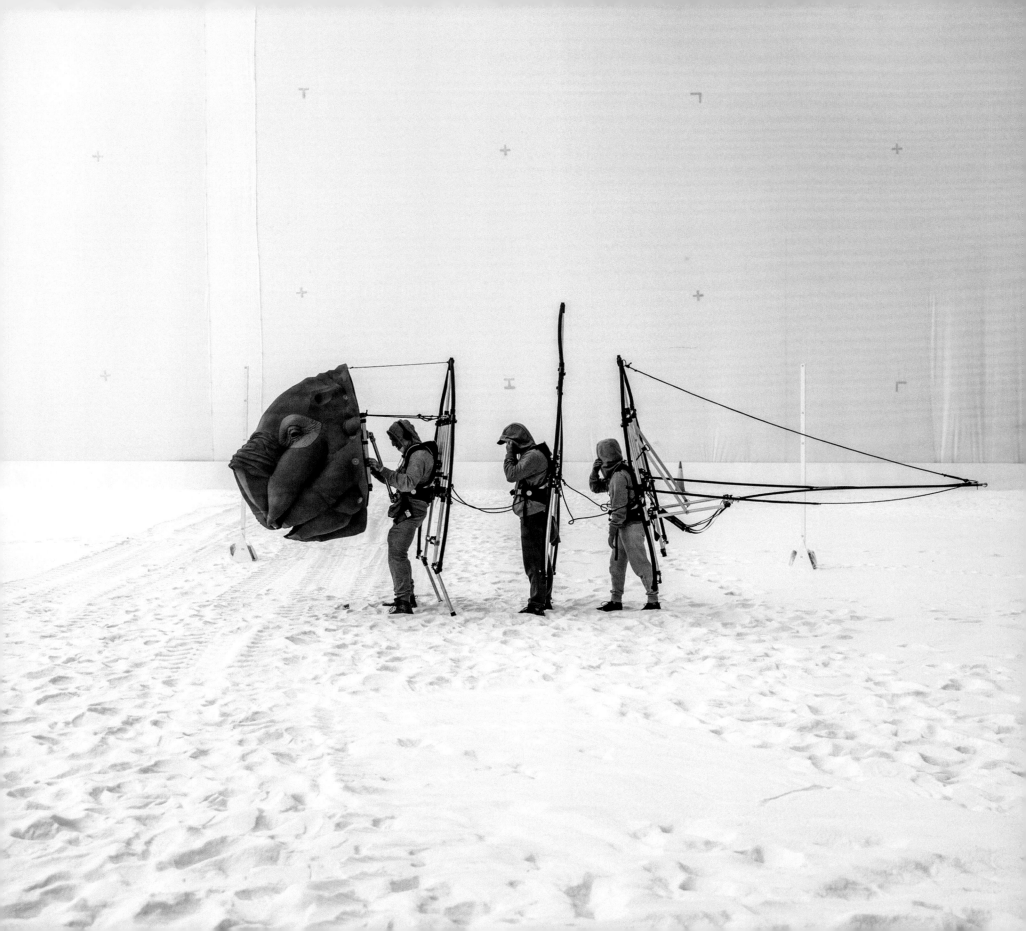

CONTENTS

FOREWORD
11

1. THE BIRTH OF MICKEY
13

2. PRE-PRODUCTION
29

3. THE CAST
77

4. THE SHOOT
109

5. VISUAL EFFECTS
125

6. AFTERWORD
147

ACKNOWLEDGMENTS
154

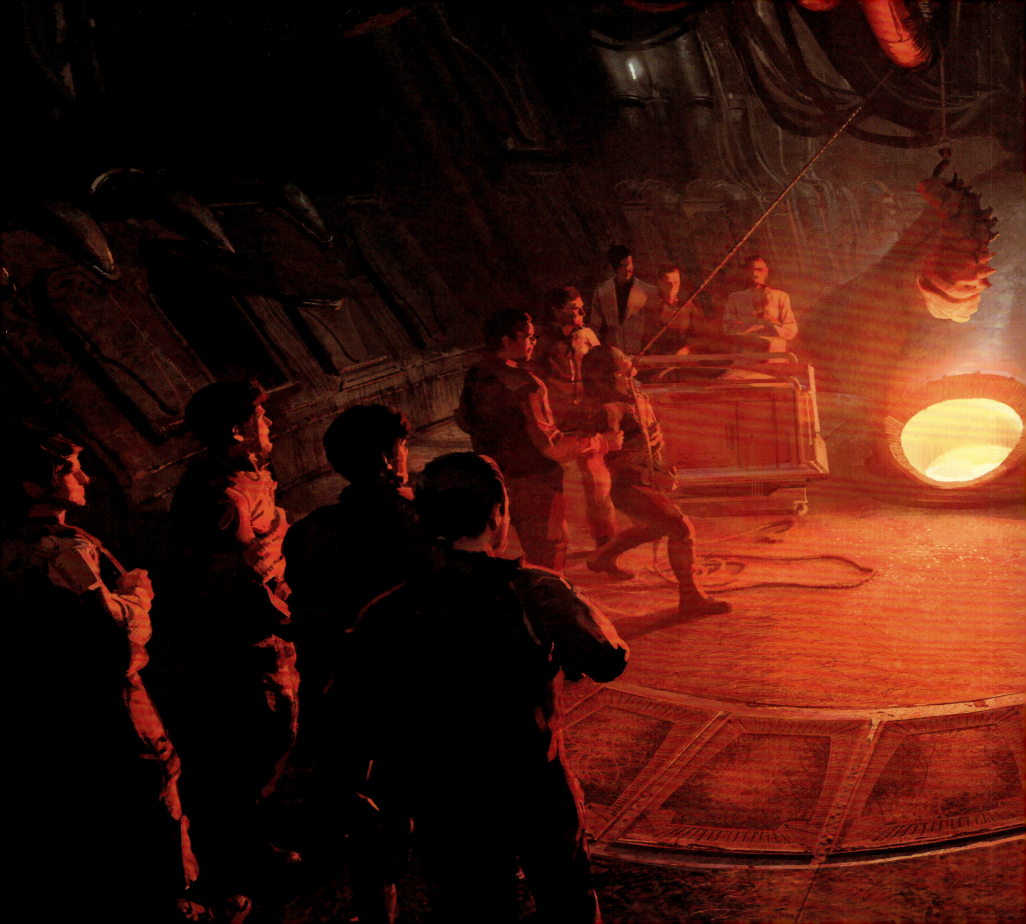

FOREWORD

A world where huge spaceships carry us to new frontiers on distant planets and where humans are printed by machines, but where those humans are still pathetic and helpless and full of flaws.

 A world where Mickey 17's endless cycle of grueling labor and pain coexists with tender love.

 A world of science fiction not filled with advanced, glossy machinery and chiseled heroes looking off into the vast unknown but with the sweat and grease of everyday toil. A not-so-glamorous sci-fi.

 This book is a record of my collaboration with Production Designer Fiona Crombie, Costume Designer Catherine George, VFX Supervisor Dan Glass, Director of Photography Darius Khondji, and many other artists who helped me bring this world to life.

 Countless drawings, paintings, miniatures, and digital images were produced between us all over London and at the sound stages at Leavesden.

 I hope these images will be beautifully preserved in this book, and I hope that whenever I open the book and look back on them, I will have a smile as peaceful as Mickey's at the end of the film.

—BONG JOON HO

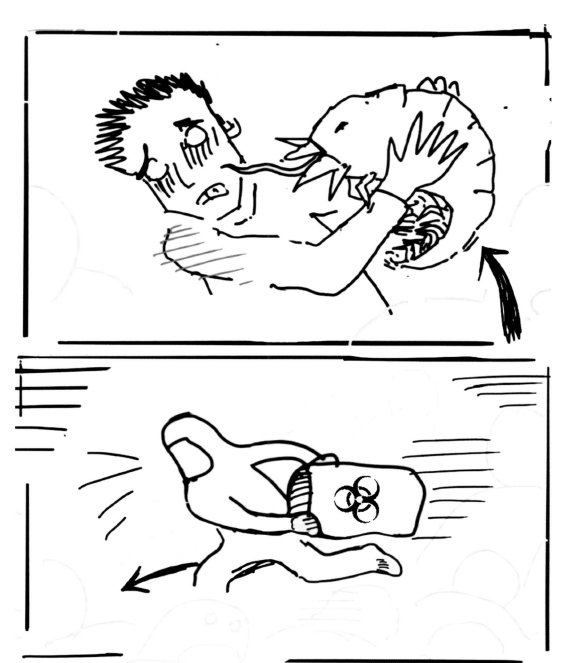

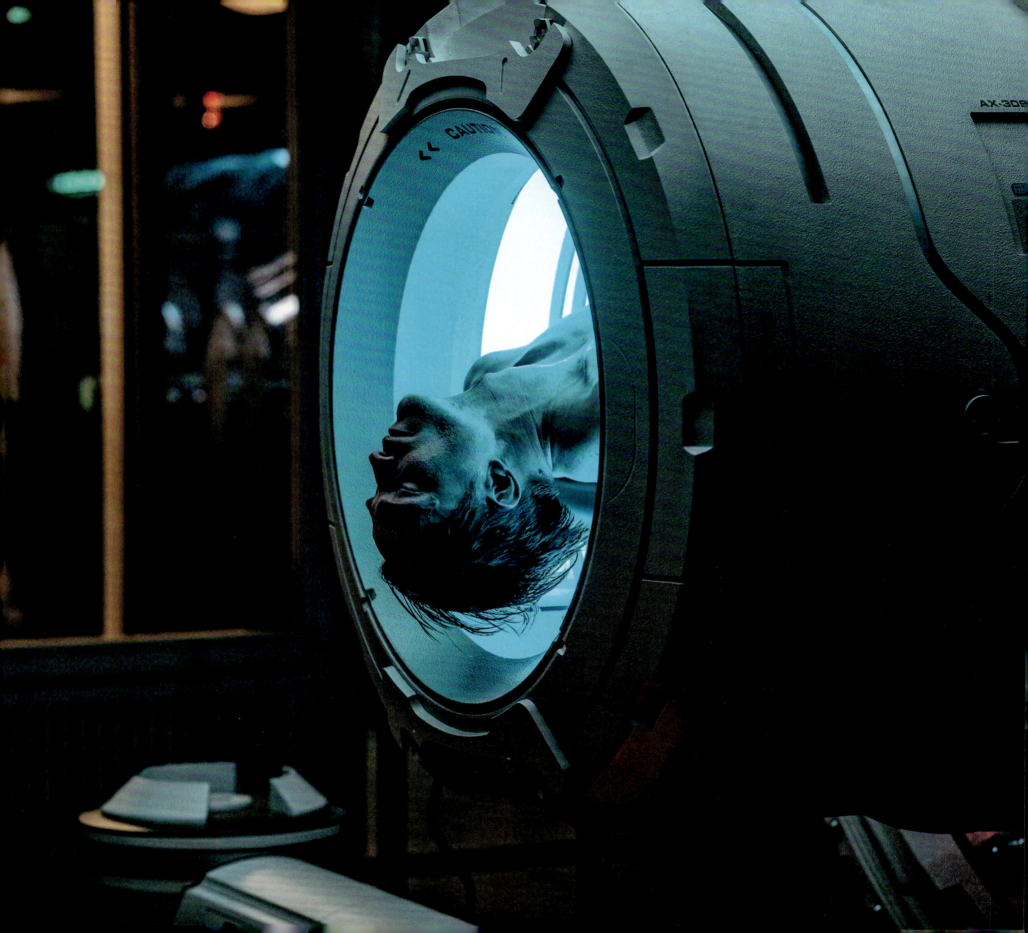

THE BIRTH OF MICKEY

POST-*PARASITE*

Parasite tells the story of a working-class family in modern-day Seoul who slowly infiltrate the lives of a rich, upper-class family. An examination of society, it is as funny as it is disturbing. *Parasite* was Director Bong Joon Ho's seventh film and saw an unprecedented level of success for a Korean movie. After winning the Palme d'Or at the 2019 Cannes Film Festival, it went on to make over $260 million at the worldwide box office en route to unanimous praise and four Oscars, including Best Picture—a first for a non-English-language film. The movie was a cultural phenomenon. It single-handedly brought Korean cinema to swathes of people who had no experience with it whatsoever. Director Bong and his cast and crew won over fans during their long awards campaign with their mixture of intelligence and warmth.

Following those career-changing months, the question became: What happens next?

"Just after *Parasite* won the Oscar in February 2020, the pandemic came," Director Bong says. "For those two years, 2020 and 2021, I actually wrote two scripts. One is the screenplay of *Mickey 17*. The other one is my next one, my first animation project. But the very beginning was actually 2019, when *Parasite* was released in South Korea and was [screened at] Cannes. At that time, I actually had another project, a story based on a real event which happened in London in 2016. At the time, me and [Producer] Dooho [Choi] were researching, and we visited some real people who were involved with that case—the family. After meeting one family member related to the case, I asked the ethical question to myself: Is it okay that I'm making this story of this case? I gave up that project, which I had prepared during almost one and a half or two years, so my brain was suddenly totally empty. Then I discovered myself in the middle of that crazy Oscar campaign in very late 2019. After the campaign, after everything, it was the first year of the pandemic when Jeremy Kleiner at Plan B sent me the original sci-fi novel of Ed Ashton's *Mickey7*."

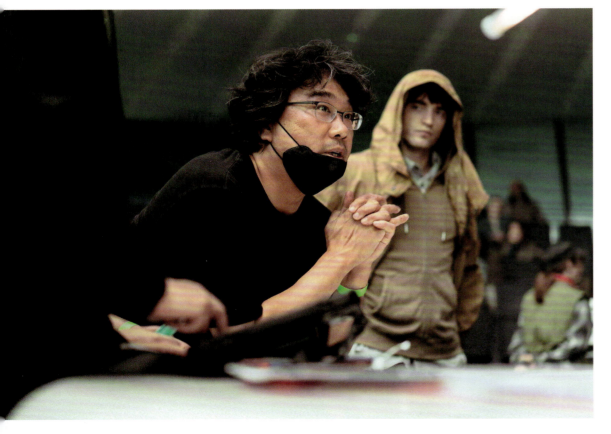

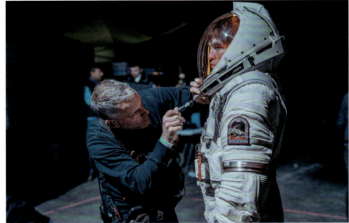

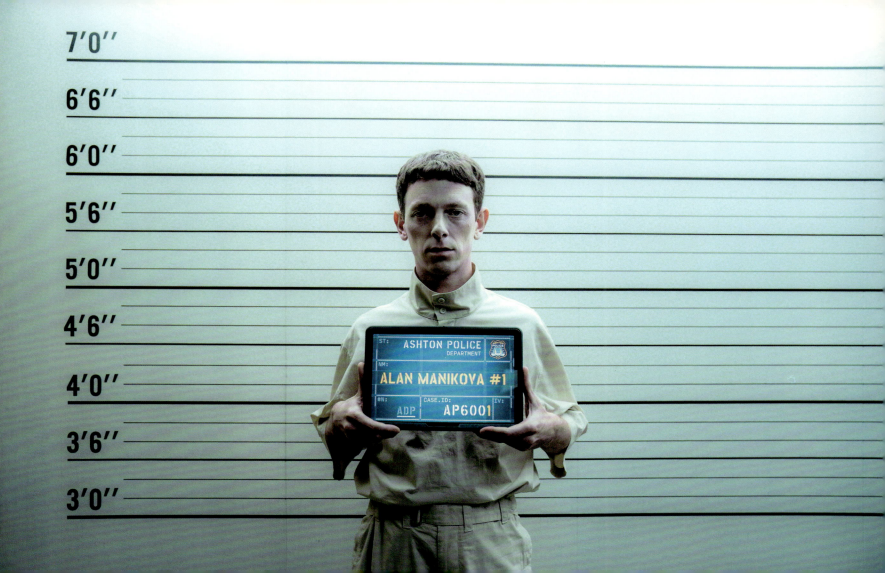

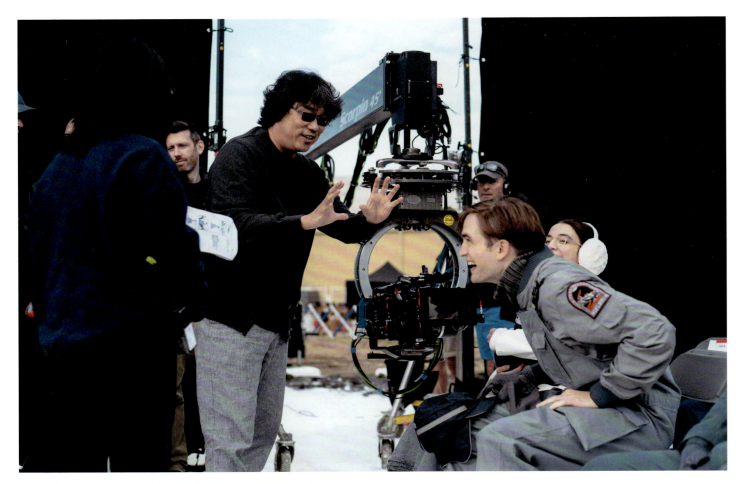

RIGHT: Bong Joon Ho directs Robert Pattinson for a scene in the movie's final moments.
BELOW: Mark Ruffalo gets into character as the foolish but dangerous demagogue Kenneth Marshall.
OPPOSITE: Mickey (Robert Pattinson) and Timo (Steven Yeun) in dire straits on Earth, with their goal to get as far away as possible—if necessary, even leaving the planet.

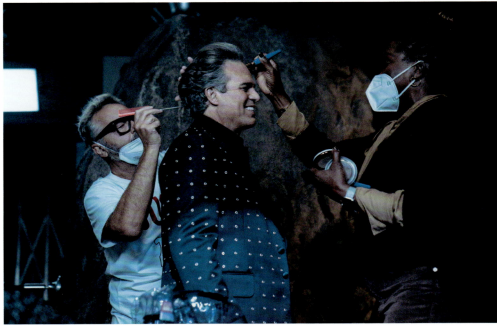

The filmography of Director Bong is celebrated for its precise camerawork, its deeply written characters, perfectly judged pacing and acting, and its balance of tones and genres. Through his particular way of seeing and expressing the world, Director Bong has been able to make films as different as 2009's *Mother*, a meditation on guilt and responsibility, and 2013's *Snowpiercer*, a dark, entertaining, and idiosyncratic sci-fi story. Director Bong does not, however, see his films as part of a canon but rather simply looks for what appeals to him in the story and characters. In the case of *Mickey7*, it was the character of Mickey. "In the original book, Mickey is a historian," he says. "But in my imagination, from the beginning, my approach was different. I really wanted to make a very detailed portrait of a goofy and quirky, young, working-class guy in an extreme situation.

"The number also, of course, means something. *Mickey7* means the seven deaths. But I wanted some more—more deaths! Very naturally, it became 17 because that implied the repetition, the daily job kind of thing that I was going for."

In late summer 2021, Director Bong spent the last few months of the worldwide pandemic writing about the death of one specific person—Mickey Barnes.

His new project was officially underway.

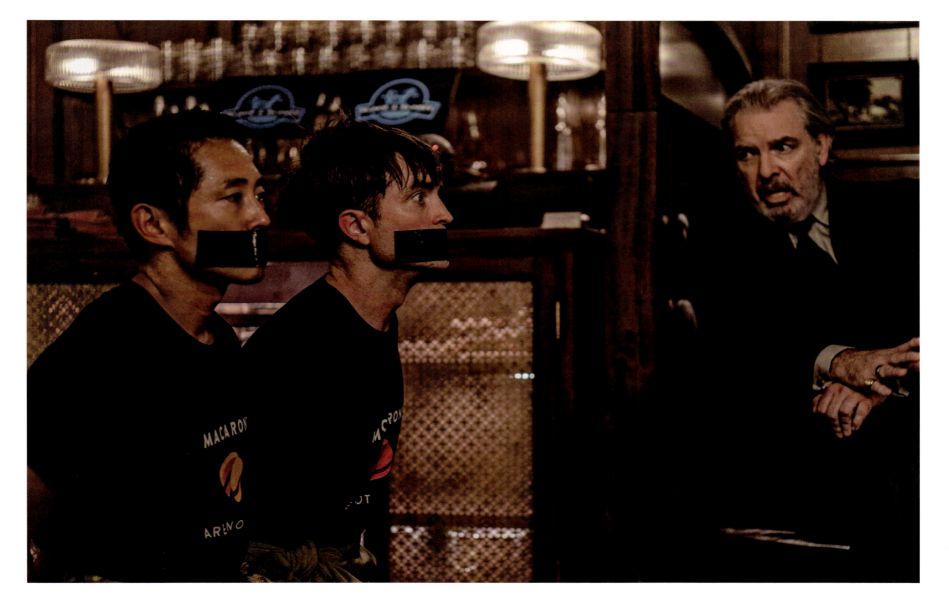

ADAPTING THE NOVEL

Mickey7 was published by St. Martin's Press on February 22, 2022. It was Edward Ashton's third novel, following *Three Days in April* and *The End of Ordinary*. Set in the far future, it tells the story of Mickey Barnes, who is part of a crew setting out across space to colonize the ice planet Niflheim. Mickey is considered an expendable, a person who is used for any mission too dangerous for the rest of the crew. If Mickey dies at the hands of an indigenous species, if the air on the planet is poisonous, if some other unforeseen tragic and painful accident occurs, it doesn't matter. Another Mickey can be made.

Mickey's life is defined by his deaths. But everything changes when a mission goes wrong and he is assumed dead and replaced by Mickey8. Is there enough life, or death, for both of them?

As Edward Ashton puts it, "The question is, if you could do this, if you could print out a new body, if you could transfer your mind exactly, everything about you—your hopes, your dreams, your love of strawberry ice cream, and your hatred of electronic dance music—all of that, into this new body, would that be you or would it just be some other guy running around getting his grubby hands on your stuff? And that is the central question of Mickey Barnes's life."

The novel was well received upon publication and immediately ushered into the celebrated company of recent high-concept, accessible, mainstream sci-fi books such as Andy Weir's *The Martian*, Blake Crouch's *Dark Matter*, and Ernest Cline's *Ready Player One*. Warner Bros. had acquired the rights before publication in a pre-emptive acquisition. Plan B had an existing relationship with Director Bong, having partnered on *Okja*. The pieces began to come together rather neatly, as Dooho Choi explains.

"Plan B has a deal with Warner Bros. They collectively decided to try Director Bong. It was an immediate response: He wanted to do it," Choi says. "He had his assistant translate the synopsis. He read it and said, 'Great,' and then he had the book translated into Korean. Even before the book was translated, he knew he wanted to do it. So we immediately got to work on getting everything set up."

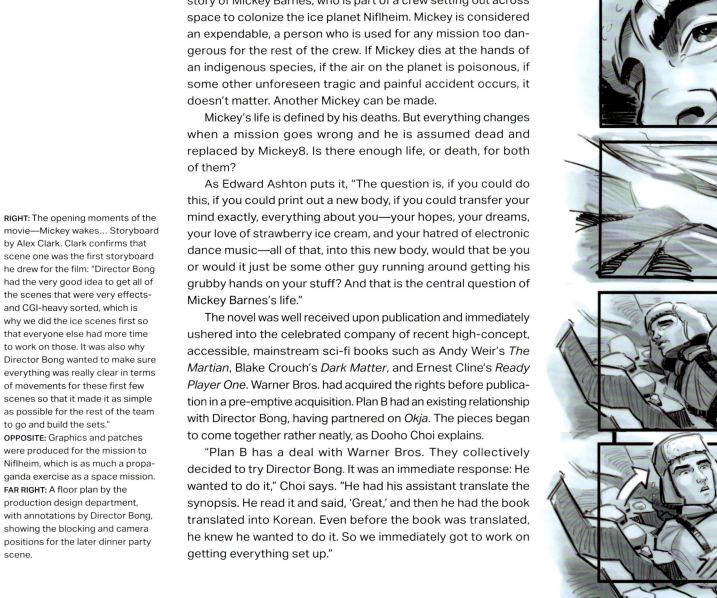

RIGHT: The opening moments of the movie—Mickey wakes… Storyboard by Alex Clark. Clark confirms that scene one was the first storyboard he drew for the film: "Director Bong had the very good idea to get all of the scenes that were very effects- and CGI-heavy sorted, which is why we did the ice scenes first so that everyone else had more time to work on those. It was also why Director Bong wanted to make sure everything was really clear in terms of movements for these first few scenes so that it made it as simple as possible for the rest of the team to go and build the sets."

OPPOSITE: Graphics and patches were produced for the mission to Niflheim, which is as much a propaganda exercise as a space mission.

FAR RIGHT: A floor plan by the production design department, with annotations by Director Bong, showing the blocking and camera positions for the later dinner party scene.

The next step was having a conversation with Edward Ashton, which was done over Zoom, and then Director Bong got to work.

"I read the original novel late in the winter of 2020. It took some time," Bong Joon Ho recalls. "Chapter by chapter, it took almost two and a half months or something. And then in 2021, I actually started adapting and scriptwriting. I did some research and thought about the story structure."

Director Bong has either written or co-written all his movies. His fingerprints are all over each one of his films, which is incredibly evident when looking at the celebrated tonal shifts throughout his stories. He became the first Korean filmmaker to win Best Original Screenplay at the 2020 Academy Awards, which is a testament to the distinct voice that he has crafted across his filmography. As different as each of his movies is, there is an identifiable Bong-ness about all of them. This all starts on the page.

> "The book feels, to me, very different to the movie, and so I was expecting one thing when I read the script and when I saw Director Bong's adaptation. I mean, it's just totally an audacious, idiosyncratic interpretation. So wild. It felt completely alien."
> —ROBERT PATTINSON

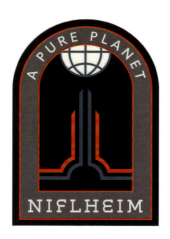

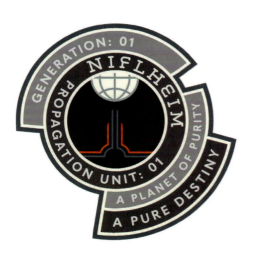

Snowpiercer is a sci-fi movie, adapted from a cult classic French graphic novel. It defies classification, but one could argue *Okja* contains sci-fi elements. The same could be said for *The Host*. After the real-world concerns explored in *Parasite*, Bong Joon Ho was not necessarily looking to switch back to sci-fi. In adapting *Mickey7* into a screenplay, he needed to make it work not only for the screen but for himself, and what that meant was focusing on the characters at its heart.

"On *Snowpiercer*, he created all new characters," Choi says. "None of the characters in the movie are in the graphic novel. In this case, he took the main ingredients of the book—the concept, the characters, the Creepers—and basically turned it into a Bong Joon Ho movie. It started with the novel but changed into something else in the scripting process."

The story went through, essentially, a "Bong filter," as no one sees the world quite how he does. Director Bong explains the changes that he made, most of which came down to tone and personality, with some significant additions: "For example, Ylfa, the Toni Collette character in the movie, is not in the original novel. Kenneth Marshall is already there in the text but quite different here—and I gave him a first name. And Timo, Steven Yeun's character, is also quite changed. The novel is very much about space exploration and technology, and I wanted to focus in on the characters. These fundamentals and basic structure I created during the first half of 2021."

Another key change was the time period. Deciding when the movie is actually set is crucial to not only scripting but will also feed into all elements of production design, costuming, even potentially how the film is colored and graded.

"The novel takes place one-thousand-plus years into the future," Choi says. "We'd never stated it, but I think the original screenplay was conceptually set around one hundred years into the future. So that's already very near-future compared to the novel. But throughout the production process, we kept bringing the action closer to now. I think it was more interesting for Director Bong to tell a story that took place in a world that wasn't very different from ours. There is definitely the feeling that this is something that could happen tomorrow. And I think in that regard, it's also similar to *Snowpiercer*."

It wasn't until well into the editing process that the decision was made to place the story in 2054, putting *Mickey 17* in a very foreseeable future.

RIGHT: A welcoming, friendly poster of Marshall encourages people to sign up for his colonization mission in a recruitment center—filmed on location in London.

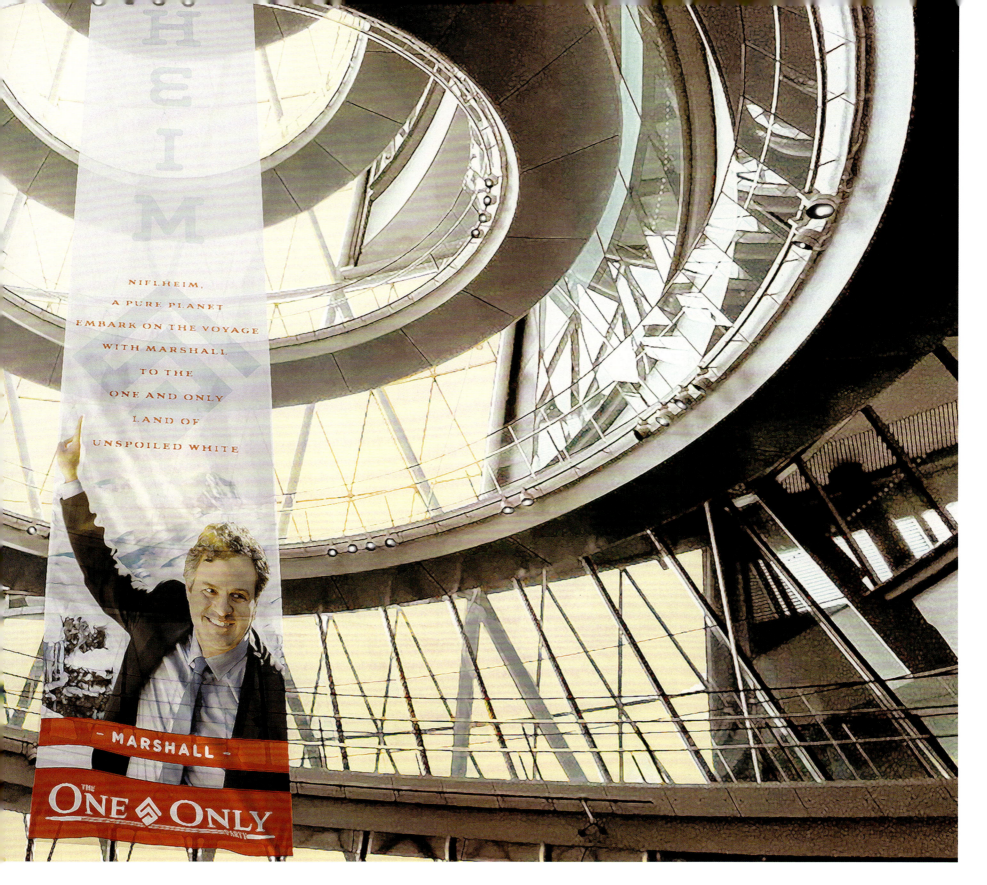

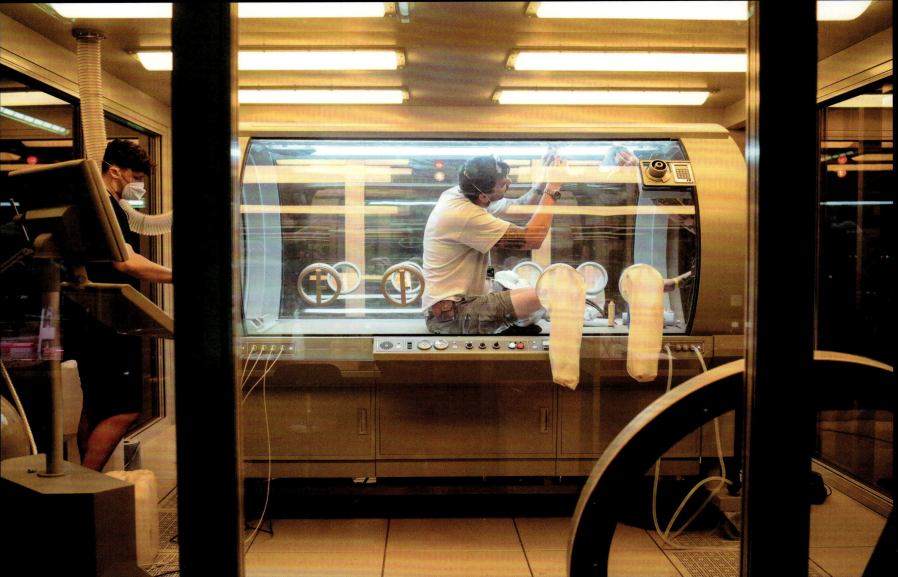

> "I was fascinated by this story of a working-class and—in some respects—very goofy and silly guy."
> —BONG JOON HO

Ashton confirms that Director Bong put his own spin on things when adapting *Mickey7*. "He has his own approach. It's not like he's taking my dialogue word for word or anything like that," he says. "But I think the spirit of it, the irreverence of it—if you look at some of his older work, particularly *Parasite*, there's a lot of that sort of gallows humor and sarcasm. In *Mickey7*, the gallows humor is literally a man on the gallows. I think that's another area where he and I are very much on the same page and another reason why I think he was the absolute perfect person to direct this film."

"I was very focused on Mickey," says Director Bong about the writing process. "The two different Mickeys and their deaths. The basic structure is the repetitions of the deaths—death is his job. It is a very strange situation," he explains. "The meaning of death, death as a job, was the very key point I focused on, and then I built up more and more from there. Who wants the deaths of Mickey, and who takes advantage of them? Who despises his deaths, but at the same time, who can use them? From that context, we can develop many so-called political layers of this movie. And basically, I want to make something funny. Something goofy, something stupid."

The genesis of what became *Mickey 17* took place during the Covid pandemic. Bong Joon Ho was in Korea drafting the screenplay and then handed it to his translator to put into English. In 2021, he and Choi met in Venice, where Director Bong was the president of the International Jury of the Competition at the 78th Venice International Film Festival.

Director Bong famously enjoys writing in cafes. Fortunately, despite the Covid pandemic, he was still able to visit cafes in Seoul—with time limitations—and focus on writing. "The actual, very intensive screenwriting with my laptop in the corner of a coffee shop in Seoul was from April 2021," he says. "I spent almost four months on my first draft. I remember the exact day I finished my first draft because I sent the script to the producers just one day before I flew to the Venice Film Festival. Plan B and Warner Bros. loved it, so I was happy about that."

RIGHT: Storyboards by Bong Joon Ho for a sequence in which Mickeys 17 and 18 are imprisoned—the only way to tell the characters apart is with a handy numerical annotation on the artwork.

OPPOSITE: Director Bong working with Steven Yeun and Mark Ruffalo. "What we're doing is very stylized. It's a little bit larger than life." Mark Ruffalo.

GREEN LIGHT

Oftentimes in Hollywood, films are set up with studios, scripts are drafted, actors and directors are attached, public announcements are made. And then nothing happens. Weeks, months, even years can go by without any further developments. Some movies go into "turnaround," others are forgotten. Even having everything seemingly lined up and ready does not necessarily mean the movie will get made. It is a long road to the first day of shooting and an even longer road to eventually seeing the film on a cinema screen.

The film world had been waiting with bated breath for Bong Joon Ho's next film. *Parasite* had been filmed in 2018—three long, world-changing years before. Director Bong was hungry to get started on his new movie. And he wasn't the only one. Warner Bros., Plan B, and the cast and crew were all eager to jump on board the new Bong Joon Ho project.

Snowpiercer, despite starring Hollywood actors and being primarily in English, was a Korean-produced film. Similarly, *Okja*, though financed by Netflix, had much in common with Director Bong's Korean filmography. *Mickey 17* is a first for him, in that it is a major studio film with a worldwide distributor for a wide theatrical release.

The first piece of the puzzle was finding their Mickey—now Mickey 17 rather than Mickey7.

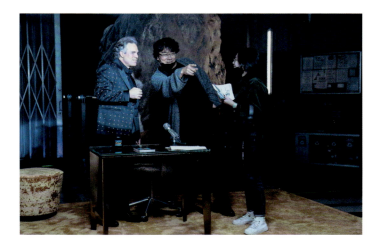

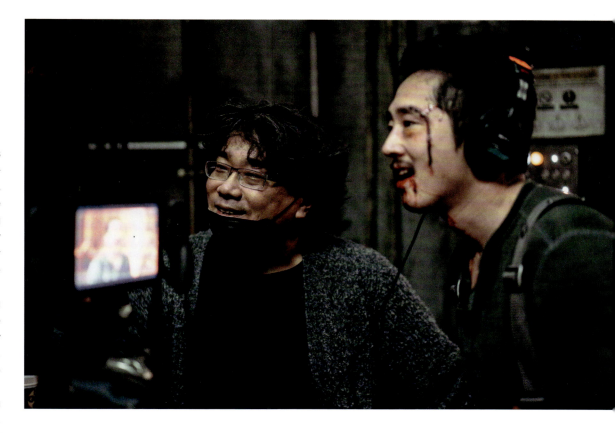

"Director Bong came to LA to meet actors," Choi recalls. "[Actor Robert Pattinson] is perfect for the role. He had been on our radar from as early as 2014. I think there was always this mutual respect, but Director Bong doesn't usually do general meetings with actors. It's only if it's specific to a thing that he's thinking about, for a part. When this came around, we were talking about Rob, so we arranged a meeting."

Pattinson has worked with some of the most distinctive auteurs in cinema, from Claire Denis and James Gray to David Cronenberg, the Safdie Brothers, and Robert Eggers. He had recently played a role in Christopher Nolan's *Tenet*, also released by Warner Bros. Pattinson was keen to start a conversation with Director Bong.

"He was my very first choice," Bong Joon Ho says. "He loved the script, and everything went quite smoothly, I think."

Pattinson was thrilled to be considered for the role. "I love his movies. Everybody loves his movies," he says. "We were having this meeting, but I had no idea what it was—the project was so top secret. I had a lunch with him, and we basically didn't talk about the project the entire time. And then I started thinking, 'Wait, is this sort of like a test? Is this even about a project?' Then at the end, he said something like, 'I have this strange, very strange movie if you'd like to read the script . . .'"

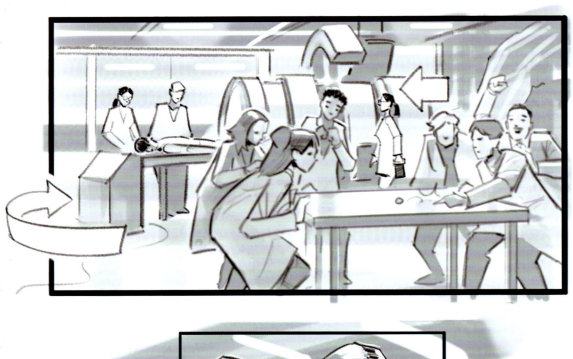

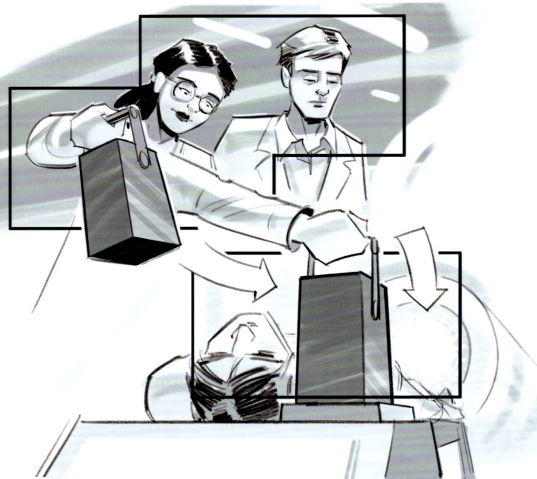

At that point, *The Batman* had come out and Pattinson was one of the leading stars with the studio, so he was immediately embraced by Warner Bros., Choi noted. "Once we had Rob, it was Bong Joon Ho and Rob Pattinson. Just the thought of it is very exciting. I think everybody that he wanted for the movie, there was mutual interest there and we were able to assemble a really phenomenal cast."

With one of the biggest stars in the world attached to Director Bong's first post-*Parasite* project, attention then turned to where they would shoot the movie. There were many logistical reasons why they settled on their eventual location, but it also fulfilled a long-standing ambition of Director Bong and Choi.

"Very early on, we met with Warner Bros.," Choi says. "We were told how WB had these great stages in London, which was amazing to hear. The thing about stages is that there is not enough stage space around. Having that security of knowing we had stages on hold meant a lot. Obviously, this was a movie that had to be very much built, even though we had some locations.

"Director Bong and I were excited to shoot in London. We had talked about doing a movie there. We also had so much success casting actors from the UK previously. I think that was the other thing about London that was very, very attractive, the fact that there's so many incredible actors who started in theater or drama school. They have this incredible infrastructure, so we knew going in that even for the smallest roles, we had a fairly good shot at getting somebody that would be amazing."

By any standards in Hollywood, the timeline of the news breaking that the film adaptation of *Mickey7* existed to said film actually shooting was fast. The announcement was made in January 2022, with the principal cast listed, and pre-production scheduled for May 2022.

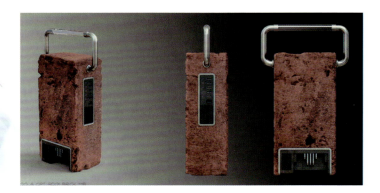

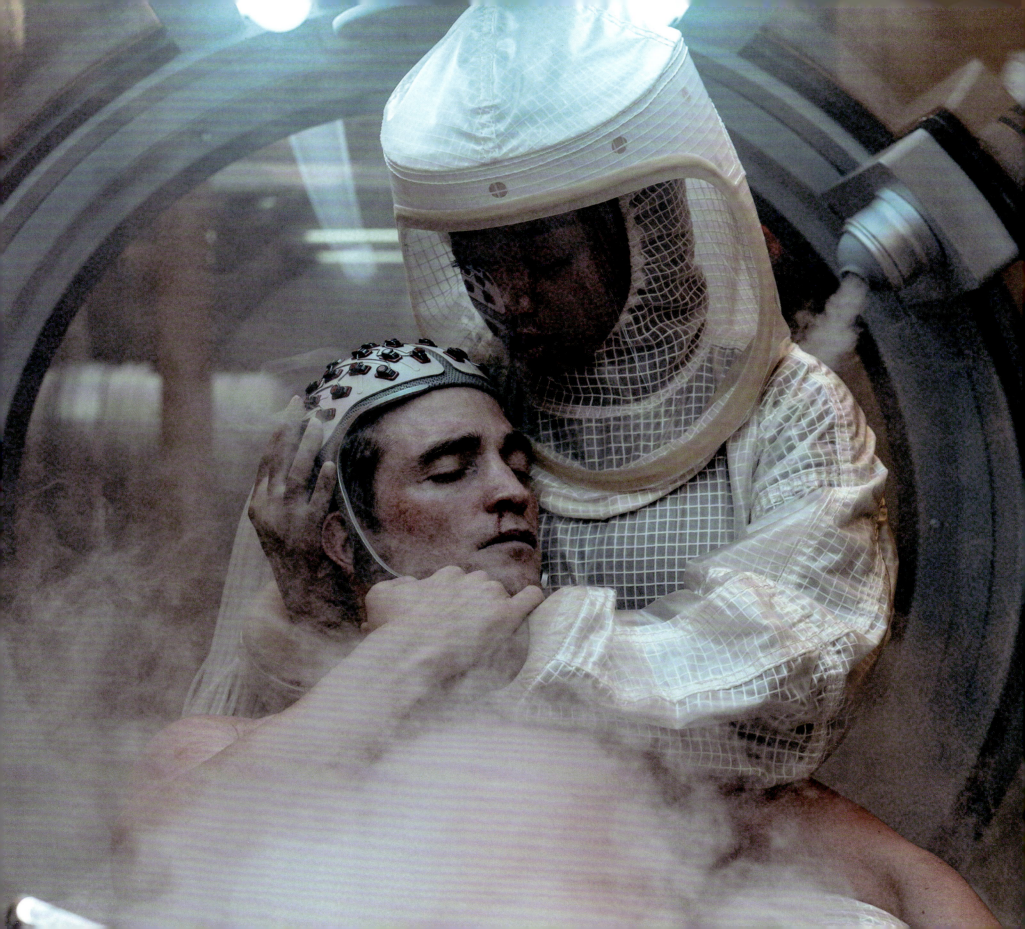

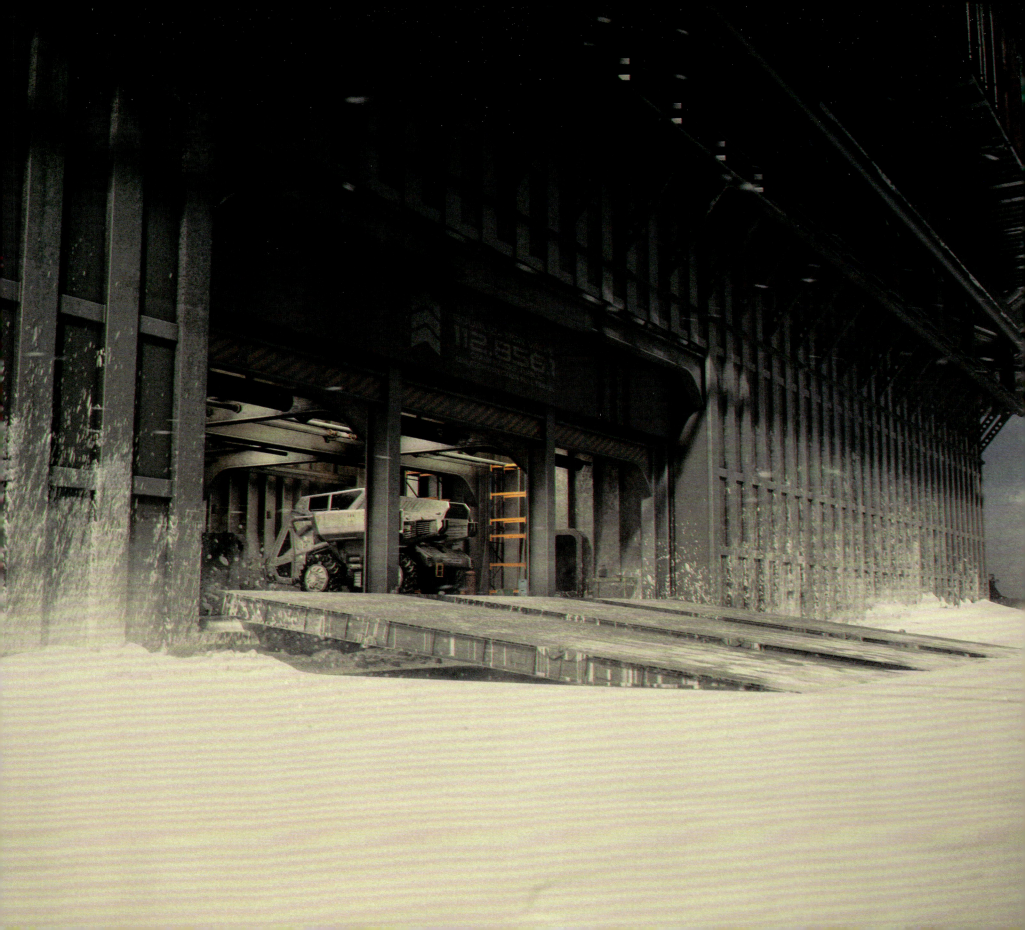

PRE-PRODUCTION

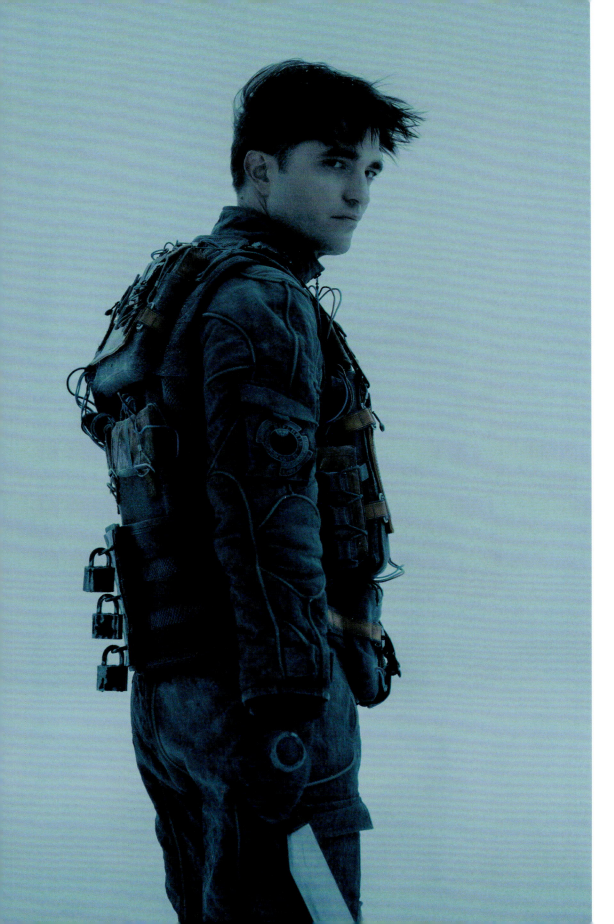

ASSEMBLING THE TEAM

Over the years, Bong Joon Ho has gathered a formidable team of collaborators with whom he has worked on various projects. Cinematographer Hyung Koo Kim worked on both *Memories of Murder* and *The Host*. Actor Song Kang-ho took lead roles in *Memories of Murder*, *The Host*, *Snowpiercer*, and *Parasite*. Actor Tilda Swinton has become a close ally following her work on *Snowpiercer* and *Okja*. *Mickey 17* brings back a lot of familiar faces, as well as adding some new blood.

Oscar-nominated Director of Photography Darius Khondji shot Director Bong's previous English-language movie, *Okja*, and was invited back for *Mickey 17*. Costume Designer Catherine George is now a veteran of three Bong Joon Ho projects, having previously worked on *Snowpiercer* and *Okja*.

"I've worked on *Snowpiercer* and *Okja*, and I've kept in touch with Director Bong and Dooho," George says. "I knew they were working on something and, as it started to take shape, I wanted to make sure I was available. In 2021, while finishing another film in Puerto Rico, I caught Covid and couldn't leave. During that time I received the script and read it in my hotel room. It was Christmas, quite surreal. That was December 2021."

Editor Jinmo Yang has worked on the past three Bong Joon Ho movies. On *Mickey 17,* he was on set every day, assembling and cutting the footage as soon as it came in. Composer Jung Jae Il found acclaim for his scores on *Okja* and *Parasite* and was tasked with creating the music for this newest endeavor.

Because the movie was creating a world from the ground up, it needed a production designer who could help bring to life this story of human printing and space travel. That's when Production Designer Fiona Crombie got a call asking if she'd be interested in meeting with Director Bong.

LEFT: "I felt I had to have a very blank slate when approaching the part." Robert Pattinson

BELOW: Costume sketches for anthropomorphic red and white blood cells, part of a children's TV show that plays a key role in the story of Manikova, the inventor of the human printing technology.

"I actually had a call from [Producers] Jeremy Kleiner, who I'd worked with before, and Dede Gardner. They said, 'There's a project—is it the sort of thing that you'd be interested in?' They must have remembered that I was a massive fan of *Okja* in particular, because I just watched it at a time where I really needed to see that film. And so, I remember when I first worked with Jeremy and Dede, all I could talk about was that film. I don't know if that's why they came to me, but they did. And they asked if I was interested, and I was like, 'Of course!'

"I was sent the script, and I did a first pass on imagery, so that I could express to Director Bong how I had seen the film and what I thought it could look like. But, actually, in our first call, we didn't even talk about that. We sort of just talked. He asked me about my favorite movies and other sorts of sci-fi that I had enjoyed or was interested in. We talked about life a bit and stuff like that. It was kind of a bit more general. And then at the end of that, I said, 'I prepared a document. Would you like to see it?' And he said yes. I sent it to him separately. I sort of annotated it, and then we had a second interview, the second meeting, where we sort of ran through the images specifically. And that was kind of the beginning, really. Those images did form a sort of aesthetic foundation for the film. There were lots of things that were left out, and then we added a huge amount more. But as a kind of beginning point, I think it piqued our interest. For me, it was a good launch."

VFX Supervisor Dan Glass is a veteran of films including *The Tree of Life*, *Cloud Atlas*, and *The Matrix Resurrections*. He and Director Bong had long been talking about collaborating on a project and the stars finally aligned for *Mickey 17*, something that Glass could not be happier about: "It was fortunate timing,

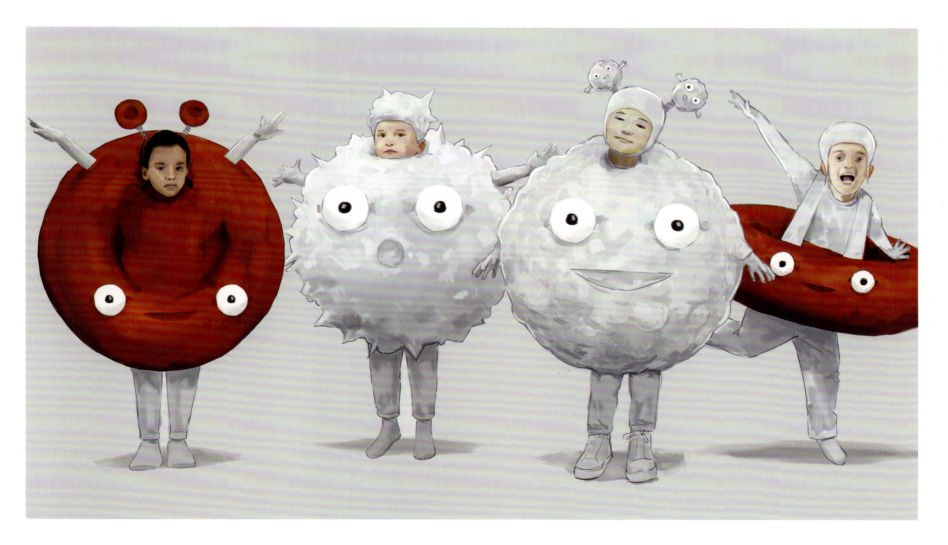

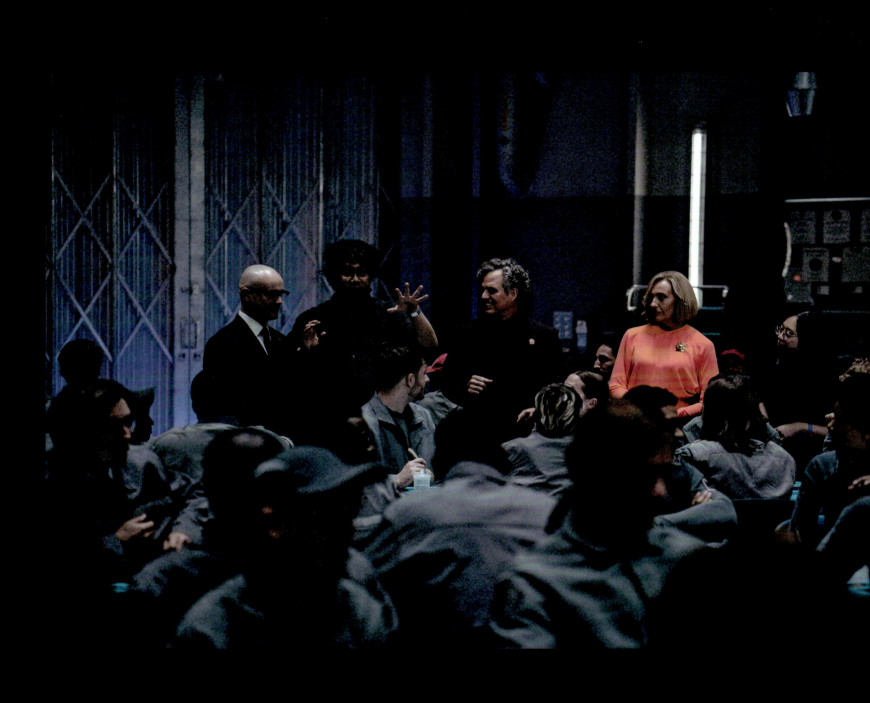

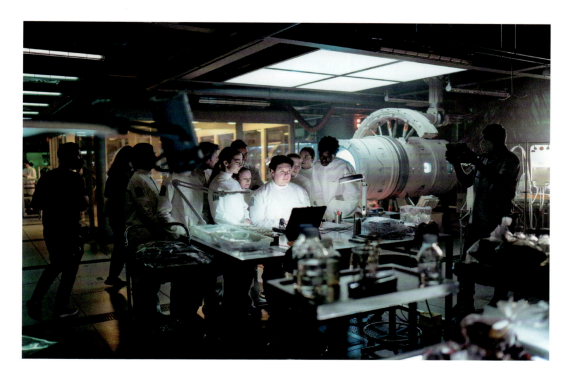

"I think it's pretty much the same," Choi says. "Working with a traditional studio as opposed to a new studio had its differences in the sense that a traditional studio has an established way of doing things, and they're so efficient in all of the departments. A lot of the crew were coming off The Flash or The Batman, and our movie is tiny. It's like, 'Three hundred extras? No problem!' Whereas for us normally, it's like, 'Oh my God, three hundred extras?!' And certainly, that adds a layer of pressure that is a bit new. But as far as the way Director Bong approaches everything, it's the same.

"He liked to joke that if he disappeared, the movie would still get made because everybody knows what to do. But I think that joke was his way of saying we're working with people in every department who are at the top of their craft. They're just incredible at their jobs. In that sense, it's like a real dream to be able to work with people at this caliber, this level of artistry, because there's nothing that's not possible."

to be available. I'm really interested to do any show he's doing, but the fact that it was sort of science fiction and creature work, it couldn't be more intriguing. I also really respect the way he likes to work, which is a long period of writing and idea development and really figuring out what he wants to do. I wish more filmmakers did it! It really helps with the whole process, to have a filmmaker who's thought about what they want—not that there isn't room for other ideas that come up along the way, but I liked having the clarity of really thoroughly thought-through things."

Director Bong's movie before Parasite was Okja, a medium-sized production filmed on two continents. It had three VFX houses working on it and featured a global cast of acclaimed actors. It was a major original movie from Netflix, which at that time was establishing itself as a place where auteur directors could take risks. Mickey 17 is a bigger film than Okja and, in terms of scale and budget, is certainly much larger than Parasite. But when it comes to the creative process of making a movie, there is no difference whatsoever.

PRE-PRODUCTION

VISUALIZING THE WORLD

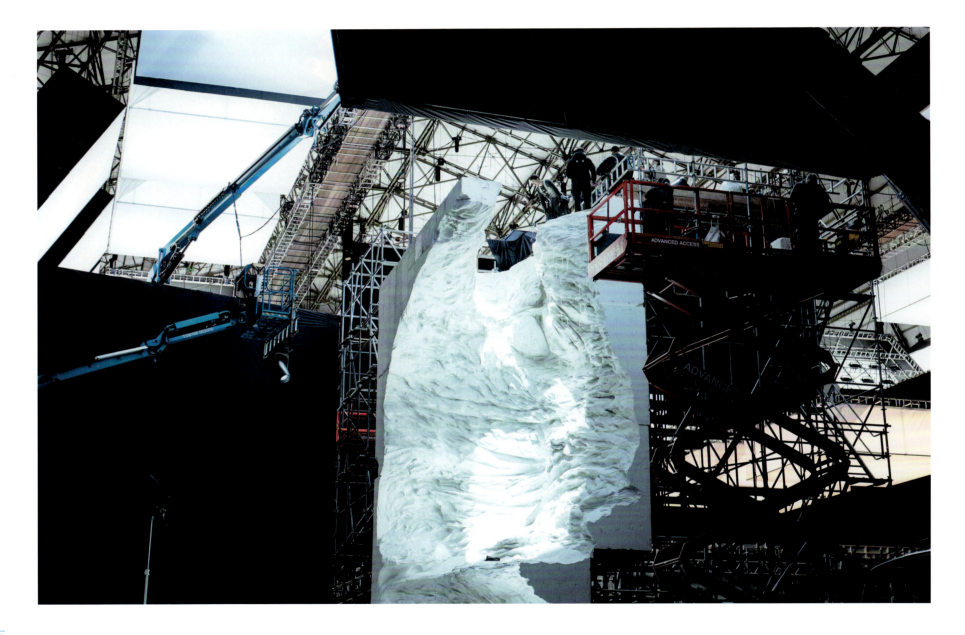

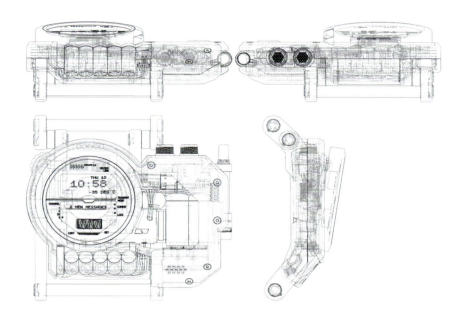

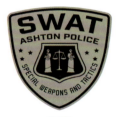

LEFT: The crevasse set constructed at Cardington, where Timo calls down to the stranded Mickey. Steven Yeun is just visible at the top of the overhang.
ABOVE: A uniform patch for the SWAT team who arrest the inventor of human printing technology, as well as the branding for the religious organization sponsoring the Niflheim mission.
TOP: Blueprints for the wrist communicator. The central circular display is detachable.
RIGHT: Designs by the costume department for the crew. Director Bong was keen to use gray as a key color throughout production design and costume design—the world of the ship is far from hi-tech.

For anyone who has read Edward Ashton's novel, their own image of the story lives on in their mind's eye. But in adapting that novel into his own script, Director Bong needed to define how he envisioned the story, and then decipher how best to communicate that story to an audience.

"Just after I finished the screenwriting, we set two or three conceptual artists and discussed the basic image I wanted," Director Bong says. "There were six or seven very photorealistic conceptual art pieces we made that were key in establishing the look of this movie, what kind of visual we were going to show in the film. Storyboarding officially began from the beginning of pre-production in April to May 2022."

Bong Joon Ho's movies are identifiably his, from only a few seconds of footage. They have a pace, look, and mood all their own. His cinematic language has crossed language barriers to be enjoyed by audiences across the world. His unique take on filmmaking is evident in how he approached *Mickey 17*.

"I wanted to make it some strange combination of a very sci-fi, very space-opera-sci-fi-on-another-planet kind of thing combined with a silly, goofy tone," Director Bong says. "The idea that humans are still so silly and stupid even on another planet, even with the very high technology, that was the subtheme I wanted to take. It could make the movie very funny and interesting, I think. It's the humor, which is very, very different from a sci-fi like *Dune*. *Dune* is very beautiful, and I love it. But ours is very different from those kinds of epic, spectacular sci-fi things. This is more human and more detailed on a human level."

For the fundamentals of the world of *Mickey 17*, Director Bong collaborated with his concept artists, director of photography, storyboard artist, costume designer, and production design team. One of the main notes from Director Bong to the art department was that the primary color was to be gray, according to Crombie.

"He was very keen on gray, and different shades of gray," she says. "We definitely had pops of color, but we were very careful about red. Red became something that we used very sparingly. Red is used very purposefully in the film. So therefore, we had to come up with an alternative safety color, and that was yellow.

"We got this email saying Director Bong would like us to have a color party. So, then I brought all my color samples, and we went up to Catherine George's workroom and she had all her samples and we basically composed it all together with Darius and Director Bong. So that was very carefully calibrated. And then, of course, it means that when you're not in a space that's gray, it's very meaningful."

In 2020, *Parasite* was re-released in theaters and on Blu-ray in a Director Bong-approved black-and-white version. For Director Bong, this offered a chance to experience the movie in a different way, to see how the monochrome color palette changes a viewer's engagement with the story. It is a question that has stayed with the filmmaker and became a discussion point with Khondji.

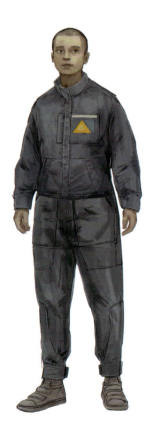
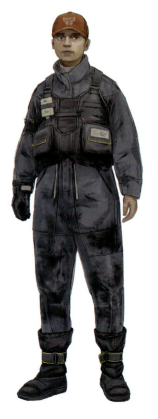

"During screenwriting, I did some simple drawings of the vehicle in the movie, the flitter, and also the cycler room."
—BONG JOON HO

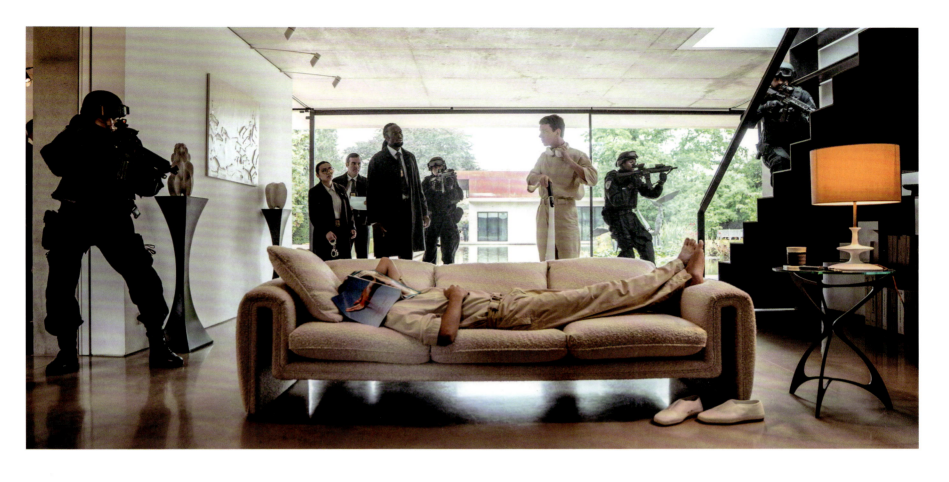

FAR LEFT: "Andrew Cartwright made all of Robert's costumes. To be so hands-on and in control of every little detail was incredible. He made the scanning suit, which is one of my favorites." Catherine George, Costume Designer
OPPOSITE: Bong Joon Ho's storyboard, showing the moment when the Baby Creeper's life hangs by a thread in the ship's cycler room.
ABOVE: The SWAT team invades the home of Manikova when the truth about him is discovered.

"Working with Director Bong is amazing because he has a very, very definite vision," Khondji says. "He has a very clear vision of what he wants. Even though he's very collaborative and works very well with his designers, costume designer, the effects team, and me, he likes to storyboard everything, and he is really driven. You know where you're going. I would ask him for colors, because, in his mind, he almost wanted a black-and-white film.

"Originally, he almost wanted to make a black-and-white film, but he didn't go that far. We made it very much into the blue and cyan, muted colors, dark colors. And then in the middle of this big canvas of muted tones into blue and green, there would be a definite red color, and then a different definite gold-brown color, a definite green color, but they will be very separated, very orientated for one character, and everybody else was gray. It was a very interesting approach. I think we all ended up following Director Bong's lead because he has a very definite way of seeing things in the scheme of color."

Mickey 17 does not resemble typical sci-fi films. It does not tick the boxes of the typical aesthetic motifs one expects to see in a genre blockbuster. It does not look like a sci-fi film, but it does look like a Bong Joon Ho film. Director Bong approached the film no differently than any of his other projects, which tend to move with ease and fluidity between tones and genres. They operate within their own set of rules.

"Director Bong told me that of course it's a story from a sci-fi book," Khondji confirms. "*Mickey 17* is in the category of science fiction. But there are some projects I've been a part of with some very serious directors, serious artists, but we don't want to actually say, 'Okay, we're doing a science fiction film, or we're doing a period film, or we're doing this or we're doing that.' We are treating it like a contemporary story in a way. This is what Director Bong was telling me. We didn't want to make this a typical sci-fi movie, you know? This was a non-sci-fi film for me. What is really sci-fi anyway? For me the points of reference for sci-fi are certain books, certain writers, and certain movies. You always go back to *2001: A Space Odyssey*, and different variations; B movies and all that. But I think this one was more like a thriller, an intimate story, not a typical sci-fi where people go to a different planet. It's true that they go to a different planet, but we didn't want to treat it like the planet was so incredibly far removed from what we know."

PRE-PRODUCTION

EARTH

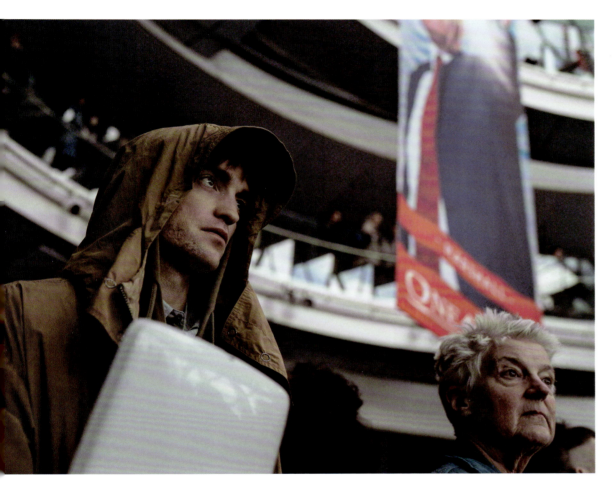

Mickey Barnes is on the run.

Along with his best friend Timo, the two are dodging through the streets. They owe money to some very bad people. One man in particular, the gangster Darius Blank, makes it very clear that unless they give him what they owe, they will die an excruciating death.

Mickey and Timo take the only logical course of action—they flee. Timo suggests they escape by applying for the mission to Niflheim. Surely, Blank's men wouldn't follow them to another planet?

The Earth of *Mickey 17* is plagued with environmental problems, extreme weather. Class divide persists. Even though Bong

Mickey gives his expert analysis of the hard drive and technology in the film: "It's advanced! Very advanced."

Joon Ho's films do not share universes—only concerns—it is not hard to imagine the world of *Mickey 17* as the tipping point before the events of *Snowpiercer*.

But like in all of Director Bong's films, there needs to be recognizability and relatability. Neither jetpacks nor laser guns live here. *Mickey 17*'s Earth is very much intended to be a version of our almost-now. Identifying the look of this time period was under Catherine George's purview.

"One of the things was the look of Earth," she recalls. "You can have a very particular look when you're in space—the crew is sent up there with uniforms—but trying to predict what are we wearing in the future is a sort of dangerous game. In that, you can go really wrong. Every time I showed Director Bong some imagery that was modern or futuristic or had any kind of 'spacey' vibe, he would sort of reel from it. I think Fiona Crombie in production design was having the same problem with the technology and realistically defining the aesthetic of an unknowable period in the future. I was starting to read these scientific prediction things, and eventually Director Bong realized we were hung up on it and he said, 'You know what? I'm either not going to have the year title card at all—it'll just be like, *in the future*—or it'll be much closer to present day.' He realized the quandary of: What is it gonna look like a hundred years from now? It has to be much weirder and much more spacey or whatever, but when you're predicting something like that, you're probably going to fail."

Choi agrees that conundrum of creating an aesthetic for space or the future is fertile ground for potential clichés. "How do you depict the future without making it into *Star Wars* or *Star Trek*?" he asks. "During prep, when he would talk to the VFX team or the art department or Catherine, Director Bong always pulled them back, I felt like. It was always, 'It has to be more contemporary,' like

things we have now or even things from the past. It's like how we have things that we use today that are from the 1950s or whatever, vintage things. Marshall has a vintage microphone that he talks into when he's speaking to all the people on the spaceship, and it's a mic that's been around for decades. He has a revolver that's a classic pistol. It's not like everything suddenly is new. A lot of the props were things that exist, but also existed in the past.

"But also, how do you show that it's *not* the present?" Choi continues. "And again, it was more to do with little things, such as: What does the flamethrower look like? What does the hard drive that Mickey's memories are stored on look like? What does the human printer look like? These are things that don't exist in life, but a hard drive is a concept that we can all latch on; we know what a hard drive looks like. The characters use cameras, and they're not super weird-looking cameras. They almost look like cameras that would exist today. But there's just subtle touches."

Even though *Mickey 17* is set in the future, it's still very much a grounded world, a functional reality. The film is concerned with the practical, the practicalities of living and dying, of surviving. That all trickles down to the set design, props, and costumes.

"We kind of came down to certain elements, a color palette," George confirms. "We know there's severe weather patterns, some sort of storm disasters, and so they had to have layers, practical layers of hoods and dust covers and these duster coats. What appeals to Director Bong as well was a kind of more androgynous look, which is sort of what's happening in the world in fashion. Some of the men are wearing layers of trousers, skirts with boots, and then with a top layer, which is a protection from the sandstorms."

"Sci-fi can be so otherworldly," Crombie says. "It felt right for *Mickey 17* that we needed to relate to the environment, that the environment has to tell you something about the circumstances of the individuals. That's quite important."

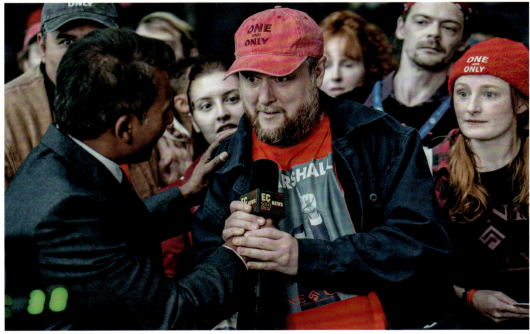

LEFT: To his supporters, Kenneth Marshall is the answer to Earth's problems. He inspires devotion, to the degree that the man pictured left (played by Tim Key) is willing to do anything to be a part of the mission, including eventually dressing up as a pigeon.
TOP: Exterior back alley rendering in heavy rain.
RIGHT: Manikova (played by Edward Davis). The inventor of human printing technology, who immediately uses it for his own nefarious means. This forms part of the film's prologue.

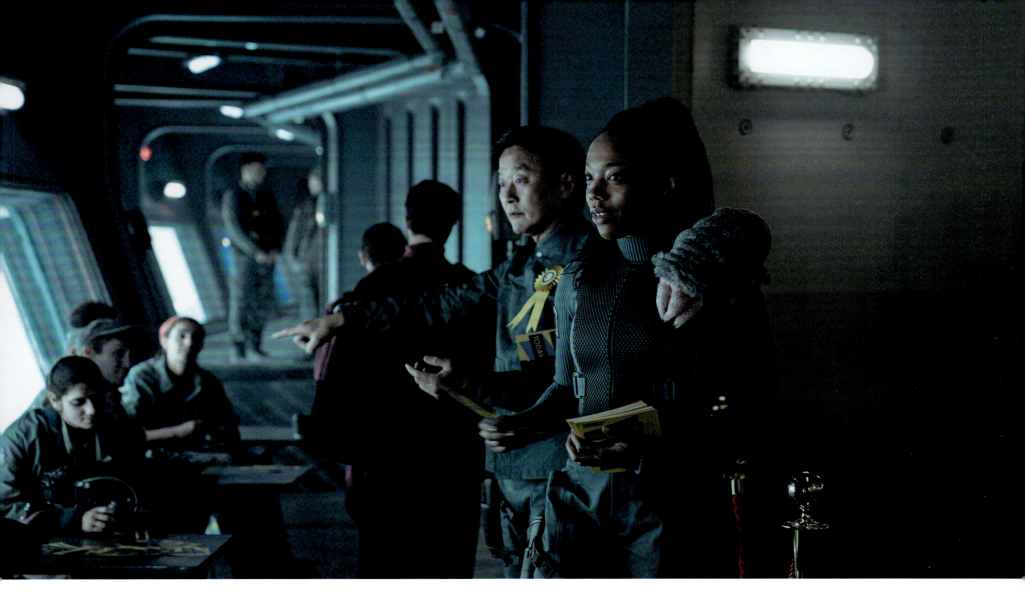

THE SHIP

Fiona Crombie says designing the ship that takes the colonists on the four-year journey to Niflheim involved contemplating what the vessel would feel like, internally, for the inhabitants. "It was teasing out what the interesting elements were that I thought we could play with in the film visually," she explains. "I work with a researcher, and we built a lot of this together. Obviously, I looked at actual spaceships, but my initial impulse and what I was drawn to was the mess. I remember looking at a lot of cargo ships and submarines, these really functional spaces that are quite otherworldly. But it was more expressionistic than that. The biggest thing was: It wasn't tidy."

Crombie's first impulses were based on discussions with Director Bong but also the script itself and the visual ideas that sprang from it. "The first thing that really struck me in the script," she says, "I think it was in the scene they're playing penny football, and they trip over a wire—someone trips over cable. That was just like a lightbulb moment for me. *There are cables*. None of this is tidy. It's not hidden away. And also, this idea of people who are bored and looking for things to do. That made me go, 'Ah, I'm somewhere that I relate to.' And that continues the entire way through the film."

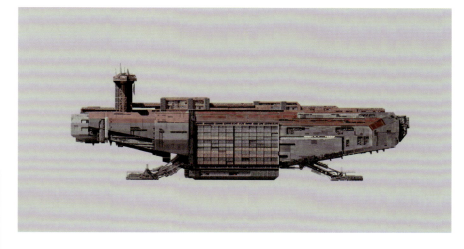

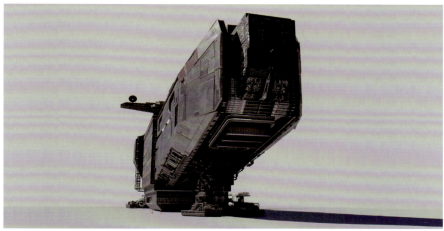

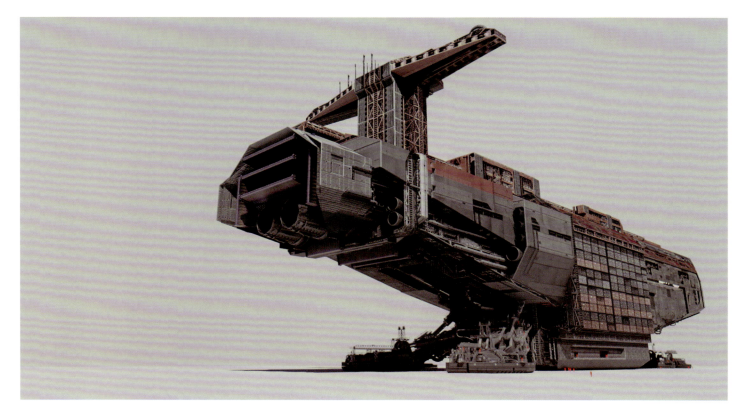

ABOVE LEFT: Nasha (Naomi Ackie) outside the ship's hallway.
THIS PAGE: Production design for the exterior of the ship, which variously brings to mind cargo ships and shipping containers, telling us something about how Marshall sees his crew.

As with the Earth-set scenes, the aim was to make this a recognizable world. The viewer is not meant to be dazzled by the strangeness and impossibilities of a craft that can travel across the galaxy. Rather, it is about finding a way to empathize with what's happening on the screen and ultimately feel closer to the characters.

What's more, filling this ship with contemporary elements not only makes the world knowable to the audience, but adds in some of Director Bong's trademark humor. "We thought about things that had a foundation in reality. We looked round the actual studio we were shooting in and the ways in which it was functional, repetitive, or standardized," she says. "We thought, 'How can we use that in the film?' It was everything from safety lighting and signage to whatever is used to shepherd people through their working day safely.

"I think one thing that I loved was the amount of graphics. Very early on, I had done a graphics file because I loved that there was like a kind of administrative overcommunication. There is so much about danger of death, how many calories you can and can't have, how many days you can do this or that, don't go here, all of that stuff. It was almost like a constant reminder that you were being managed. And also, the whole danger of death thing—don't fall here, don't do this. I thought that was kind of funny. So, we just had those graphics and signage everywhere."

RIGHT: Artwork by Fiona Crombie's production design department, showcasing the flitter—the vehicle used to explore the wintry surface of Niflheim. "It's very kind of chunky, bulky—it is not designed to be aesthetically appealing or anything like that or even aerodynamic." Dan Glass, VFX Supervisor

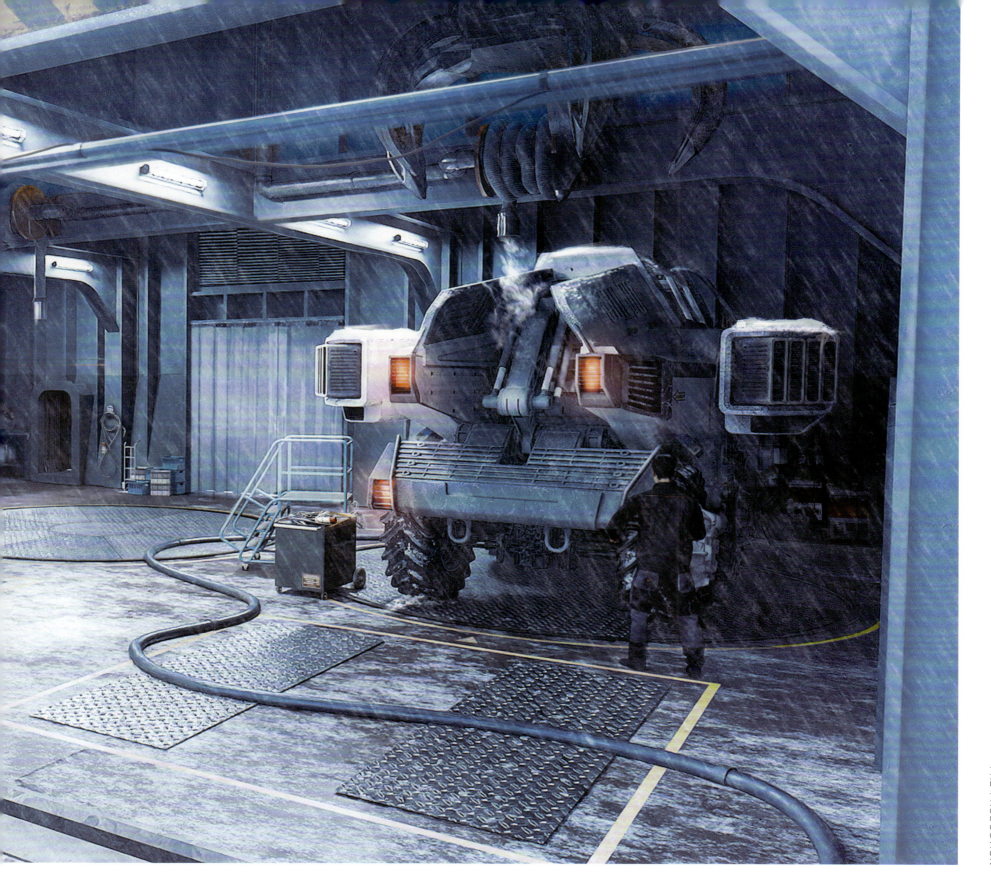

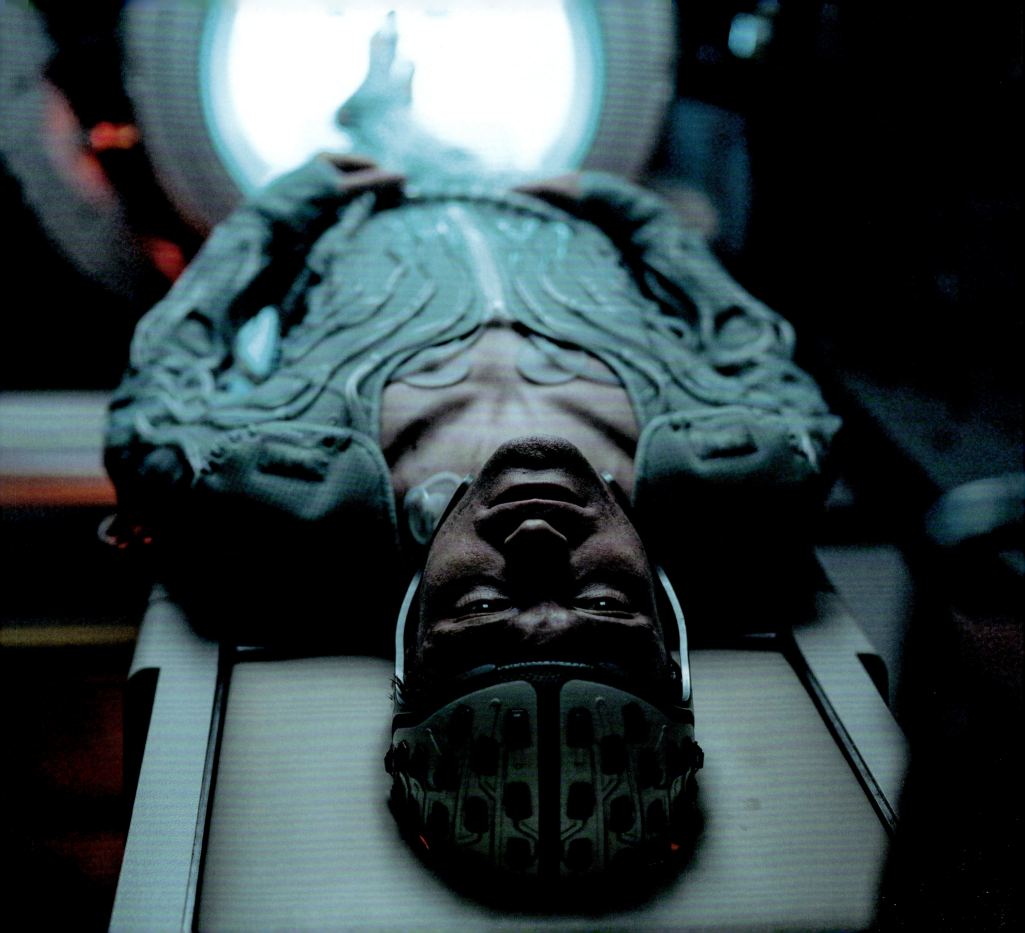

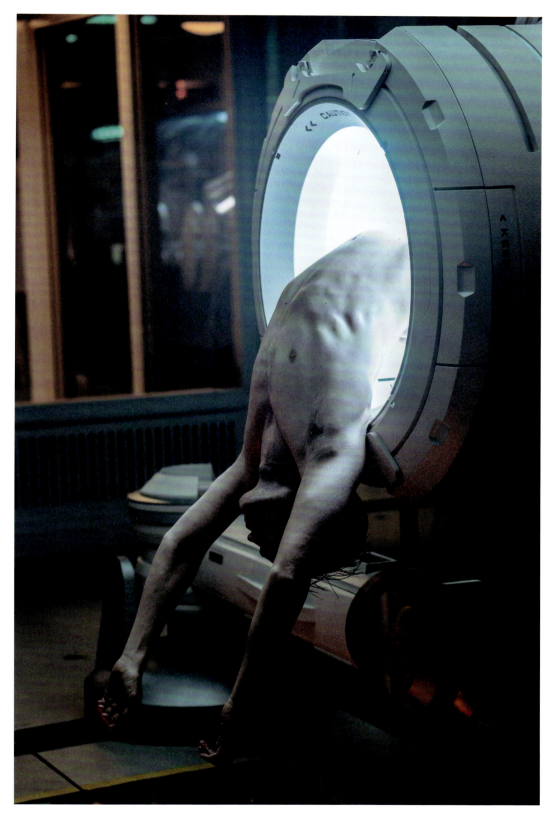

THE HUMAN PRINTER

The miracle of birth is an incredible thing to witness: a new life entering the world for the first time. But with Mickey, each new version is not a new life, and it is not for the first time. It is a continuation. Reincarnation, in a spiritual sense; a production line, in practical terms. A new Mickey can be produced at the touch of a button. Every thought, every memory in his mind, and every molecule in his body, uploaded into a portable hard drive nicknamed "the brick."

The inventor of the technology ended up using the machine to print multiple versions of himself, enabling him to commit brutal acts with his doppelgänger acting as an alibi. So, the law decreed that only one version can exist at any one time. Only when the last Mickey dies can the new one roll off the conveyor. It is a seamless, highly polished system, but it is not magic. In portraying the human printer, Director Bong wanted to lean into the gnarly details, showing what it takes to make a person.

The first official glimpse moviegoers around the world got of *Mickey 17* was a 45-second teaser released in January 2023, showcasing Pattinson as Mickey inside the human printer. The machine is the centerpiece in the movie, and getting it right was vital.

"It was our first major set," Crombie says. "Our first actual set in the studio was the human printer room. [For the design,] I looked early on at MRIs and these kind of machines in which you can be fully scanned. But I also looked at machines that weave,

> "I think there is a CG shot inside the machine of various organs being built. That's the gory part of Director Bong."
> —DOMINIC TUOHY

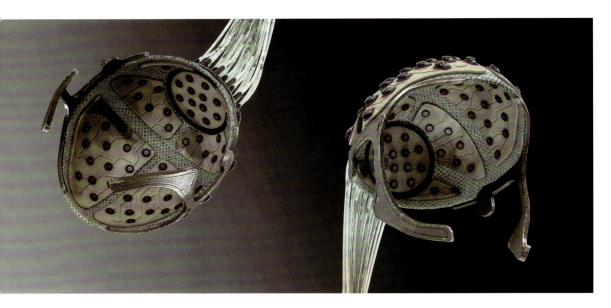

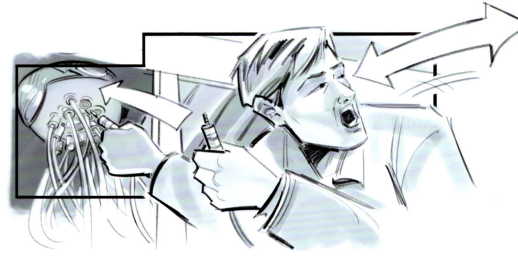

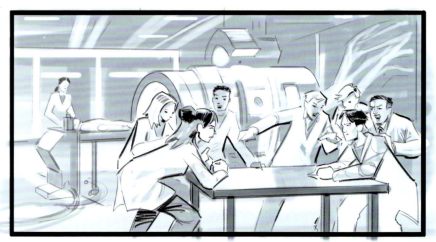

with the idea that this body is put together. I remember looking at all these pistons and needles, just thinking about how the sinew of the human body could be strung back together. I think it's quite simple. It's really beautiful. The machine itself has got this great relationship with gravity. So, it's kind of an arm holding it up at the top and then one holding it at the bottom. It's almost floating in space, but not actually. It's just like the way that it's counterbalanced."

Mickey 17 exists in a wonderfully flexible moment in time. Because of the sheer fact of human printing, the film is set in the future by necessity, but not an unrecognizable one. The world of *Mickey 17* has as much of the past and the present in it as it does the future. These details can either be playful and esoteric or as a means of grounding the sci-fi trappings of the film in a relatable way. Crombie says the color scheme chosen for the exterior of the human printer was important to convey a sense of familiarity to the audience.

"We were really attracted to this color that we kept calling IBM cream," she says. "It's kind of a slightly dated color. We have a lot of gray in the film, but when it comes to certain technology, like the human-printer-related technology, that's an IBM color. It's made of textured plastic with this old-computer cream color."

Some degree of functionality is also necessary to sell the reality of the machine—something that Bong Joon Ho was keen to support. "We got involved with the human printer," Special Effects Supervisor Dominic Tuohy says. "It was a drawing by the art department. It was a concept that Director Bong liked, and then it became this practical instrument. So, I then said to him, 'Should there be parts of this that move?' because it's a human printer, and Director Bong asked, 'What do you mean?' I said, 'Well, should there be bezels that move on the outside? Like a focus on a camera focusing? And the bed that the actor is lying on, should that move backwards and forwards as if it's printed, like a printer that you've got at home when you see the papers getting spat out?' And Director Bong was like, 'Yes, yes, yes, yes.'"

There was no other way for Tuohy and his team to work but to start from the ground up. They had to find a way to make every little detail come to life, in a way that would work for the needs of the director, the actor, the cinematographer, and the audience in theaters. "Okay, so first we need to build a tube," Tuohy says. "The tube now needs to support a conveyor belt. The conveyor belt needs to be made because it's all bespoke. It's not like we can just get a conveyor belt from the sport shop. We've got to make our own one. We have also got to make it in keeping with the rest of the medical equipment in this lab set.

TOP LEFT: The brain scanner machine used to read Mickey's mind, to upload and download his memories, and therefore reuse them again and again.
LEFT: Director Bong had a clear vision of how he wanted every shot to be, with storyboards capturing movement and nuances like expressions. It is the film, frame by frame.

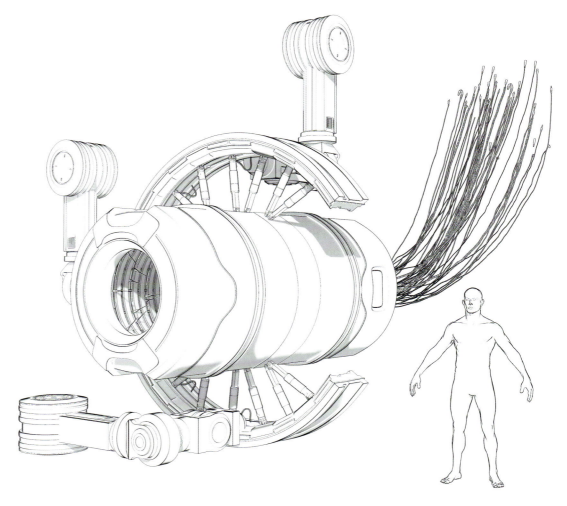

RIGHT: Artwork for the human printer, expressing not only the broad strokes of the design but also the scale relative to a character. Following various iterations of the human printer, this was the design that crystallized the filmmakers' concept. Fiona Crombie's team used this as the basis going forward.

"So, it should be stainless steel. But stainless steel is really heavy. So, it's our job to say that we can make that out of fiberglass. But if you look at the bezel, for example, Fiona wanted it to be in stainless steel. The problem with making that in stainless steel is that in order to do it accurately it would simply weigh too much. So, what we ended up doing is we made it out of chemiwood, which is like a composite wood, and then we put a vinyl wrap over it. That was a stainless-steel wrap. And that is how we do things; it's smoke and mirrors.

"Normally, the biggest problem we have as a special effects department is everything we do is noisy," he continues. "A motor is making a humming noise, there's a hydraulic pack or there's something, and we're always trying to make it silent. When we showed Director Bong the human printer, we explained that it was a bit noisy, and he was like, 'I love that noise.' He said, 'That's the life of the machine. The machine should sound like that. The sound in my head for the machine is that noise.' So, I think we spent three hours running the machine, and the sound department recorded every little motor twist in the stopping and variations. That's gonna make the soundtrack for the printer when it's working."

When it was indeed all working, the filmmakers did a test during pre-production with Pattinson placed into the human printer for the first time. It was a milestone moment for the production and one that Crombie remembers well. "I am not kidding when I say that I think there would have been sixty people on that set," she says. "It actually really was weird. I remember Rob asked a few questions about the printer but, y'know, he basically spends his life being looked at. I just couldn't believe how many people came to watch him go in that human printer. It was a bit of a spectacle."

THE CYCLER

Bong Joon Ho's films entertain an ecology in their own right. The people and the environments connect to one another. Sometimes it is very literal, such as the two train carriages in *Snowpiercer*, or other times it is symbolic, such as the co-dependent two families in *Parasite*. Sometimes the pieces of a Director Bong film interact with one another in a harmony that enables him to conversely explore an unsustainable model. The food chain of *Okja* is an excellent example. In the new film, Mickey 18 would not exist were it not for his predecessor, and the entire colonization mission itself would not have happened were it not for Niflheim.

In *Mickey 17*, the element that creates life, the human printer, and the waste disposal system, also known as the cycler, are intrinsically linked. Fiona Crombie remembers discussing with her department that the lab in the film, where life begins, will set the rules for other important rooms, such as the cycler.

"It'll give us the things that we feel work well. And then from there we can go forward," she says. "The cycler room wound up being very directly related in an opposite way to the lab. We actually reused lab dressing for the cycler room, because it felt like it has to sit within the same language. They are related to each other because the base of one sits above the other. In the reality of the ship, the lab is above the cycler room."

The cycler takes raw organic waste from the ship and combines it into a new body for the next Mickey. There could be no more fitting a metaphor for how the mission sees Mickey. He is in essence a new piece of plastic packaging, reformed and created from what has been used and discarded by a consumer-driven society.

"The cycler is a very important space in the movie," Director Bong says. "It means death and birth at the same time. It has a steamy visual mood and sometimes it looks like hell—a burning hell. Many things happen there. And the very basic drawing of the cycler structure I did during screenwriting."

Crombie says getting the cycler right was vital. "It took the longest. I did multiple versions from the very beginning, when I first started on the project and I was working at home," she says. "I

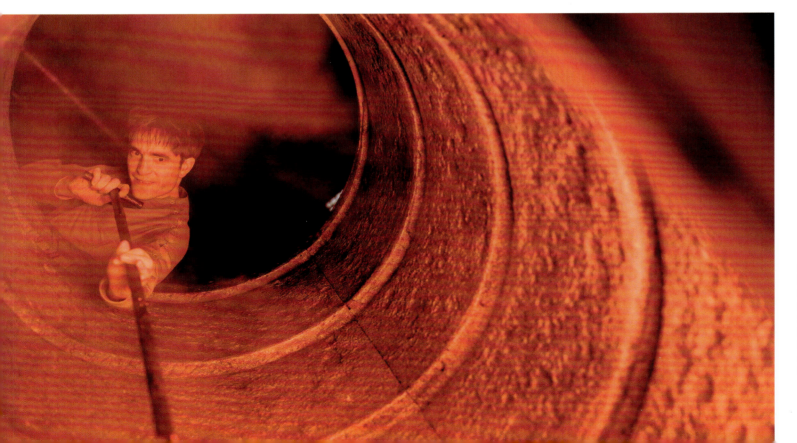

LEFT: Mickey 18 showing himself to be more volatile and unpredictable than his predecessor.
RIGHT: When creating the storyboards, Director Bong clearly explained his vision, describing scenes in meticulous detail, even acting out expressions and movements to plan the film frame by frame.

was presenting cycler ideas right up to when we were about to start building it. We were still kind of working through what was the cycler, and that took a while. In the beginning, it was a bit more of a living thing. We talked about it being like an organism, but it wasn't that. Then I remember Director Bong saying how we shouldn't be in awe of it. We shouldn't be going, 'Oh, there's another meaning here.' There's not; it's a garbage disposal. It's that. We kind of moved through different versions, or certainly I did, as I was interpreting Director Bong. It might be that he had a really clear vision of it. But for me, it took me a few steps and processes to get to the point where I was like, 'Ah, it's a garbage disposal.'

"Eventually, within the room, we put in five cyclers, so it became even more ordinary. The one that the action is around is in the middle, but there are other ones, so we decided that it was like a recycle center, where you might put your plastics and then put your cardboard, your food waste or whatever. So, it became even more ordinary, because there are multiple."

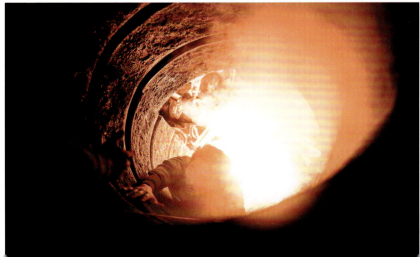

52 THE ART AND MAKING OF MICKEY 17

"It's dark and it's quite wet. It's sort of shiny and steaming hot."
—FIONA CROMBIE

OPPOSITE: In the cycler room, Marshall is grandiose in his war attire. Bong Joon Ho prepares the scene in which Marshall presses a red-hot poker to Mickey 18's face, the better to tell the two Mickeys apart.
THIS PAGE: Film stills showing an earlier action scene in the cycler room. When they first meet, Mickey 18 is more of a confident, even volatile, force than Mickey 17.

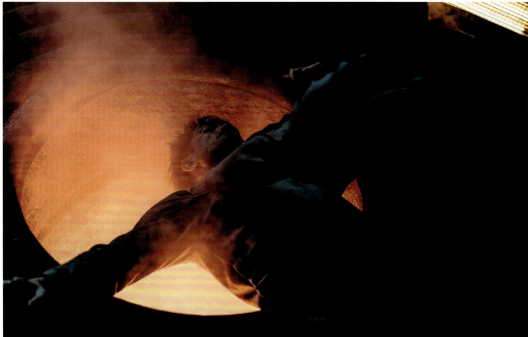

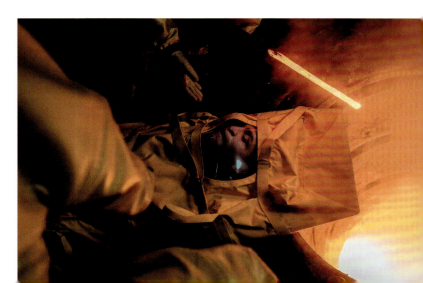

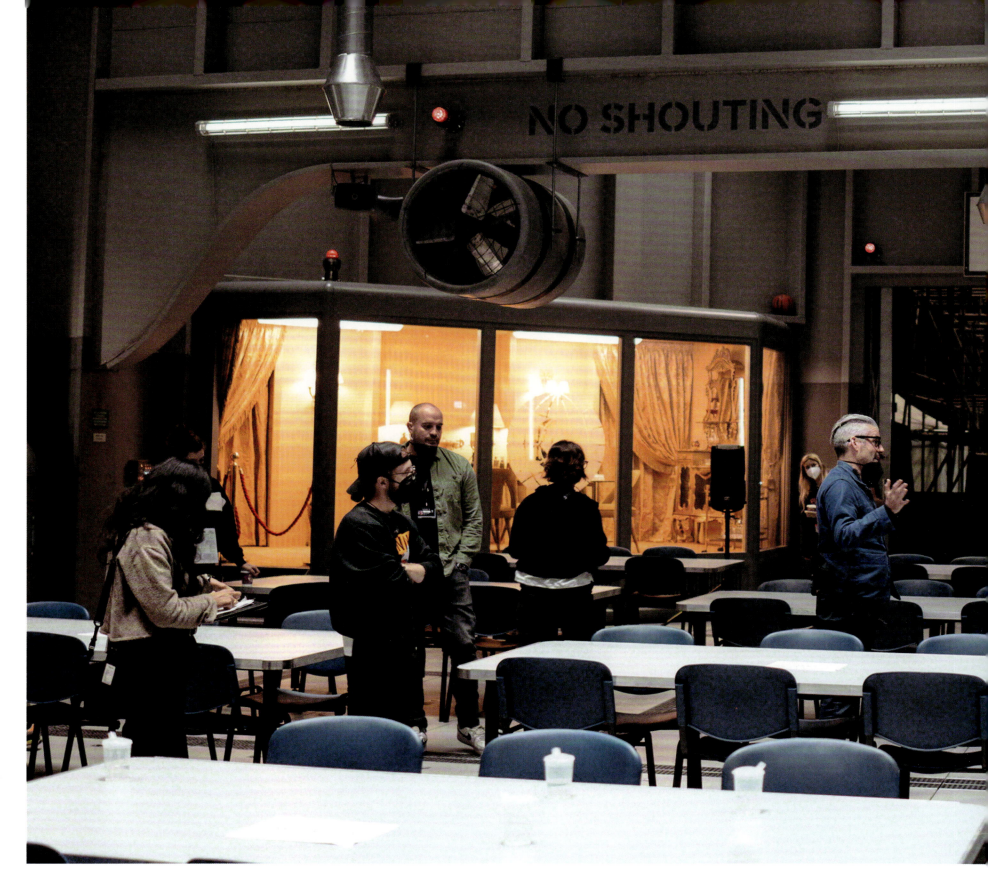

CAFETERIA

In establishing the look of the *Mickey 17* ship, Director Bong, Fiona Crombie, and Catherine George all agreed that it is essentially an oil rig, but in space. The people on this voyage eat, work, and sleep. As such, the cafeteria becomes the heart of the ship. It is the communal hub even though there is nothing communal about it. It is purely a functional space.

Bong Joon Ho has a knack for finding or creating sets that showcase his creatures. Scenes are crafted for maximum impact, perhaps in an unexpected way, putting something wild into an otherwise unremarkable scenario. For instance, the appearance of the creature along the river in *The Host* or *Okja* stampeding through the shopping mall.

The same can be said about the cafeteria. It needed to be a substantial but unassuming space. In the film, it would later host a centerpiece scene, where an unpredictable element is introduced to this otherwise carefully controlled environment and turns the whole story upside down.

Even with a significant budget and dedicated space at Leavesden, the filmmakers still had to be inventive with their set design and construction. "The thing that was complicated generally about this movie was that we didn't have many studios," Crombie says. "We actually packed four sets into that studio space. We had the cafeteria, and the cafeteria was built right next to the committee room. The cycler was at the other end, but the cafeteria and the committee room both physically joined the long hallway—a long hallway with windows on the ship. So, we were just hitting that studio with everything. There were just people everywhere; it was quite intense. So, it meant that all those sets actually stayed up for longer than they probably had to stay up. We shot it out, but then we couldn't strike anything because we were shooting in other sets.

"The cafeteria was a pretty simple set. I mean, it required a lot of decoration, but actually as a shape it's quite simple. It's got a big footprint, but originally it was bigger than that. I read somewhere that submarines look much bigger, but when you're inside, they're really squashed. And it's because they have multiple engines; basically, if something fails, they've got the equipment to survive. That's what I read somewhere, and it really resonated with me, and so we decided that that should be involved with all of the spaces on the spaceship. With the

corridors, there are constantly up and down ramps or the ceiling suddenly drops or there's an odd angle to the corner. There is never a straight line. We tried to not have straight pathways anywhere, and that was because we wanted to have the sense that they were living around something, such as the cycler. But there were a couple of really big spaces, the biggest of which was the cafeteria. And so that was always intended to be the biggest space. But we could not make it big enough because we just couldn't fit it on the stage because it was so jammed. I think it was fine!"

Every element of a Bong Joon Ho film has been thought through, in painstaking detail. Nothing is left to chance. When it comes to his mise-en-scène, even a potential bit of background set dressing serves to underline the themes of the movie. "We did some vending machines, which were really great," Crombie remembers. "Everything on the ship is about control. It's all kind of limited to how much stuff you can have. This level of control was really well illustrated by these vending machines, where you could go and you buy your toothpaste, your bit of soap, your comb, and all of this sort of stuff; it's portion controlled. We had those machines all around the place, which I loved. Brilliant, really detailed."

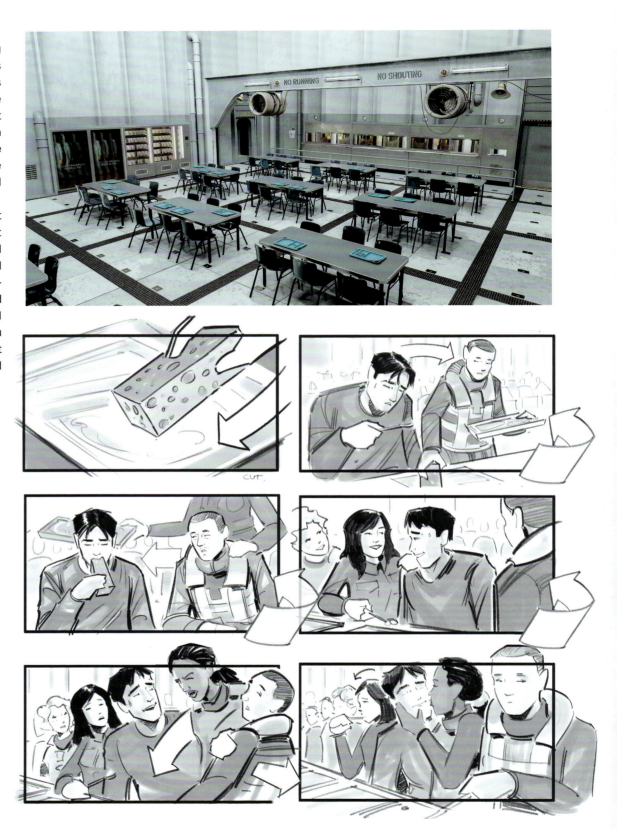

THIS SPREAD: The cafeteria set comes to life during the filmmaking process, showing the stages of storyboarding, set preparation, and a final film still. The cafeteria set is deliberately recognizable and not cluttered with "futuristic" gadgets. This was important to Bong Joon Ho, as Production Designer Fiona Crombie explains: "We had this conversation about how much do you reinvent? It is a big movie, but actually when you break it down to what we were trying to do, we have to be quite clever. Director Bong was of the opinion that you don't reinvent things that work. We don't want to remove this setting too far. We want it to feel like it's quite current."

56 THE ART AND MAKING OF MICKEY 17

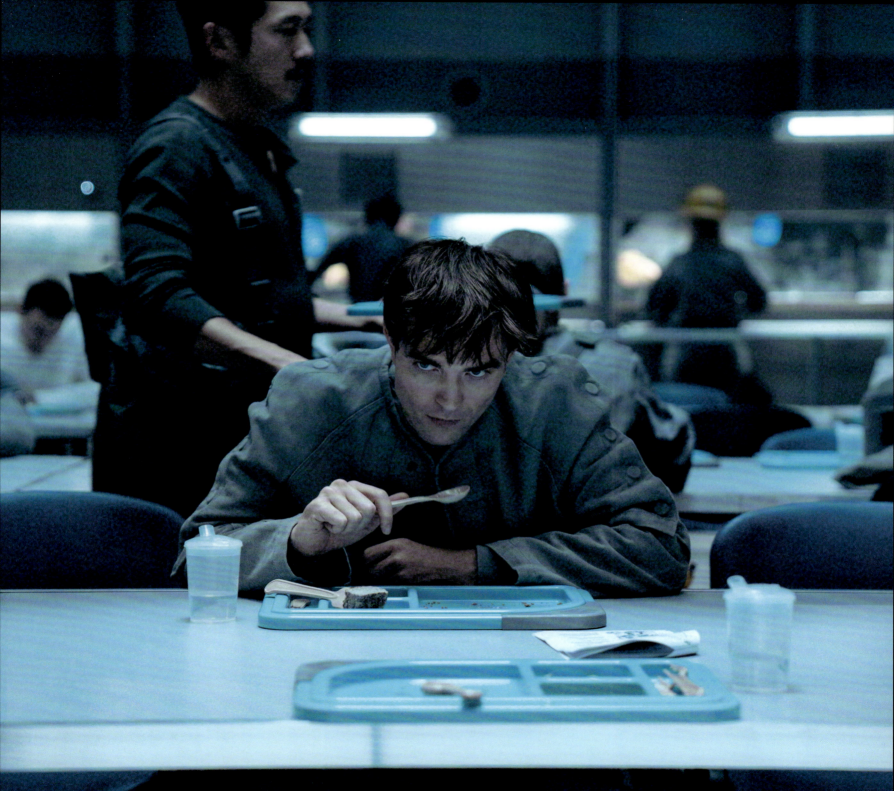

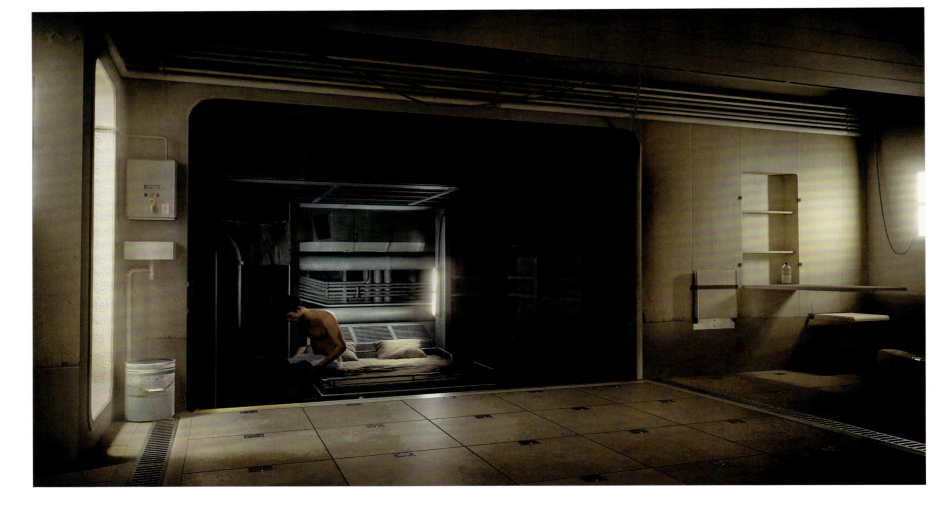

MICKEY'S ROOM

Mickey is disposable. He is not seen as a person or one of the team. Instead, he is viewed as a tool, a utensil. It is only fitting that his quarters are more suited to somewhere the crew would keep the buckets and mops. Dark, cramped, filled with hard edges and hard lines. His room looks cold and unwelcoming: Zero effort has been made to make it feel like a home.

The production needed to create four rooms for the movie: Nasha's, Kai's, Marshall's, and Mickey's. The filmmakers found inventive and economical ways to make all this work in a way that perfectly suited the needs of the movie—showing they could be just as efficient with money and space as Marshall himself.

"They are modular," Crombie says. "We created a modular concept, and in practical build terms for Nasha and Kai, we just doubled their rooms. We reorientated them. So, the bed is in a different spot, but the build is identical. Then we built in exactly the same shape, but in reverse on the back, and knocked through a wall and created Marshall's quarters. Marshall's rooms are actually Nasha's, Kai's, plus a half, for his whole space."

And then there's Mickey's room.

"Mickey's we made slightly different because it was meant to be the worst one," Crombie added. "Yeah, the worst. There's quite a lot of open cabling and pipes behind his bed. Director Bong said a great thing to me about how sometimes Mickey would come home from a day's work, and there'd be a footprint on his pillow. There would just be people coming in to fix the gauge or check the pressure, stuff like that—that's his room."

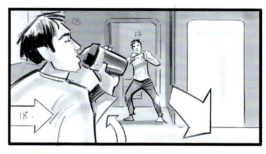
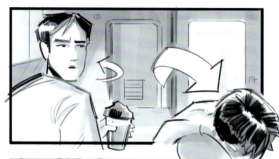
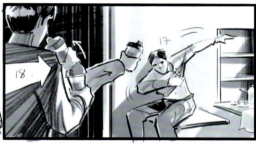
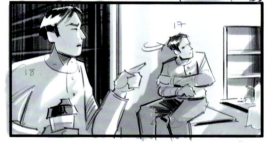
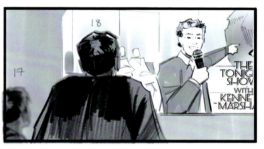

OPPOSITE: Concept art showing Mickey's lonely existence in his sterile room.

BELOW: "It felt like a very alive piece of writing, and obviously the part offered up so many different opportunities of how to play it." Robert Pattinson

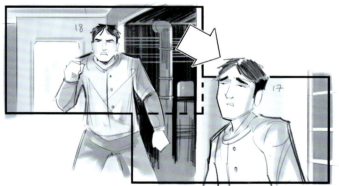

ABOVE: The challenge in having two characters in the same scene who appear all but identical is differentiating them in concept art and storyboards. The two Mickeys have different personalities, and it is possible to tell them apart from their expressions and body language. For quick reference, a note saying "17" or "18" was also added to relevant panels.

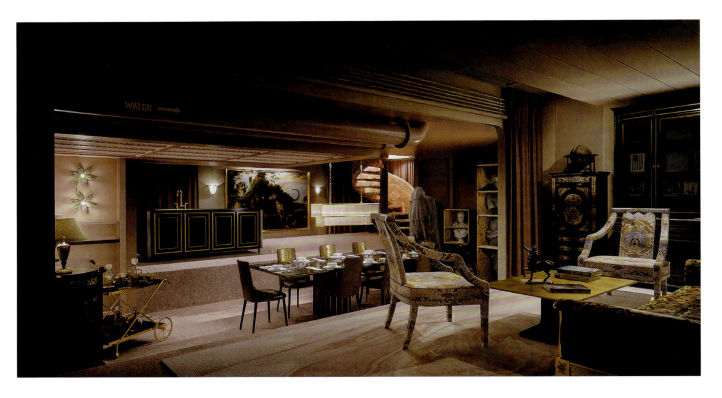

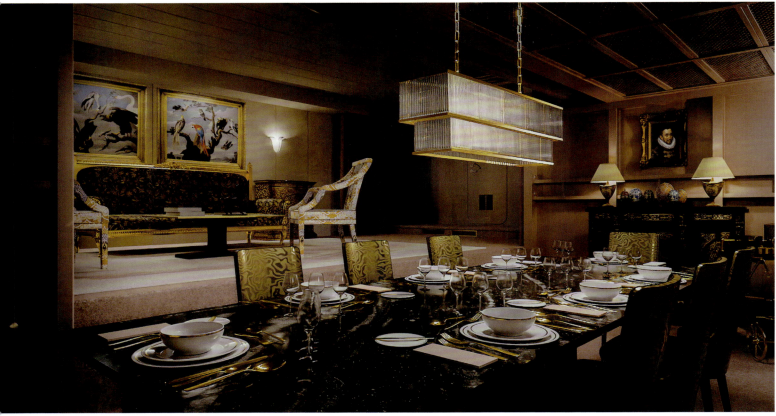

THIS PAGE: Set photography showing Marshall and Ylfa's grand, indulgent apartment, a world away from Mickey's habitat.

OPPOSITE: Bong Joon Ho's storyboards for a key sequence set in the apartment, one which reveals Marshall's true colors and acts as a catalyst for Mickey 18's actions in the second half of the movie.

MARSHALL'S APARTMENT

There is a clear hierarchy on board the ship. If it wasn't already obvious in terms of treatment, social status, clothing, and food, the living quarters make it evident. If the crew live in varying shades of gray, Marshall and Ylfa are on the complete other end of the spectrum. Establishing this hierarchy, in position and aesthetic, came from the script and went to the production design department to realize.

"Why is Marshall's [apartment] not gray?" Crombie asks. "Because it is important that the viewer immediately understands that there's a privilege because they have that interior design, whereas everybody else's spaces are generic. We always talked about that there was a baggage allowance that every person had on the ship. Mickey got the least, so when it came to decorating his room, it was very, very little. In fact, there was nothing that was personal. And then, incrementally depending on your rank, it would increase, so there might be a little personal stuff for Nasha and then Kai. But Marshall blew it apart. He had paintings and sculptures, his own furniture—you name it. I really thought that was appropriate because it's that sort of thing of people going to conquer a new place, but bringing what they have, their culture, with them. They're not even looking at what's new."

The bespoke items in the apartment are all perfectly of a piece with who Marshall is, which informed the character for Actor Mark Ruffalo—and which he has a permanent reminder of. "I think there's a stuffed lion in there, that he'd probably killed from a helicopter or something totally ridiculous," says Ruffalo. "There's a Jeff Koons-style sculpture that they made of me as a Roman senator. It's so kitsch. It's literally like a modified version of myself. It's fake marble. It really captures Marshall because it's just phoney in every way. And I have it in my house—they sent it to me."

Ylfa, too, has her own kingdom: the kitchen.

"And then, of course, you have Ylfa's kitchen, where she's got all her bits and pieces," Crombie says. "It was great. It was really bold: pink and gold and yellow and black. Lots of fake fur. It's kind of shocking. I can't wait for people to see the movie because you're in this grayscale world, and then suddenly you're in the opposite.

"A lot of thought was put into what would the food be. What would they have with them? So, we had a lot of things that were in brine, dried things, and then we had things that were being pickled, but also substitutes—things that look like something else. The question was: How are you going to sustain this colony? Food technology is a big part of it, such as growing meats, the science and atmosphere of all this. A lot of that was in the lab set, but you also sort of see that in the kitchen as well."

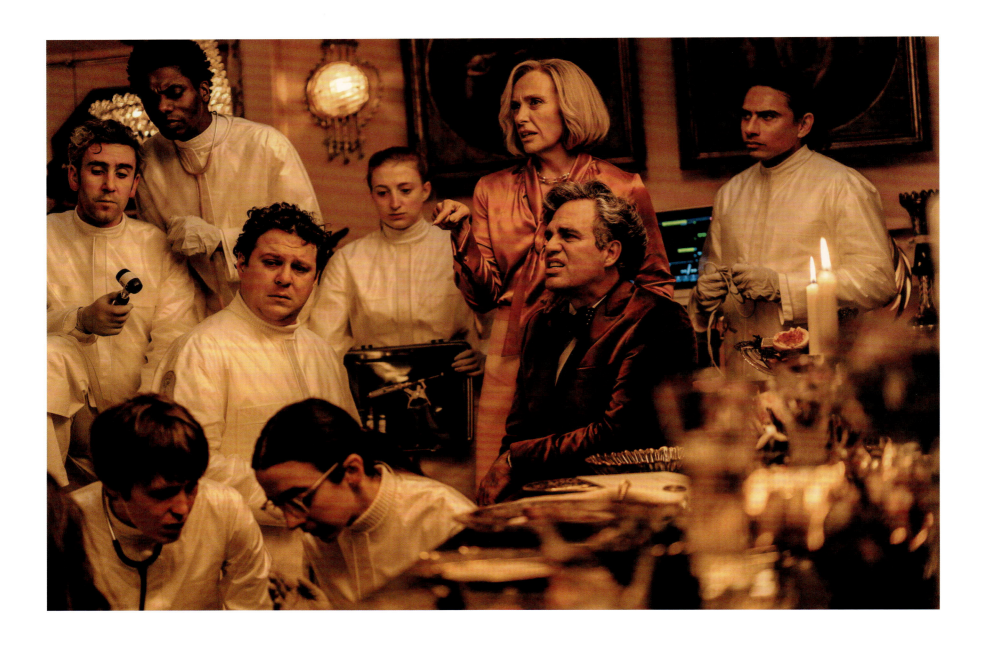

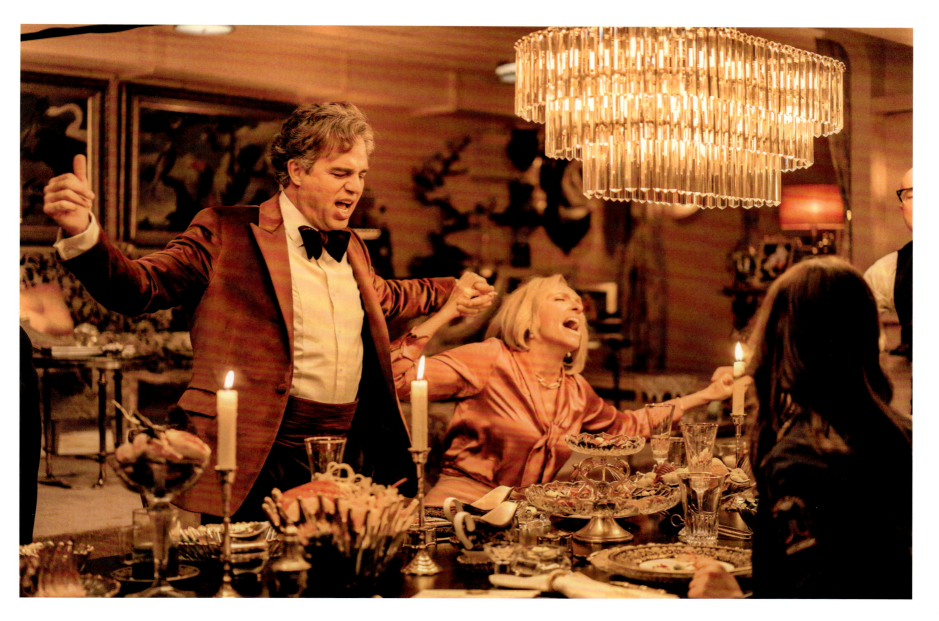

THE STORAGE ROOM

After a celebration in the cafeteria turns into a bloody massacre, Mickey 17, 18, and Nasha are thrown in jail. This ship being an economical vessel, there is of course no actual prison, so instead the three allies are unceremoniously crammed into the storage room.

What is a fairly straightforward dialogue scene—until the arrival of Timo—was actually a logistical challenge. It required complete patience and endurance on the part of the actors. "They were all tricky and they were all fun," actor Naomi Ackie says. "But I guess the trickiest thing to shoot was there's a scene where me, Rob, and Rob are put into cells. And that was hard because it was like a lighting situation. It took us about a week to do this scene because there were so many moving parts, and obviously Rob is swapping himself around. The cells kind of look like giant animal cells that you would put a rabbit in or something like that. They even had the water bottle on the outside of the cage that you feed a hamster with.

"The light would come through the bars and the set was all bars all around and they're kind of stacked up on top of each other. So, it was complicated to do because either Rob is swapping around from cell to cell, or there's a lighting situation; so that kind of stuff was really tricky. And it took a very long time, but everything kind of took longer, obviously, because Rob is swapping between characters and he's changing his teeth and his hair is slightly different, so there was that."

LEFT: Steven Yeun on set at the storage room that doubles as a prison.
OPPOSITE: Storyboards for the scene in which Mickey 17, 18, and Nasha are imprisoned. It is a confined space, offering an interesting challenge for the actors, set designers, and director of photography.

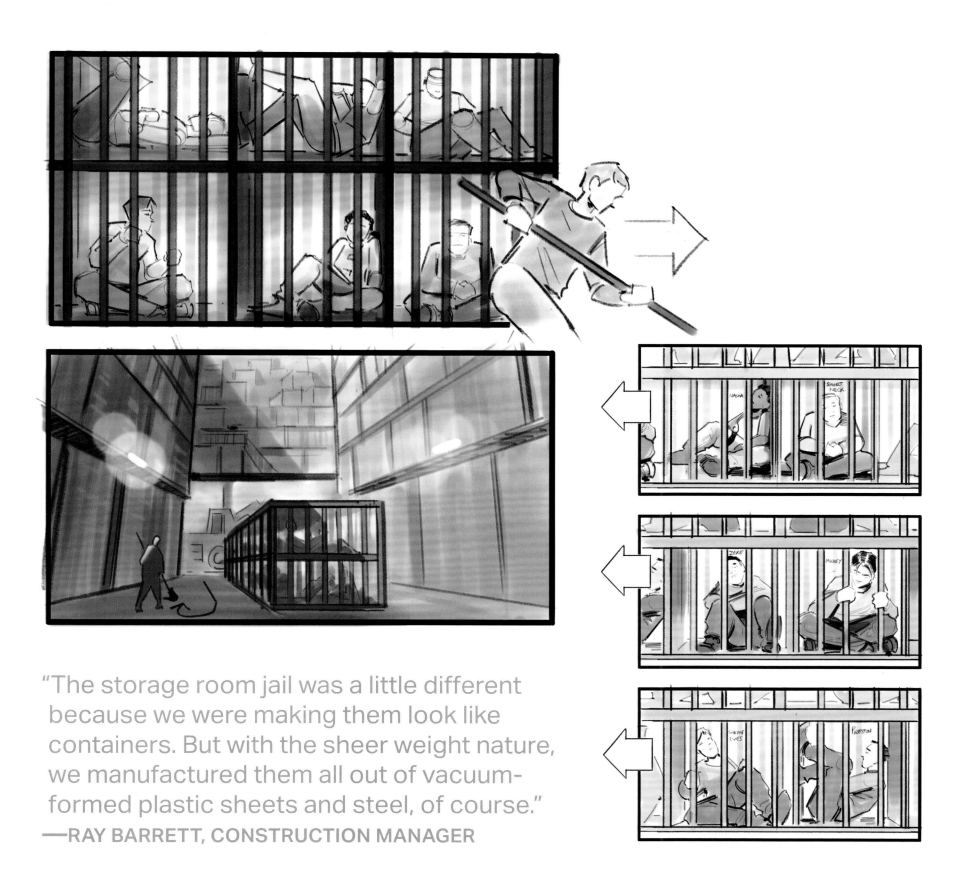

"The storage room jail was a little different because we were making them look like containers. But with the sheer weight nature, we manufactured them all out of vacuum-formed plastic sheets and steel, of course."
—RAY BARRETT, CONSTRUCTION MANAGER

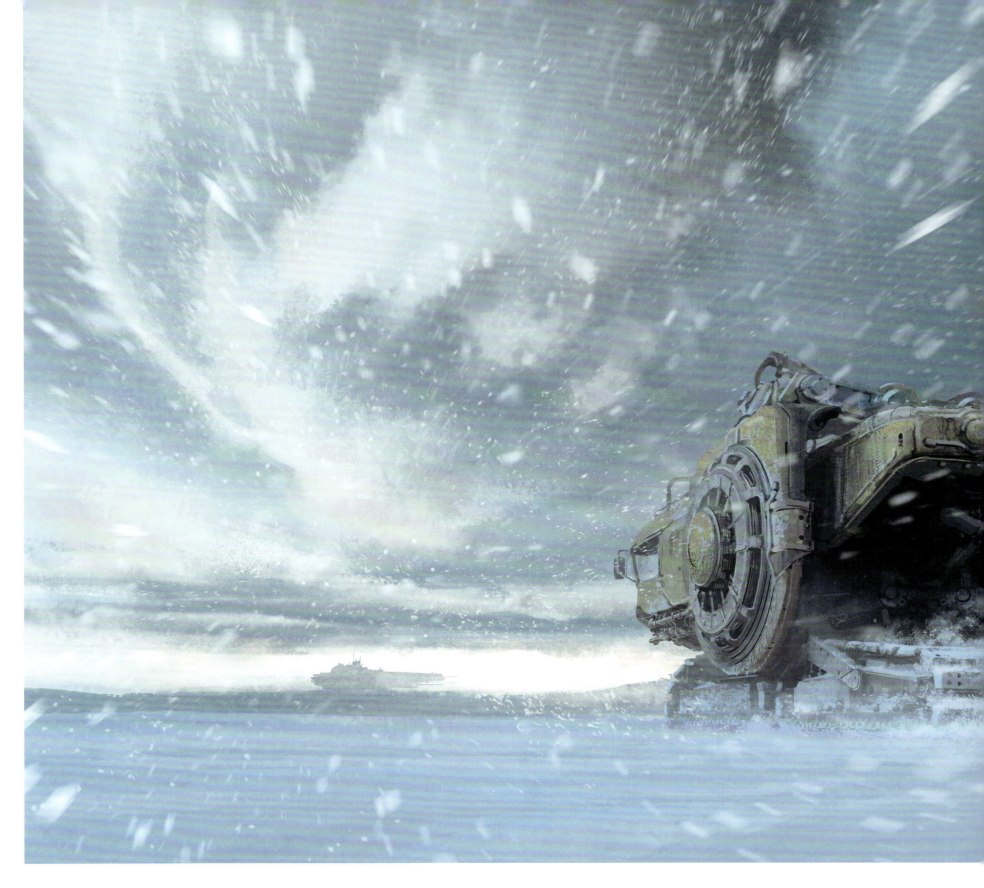

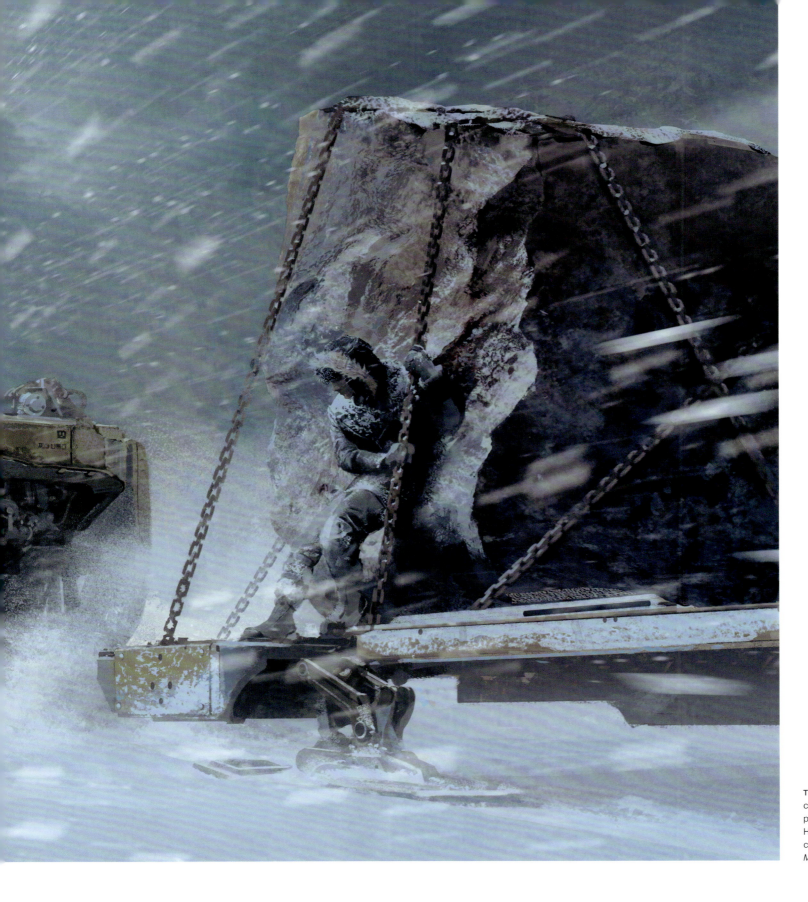

THIS SPREAD: A key piece of concept art by Jaime Jones. Jones produced designs that Bong Joon Ho used when visualizing the movie, capturing the scope and ambition of *Mickey 17*.

PRE-PRODUCTION

67

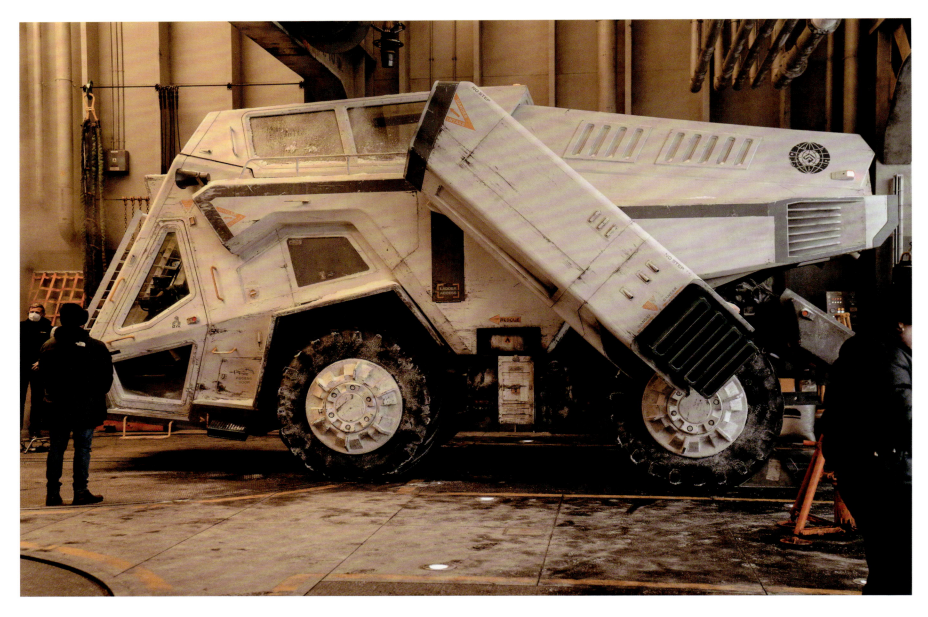

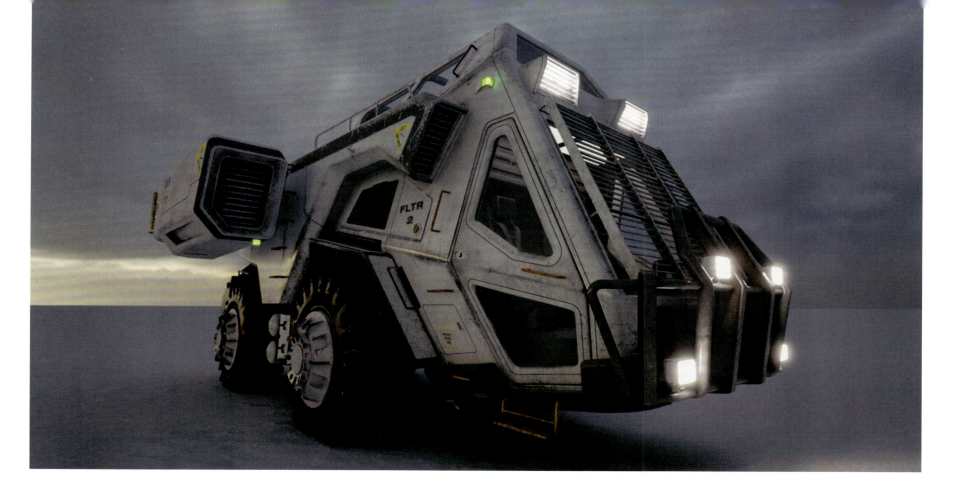

THE FLITTER

For navigating the unforgiving surface of the planet Niflheim, the colonists need a vehicle.

Enter the flitter. Like all the engineering in the film, it is a practical and functional piece of machinery. The flitter crosses the snow and ice of Niflheim, brutally cutting through the world and blazing a trail all the way from Earth into this new, human-controlled world. For Marshall, it is his version of a pageant. He stands proudly upon the flitter, broadcasting on his microphone in his outdoorsman winter attire like a conquering king upon his warhorse. There is an exposed upper deck, similar to a luxury yacht's, above the far more chunky, unglamorously shaped machine, which already looks scuffed and worn. Marshall sees Niflheim as unblemished, virgin territory—which he himself is here to spoil.

The first step when creating the flitter fell under Fiona Crombie's remit. "I was involved in the referencing and the concept and then the design of it, working with our art directors," Crombie says. "My supervising art director, Jason, was very involved in that, and then a couple of other art directors were really involved. And then we would hand that over, for the actual build was with the special effects team. Then set decoration came in and did all the fit out. So, all the seats and all the details of straps and all the instruments and everything—that's all from the set decoration department."

The basis for the flitter comes from the script, Crombie explains. "It's written as, 'It flies and it drives.' So, I looked at all-terrain vehicles with ridiculous wheels. For me, I felt like it had to look kind of like a creature, so it seems it's burrowing, you know? It looks a bit like a cockroach. But it's essentially like a kind of deliberately chunky thing, not aerodynamic, not elegant. It's a functional, all-terrain, all-weather, can-get-you-anywhere vehicle."

Special Effects Supervisor Dominic Tuohy and his team worked to create a flitter that was as practical—and believable—as possible. "The flitter was a great thing to be involved in," Tuohy says. "The brief was really clear. We had a concept. It all started with the wheels, the diameter of the wheels. We started to look

at what vehicles were out there that we could use as a donor vehicle and then work back from that. We based it on a JCB Fastrac, and we changed wheels around, putting front wheels on back wheels and stuff like that. That was our donor vehicle."

The JCB Fastrac is a type of tractor and offered the special effects team and set dressers lots of exposed moving parts to utilize, Tuohy says. "There's already a hydraulic system that's in this tractor system, so we could plumb into that. So that was another factor why I wanted to use that vehicle, because it did multipurpose things for us. You work back from there. You've got this vehicle, and then you've got to move the steering wheel, the brakes, the hydraulics. You've got to stop putting it into areas where they're just floating in mid-air.

"As a department, we managed to build this all in-house at [Warner Bros. Studios,] Leavesden. We did a steel construction of the bodywork and then we made inserts of panels for all the levers and stuff like that. Along with the set dec department and props, we re-dressed it. And we had a vehicle that could stop and start. It could travel at high speeds if required."

The production had a finished flitter. The next challenge was they needed two more of them. "It's one of those things that you start off with, 'Can we make one?'" Tuohy adds. "And then all of a sudden, it's like, but we've got three in the film. How can we make

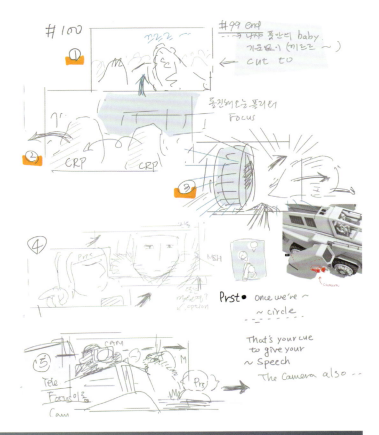

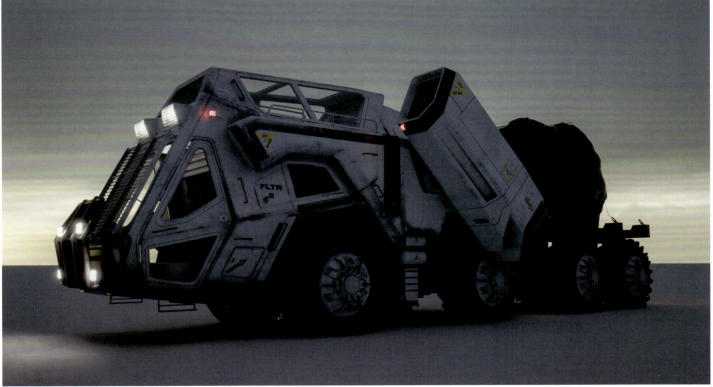

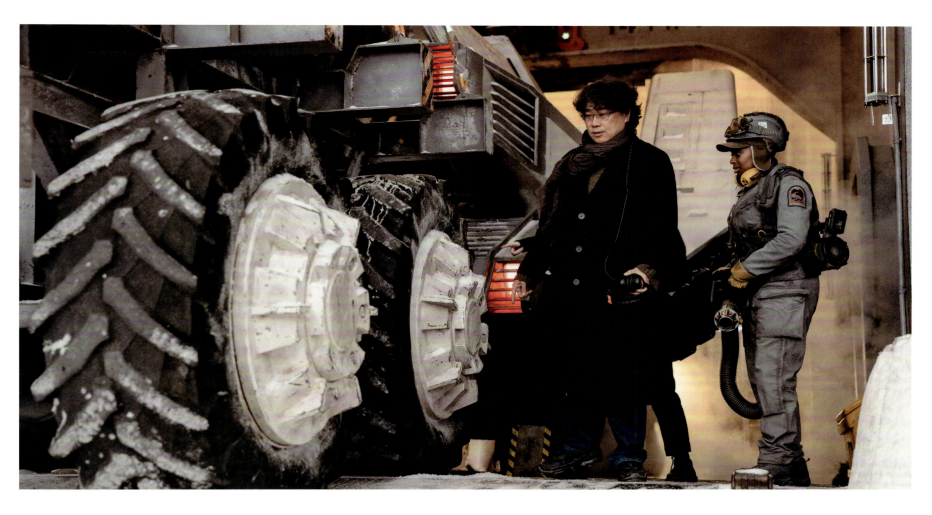

three? That's where Director Bong is very clever, and it becomes, Can we make part of a second one and use that to make it look like it's the third one along because we, the camera, would be the third one? You do what I called old-fashioned filmmaking. You start moving these vehicles around to make them look like we've got three, but in fact, we've only got two, with the third flitter created digitally."

Thankfully, the team had the space to create all the necessary flitters. Cardington Studios, located in Bedford, UK, is a massive hangar. It became the basecamp for the alien planet, Niflheim. "We ended up building one and a half vehicles, but they all were identical," Tuohy says. "They all had moving parts, canopies, the sprocket motors on the outside. It's funny because when we built it in Leavesden, in our workshop, it was really large and just about fitted out the doors. We had to make it so that we could unbolt sections of it and put it on the roads and move it from Leavesden to Cardington. But then you put it in the space at Cardington and it just looks like a toy. The scope of what we did at Cardington is massive."

LEFT: Concept art for the flitter, a vehicle that is at once a functional machine for traversing Niflheim and then later can also serve as Marshall's war chariot.
TOP LEFT: "Normally, during screenwriting I am not making storyboards, just drawing some things, some simple, key images. For example, while I was writing *Parasite*, I did have a drawing of when she pushes the door to the basement open—that weird, unique, strange image. But the storyboarding process comes later."
Bong Joon Ho
ABOVE: Director Bong assesses the working flitter vehicle during the shoot at Cardington.

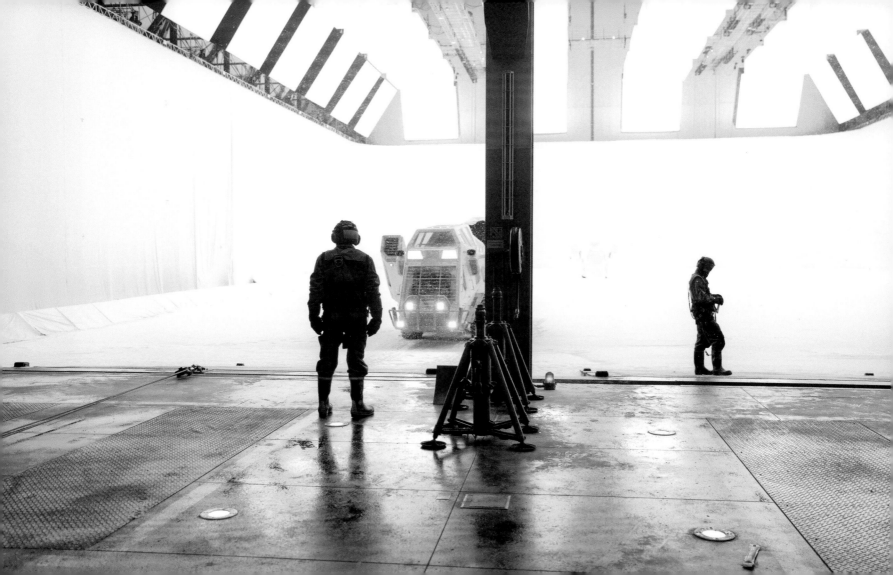

NIFLHEIM

Niflheim is described in the script as a planet of endless snow and ice. The mission slogan and advertisements describe it as "the one and only land of unspoiled white!" It's also the ship's destination after a four-year journey through space. For Mickey and the rest of the crew, this is to be their new home.

At first glance, it may look like an unforgiving, barren world. Niflheim is unlike Earth and juxtaposes with the interior of the ship where the characters—and the viewer—spend much of the film. Crombie explains this was intentional.

"It's just white. It's very simple. It's very, very clear storytelling and a beautiful thing," she says. "I think what is both beautiful but also tragic is that they arrive on this pristine planet with everything living in harmony with the environment, and then the ship arrives and, well, how does that go, if history is anything to go by? So, I think that clarity of this white environment was really important. It's also just really, really, really simple because the chaos and the detailing and the layers that are inside that ship are set in contrast to this pristine white planet."

If this makes Niflheim sound like a blank canvas, that's because it was. And something Khondji enjoyed painting upon. "There was this gigantic world of white, which was snow, which was the planet where they go to—entirely white," he says. "It's like a white piece of ice, where the only tones were the creatures; the creatures were in this dark grayish color, but everything was white. And then you will see red. There will be blood or fire. Everything else was white. It was very interesting. I feel I want to think about it like an anti-sci-fi, a non-sci-fi film, but when I describe it to you, I'm describing a real good sci-fi story!"

In creating the world of Niflheim, vision and preparation were integral to the schedule, the budget, the actors' experience, and ultimately, the verisimilitude. The VFX house DNEG worked on a great deal of the environments for the movie. VFX Supervisor Dan Glass managed the overall process. The team had Director Bong's storyboards to work from to help visualize Niflheim and plan exactly what computer graphics they would need down to individual shots.

"It was a really smart, pragmatic, and selective use of pre-viz, which I have huge respect for," Glass says. "I think sometimes these tools are almost always delaying making decisions or a kind of failure when you don't have clarity. But for Director Bong, it was a way of ultimately translating his ideas and his boards into what he wanted. And then from that, of course, we can break down very specific things: I can build lists for the first AD. You can pull out all this information in a structured form to help the shooting schedule.

"The other thing that it helped is how you can push the pre-viz quite far these days. It always used to be very fast, iterative work. But the advance of things like the real-time game engines, such as Unreal Engine, means you can produce really awesome-looking images that look like the quality of animated movies and shorts from ten years ago. We pushed it into that level of quality. I knew that that material would be important for feeding the cut later. Because we're gonna shoot all this material. People standing in a big white environment, there's gonna be nothing there. And that can be hard to work with editorially without some placeholder for what's going on in the background. So those things were produced with Darwin 10. It helps with the planning up front, but also, we can strip out the CG, which made up the pre-viz, and then put the photographic one on the top as they built the first cut of the movie, which is how we did it. And as a result, it enables the director's cut to be more understandable because you've already got all that action in place."

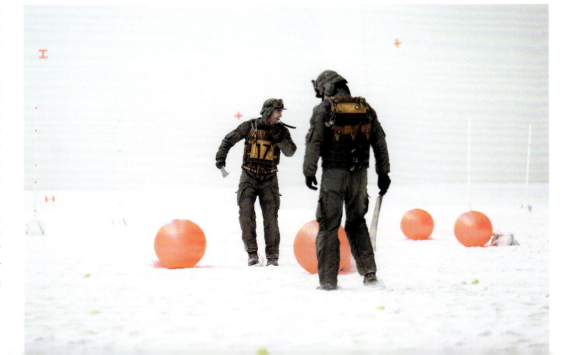

OPPOSITE: Filming at Cardington, doubling as Niflheim. Looking closely to the left, one can see the white sheets draped along the sides that would enable the VFX department to expand the depth and size of Niflheim for the finished film.
BELOW: The two Mickeys toward the end of the movie, amongst performance markers that were placed by the VFX department.

THE CAST

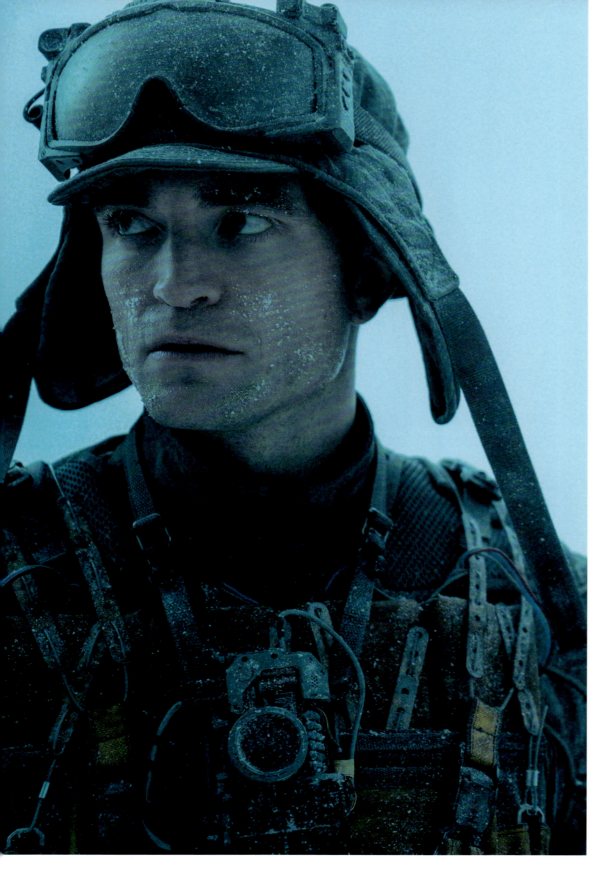

MICKEY 17

Mickey Barnes is the hero. But in a Bong Joon Ho film, being the hero is never simple. It is not so black-and-white as to have a hero and a villain. And Mickey himself does not see himself as a hero. He's barely the protagonist in his own life. If ever there was a victim of circumstance, it is Mickey Barnes—a man who finds himself in increasingly dire situations, most of which end with him dying.

"His expectations for his life before the story starts were so minimal," Pattinson says. "But then these awful things keep happening to him, and instead of becoming resentful, or fighting back, his way to survive is just to keep lowering expectations into the negative. His thinking is, 'Yeah, my life was shitty before but, you know, at least now I have a girlfriend, even though I'm being tortured every day.' It's kind of odd. It's a strange attitude: To kind of still have an essential goodness and sweetness to him, but at the same time, his lack of self-confidence veers dangerously close to being a sort of pathological thing."

For his entire life, Mickey has been carrying the burden that he caused the death of his mother. In the script he says, "My entire life is a goddamn punishment." What happens from then on isn't so much atonement but more Mickey feeling like he's only getting what he deserves.

"I was trying to figure out what his motivation is," Pattinson says. "By saying that he thinks he pressed a button in the car when he was a child and ends up causing the death of his mother, there's a real darkness and shame which this all comes from. He becomes a sort of, almost like a biblical character, with all these references to: I deserve to be punished, I deserve to be punished, it's my fault. I was thinking that was interesting, to have this guy who sees himself as Job or something. But at the same time, he's like a clown. He's like a silly Job."

In different hands, this could all be rather morbid and tragic. But Pattinson and Director Bong found other notes to play. How Mickey processes grief and the world around him is entertaining, surprising, unique, and endlessly engaging. For a sci-fi movie that encompasses human printing, space travel, far-off planets, and alien races, Pattinson found some unlikely references to help bring Mickey to life. The great actor and comedian Charlie Chaplin once said, "Life is a tragedy when seen in close-up, but a comedy in long shot." This interplay is crucial to who Mickey is—his life is so dire that one has to laugh.

"Director Bong allowed me to have this quite strange physicality in a lot of the action scenes, like especially how Mickey 17 moves around," he says. "I was trying some Buster Keaton-style stuff, or maybe some Laurel and Hardy kind of things, such as running into things and just sort of looking over all the time. It was just really fun to do. Normally, I don't think that kind of performance really goes in a big-budget sci-fi movie—it's only in movies by Bong Joon Ho that that would be allowed.

"It's a surprisingly complicated character. In some ways, he's presented as an everyman, but he's kind of not an everyman. His relationship with guilt and self-confidence is strangely unique. It's funny, the way Mickey looks at his own life, even before the story starts. He's a pretty, pretty odd dude to begin with, in my interpretation of it anyway."

When it came to Pattinson crafting that interpretation, even down to Mickey's voice, Director Bong was happy for him to go in whatever direction worked, to a point.

"When I initially started out, I got obsessed with wanting the character to be Steve-O from *Jackass*. I listened to an interview with Steve-O years ago, and he was talking about that first season of *Jackass* where you got paid $50 for a nondangerous stunt and $100 for a dangerous one," he says. "He kind of didn't

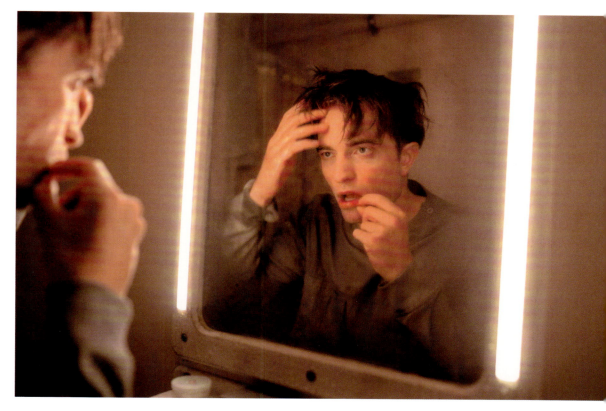

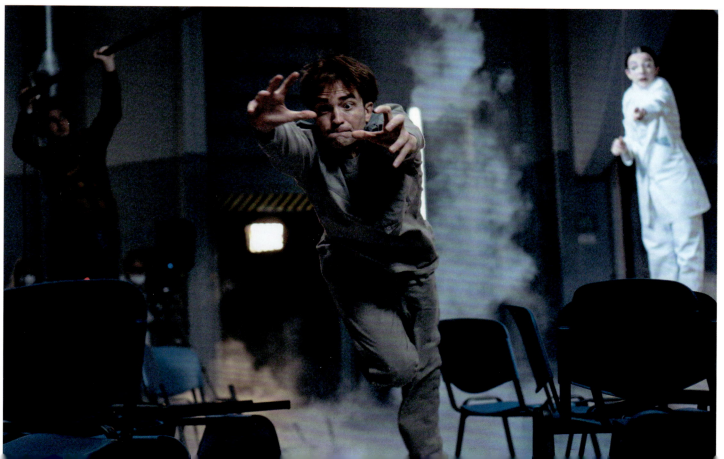

THIS SPREAD: Robert Pattinson showing different sides to Mickey 17, from the beginning (above) to the middle (left) and end (far left) of the movie. "For Mickey 17, it's not that he's just been a total idiot his entire life. He's had to do what he's done because he's had no choice. There's actually a kind of logic for that, which isn't initially visible," says Pattinson.

want anyone to know that he thought things were dangerous, so he'd just be like, 'Oh, that one's not dangerous, I'll do it for $50.' I was kind of thinking about that strange masochism of the *Jackass* guys and how that could be kind of funny for Mickey. And so, I kind of planned this whole performance, I got Steve-O's voice really down. I really committed to doing an impression of Steve-O. And then Director Bong said after the read-through, 'What is this voice you're doing?' I explained, it's Steve-O from *Jackass*, and Director Bong said it sounds like nails, nails on a chalkboard. I said, 'Yeah, should I do it?' And he was like, 'No, don't do it.'"

Director Bong noted that Pattinson was meticulous and detailed in his preparations to play the Mickeys. "He really showed me so many great, wonderful details and ideas which I never imagined, and he made me very happy on set," he says. "Rob did it in such a great way. The character description and the many subtle emotions and facial expressions are quite new, I think, something we have never seen in his previous films."

Mickey is not an expert in any particular field. He does not hold the mystery to life or death or love. At the end, he is ultimately just Mickey Barnes, and he cannot offer much more. Something he seems aware of even as the narrator for his story.

"Something I realized as I was recording the voice-over was that Mickey doesn't realize he's in a sci-fi movie," Pattinson says. "Not at all. All the expositional stuff about describing the human printing, I didn't really realize how to do it until after the movie was finished. Whenever I'm describing anything scientific, I was thinking to play it as the guy who is trying to bullshit to his friends about knowing what he's talking about, but he has absolutely no idea what he's talking about. I mean, he's literally like a janitor who has overheard something which people said, wasn't interested at the time, but now it's like he's being interviewed on the news about it. He's trying to sound smart but has no idea what he's talking about."

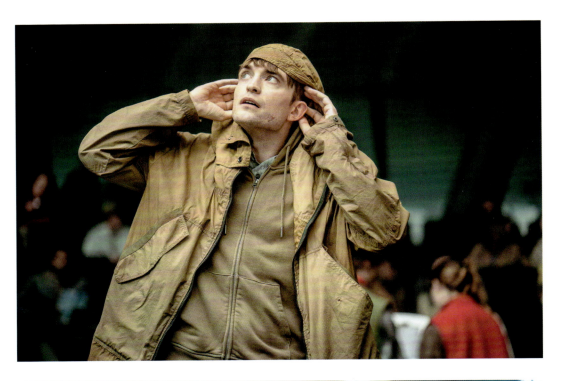

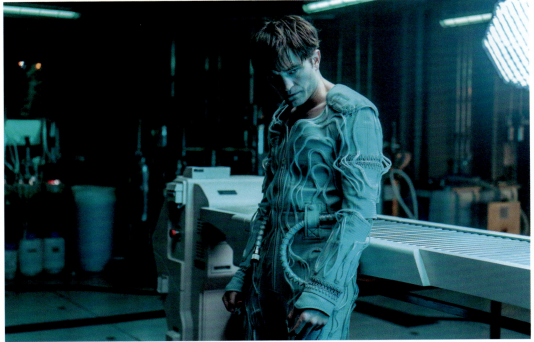

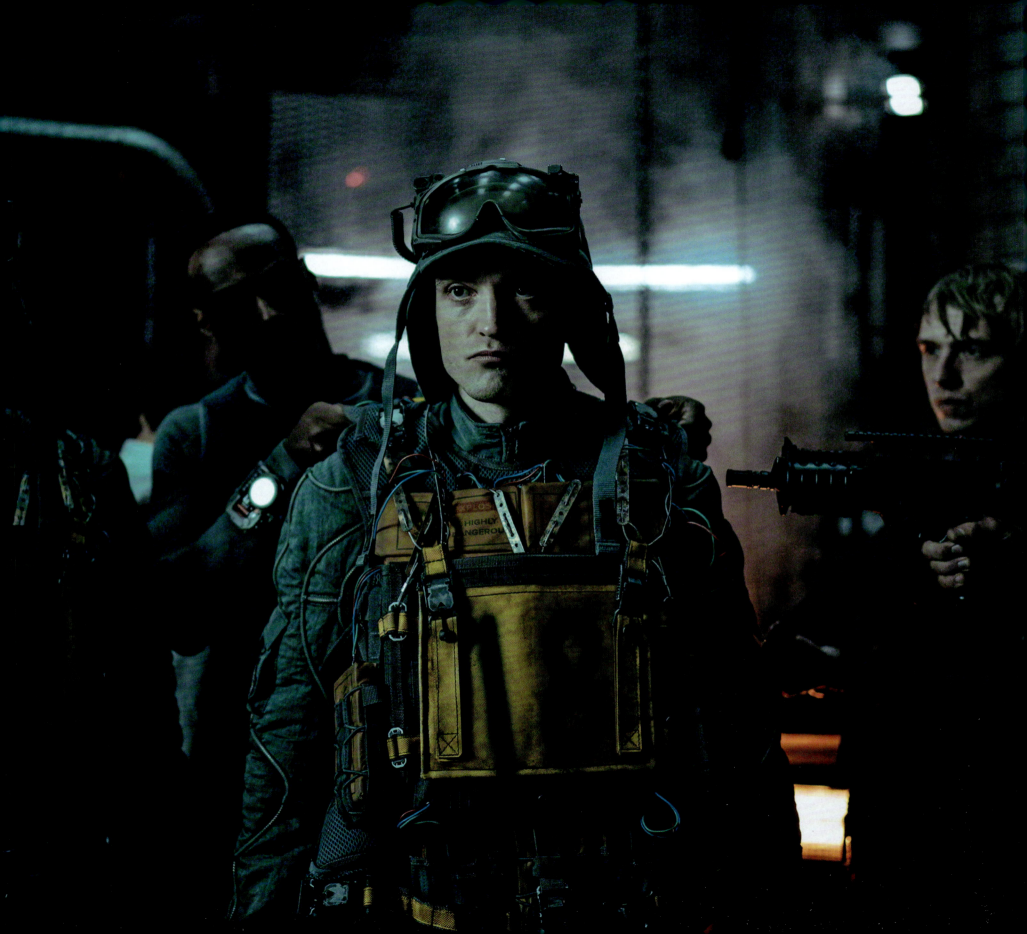

MICKEY 18

Mickey 17 is just one half of the story. The other is Mickey 18. Given that Mickey after Mickey has been reproduced out of a human printer, it is easy to assume they'd be exactly the same. But life—even life from a machine—is not that neat and clean. "I kind of found the more we were working on Mickey 18, it's almost like he's all of 17's repressed id coming out," Pattinson says. "He's more comfortable in his body and doesn't doubt himself as much. Mickey 18 arrives on the scene for around 36 hours and basically almost destroys both of their lives."

The question for Pattinson became how far to push their differences. Are they polar opposites, two sides of the same coin? It was not only about making the characters distinct for the story's sake but also for the audience's sake. "Like so much of this, we kind of started out in one direction then changed course," Pattinson explains. "When I first started playing it, I was playing it wildly differently to 17. But it's kind of like threading it through the eye of the needle, trying to calibrate both performances, because you can't be too different. If you were, then in the world of the story, everyone on the ship will be wondering, Why are you doing this voice? Why are you walking differently than normal?"

Even though he didn't turn the entire character upside down from 17 to 18, Pattinson found subtle ways to transform between the two versions—something he continued to work on even in post-production and Automated Dialogue Replacement (ADR).

"I must drive editors absolutely crazy because I kind of experimented with different accents throughout," he says. "I was constantly saying, 'I'll fix this in ADR!' Mainly, 17 is just completely wound up with anxiety the majority of the time, and that just naturally makes the voice a higher pitch. 18 is just more focused, a little bit more relaxed, which gives a slightly different impression, I would say. Director Bong would tell me, 18 should be like [Actor] Peter Stormare in *Fargo*."

This discovery of the character, and the continued crafting of him, was a journey that Pattinson and Director Bong embarked on together during the shoot. "Mickey 17 was actually the exact same as I expected and imagined," Director Bong says. "But Mickey 18 was subtly quite different to what I imagined when I was writing the script and my descriptions of the Mickey 18 dialogue and behavior. Rob Pattinson showed me something different and something beyond my ideas. I'm really grateful for that."

> "He was so ambitious and ambitious in a good way. The role is quite difficult for Rob; he has to make some very interesting contrasts between 17 and 18. Even in the same frame, he has to express subtle nuances and subtle contrast and the difference between them."
> —BONG JOON HO

Mickey 18 is a mistake. He should never have been born, and yet he feels like he is entitled to his turn at life now. Perhaps that explains why he has something of a chip on his shoulder. "In the script, it read like he was incredibly angry, and I was trying to kind of figure out, How does this happen?" Pattinson says. "The machine is slightly broken when he's being printed out, so what is it exactly that happened to 18? Other than having a slightly misprinted tooth.

"He's kind of damaged his prefrontal cortex in the printing. So, he's just a little bit less inhibited. He has less impulse control. Instead of accepting and bearing his resentfulness about various different things that have happened, he's instead actively playing them out. It's kind of like *The Mask*, the Jim Carrey movie. That's kind of how I was doing it. Or not *The Mask*, more like *Liar Liar*. I mean, that's kind of out there. But it's like, there's a goblin, there's a version of you, a doppelgänger of you that is saying all your secrets, doing everything that you secretly want to do, and being the person you want to be."

Playing two all but identical characters required a huge amount of mental and physical commitment and concentration from Pattinson. To make his job as easy and effective as possible, the costume, hair, makeup, and VFX departments were all on set, as well as a body double who Robert would rehearse and then shoot with, for support.

LEFT: At the climax of the film, Mickey 18 is preparing to head out onto Niflheim, armed, with his future and the future of the planet at stake.

"18 has more layers than I imagined during screenwriting. That's the great gift Rob gave me during the production."
—BONG JOON HO

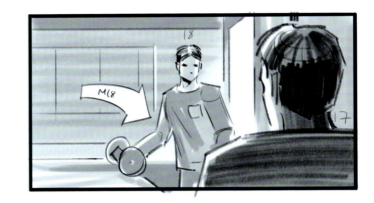

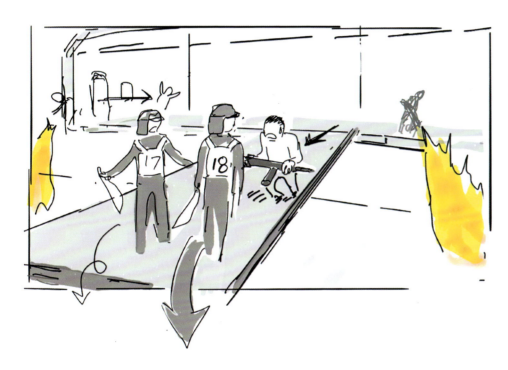

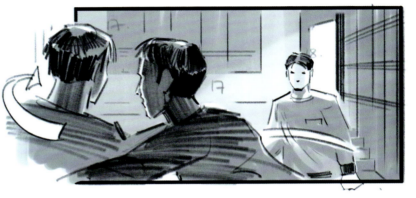

ABOVE: Another of Bong Joon Ho's sketches, showing his trademark expressiveness and clarity of staging.
RIGHT AND OPPOSITE: Communicating how storyboards inform the finished movie. They are essential for everything from rhythm to staging, showing not just emotion but practical considerations such as lighting. They are there, if needed, for both the actors and crew.

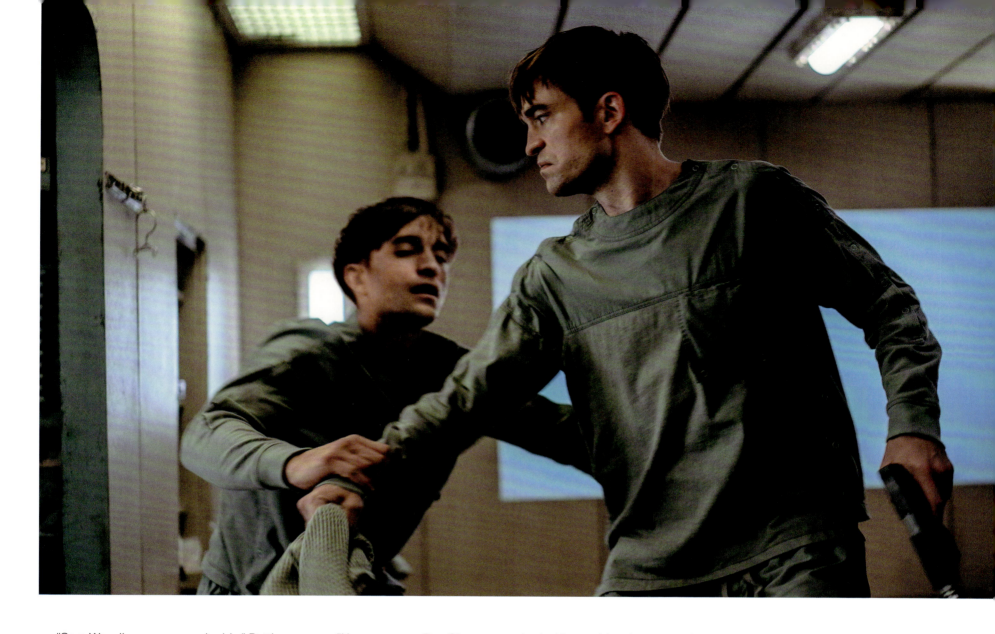

"Sam Woodhams was my double," Pattinson says. "He was great. Sam was part of the rehearsals from the beginning. And so, we were kind of talking to Director Bong a lot as if we're both playing the characters, which was incredibly helpful, and he's a really good actor as well. We blocked things out in various ways. Sometimes we'd be playing it as if I wasn't gonna be playing both parts and then I'd get inspired by whatever Sam was doing or fluctuate between the two characters back and forth throughout rehearsals to see kind of what felt right. I think the hardest part of the whole thing was that you have to be quite definitive about what you're going to do before we start shooting it because whatever you decide in the rehearsal, I then have to mimic exactly the same thing and the general physicality that Sam had. It sort of becomes this kind of weird game of 'memory Twister.'"

Dan Glass was tasked with matching the two performances and offering a digital hand on set to aid post-production. He explains that Pattinson's acting achievement over an eighty-day shoot was nothing short of remarkable.

"Sam was constantly trying to learn what Rob was doing," he says. "Then you've also got Rob—it was super, super challenging to be managing these two characters that have different personalities and different behaviors, that to a certain degree he was evolving across the shoot, which is natural. Then from a VFX point of view during the shoot, we're seemingly randomly saying to him, you've got to be 18 first, now 17. How he kept it in his head? I'm seriously impressed."

THE THERMAL SUIT

For their expeditions onto the unforgiving surface of Niflheim, the would-be colonists wear specially designed thermal suits. But for that very first touchdown and one-small-step-for-a-man-from-a-human-printing-machine, Mickey wears his spacesuit. Catherine George created this key piece of wardrobe by digging into past genre movies, but also researching domestic and international space programs. "I had explored many different styles for spacesuits in a previous film, so I was able to draw from that research. A major insight for me was the contrast between NASA and the Russian space program. NASA focused on a modern, polished product to protect that image of America, while the Russians prioritized functionality over aesthetics.

"For the thermal suit design I wanted the interior to be exposed. The heating system is visible on the outside. Fiona Crombie, our Production Designer, had simultaneously started to incorporate this idea as well in the sets—making all the pipes and wiring visible. It was fascinating to explore this concept of exposure rather than trying to conceal everything and create a polished look.

"My cutter, Andrew Cartwright, and I mapped out seams on a body form following the main arteries, where he stitched the trim for the heating pipes. It was an incredibly complicated garment to construct. I had an amazing team of technicians.

"Dan Grace, the wardrobe supervisor, and I also decided to make the spacesuit in-house. Again, Andrew was excited for the challenge and created an incredible detailed and intricate suit. The helmet was produced by FBFX. They are experts in spacesuits and making the beveled glass. The helmet featured some exposed wiring around the edges, which was essential for our needs, like installing the fan. You could see the fan and the wiring inside, along with a communication device we included. The fan was crucial to prevent the glass from fogging up, which was a significant issue. Additionally, we incorporated a lighting system into the helmet, which our gaffer controlled and our DP had to review and approve. There were many collaborative elements in these costumes."

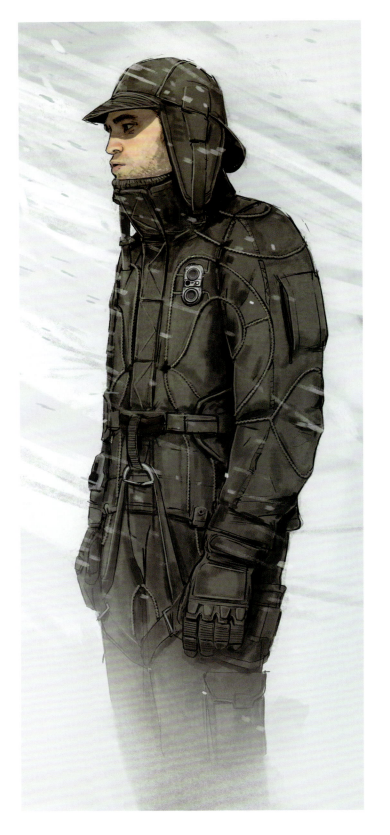

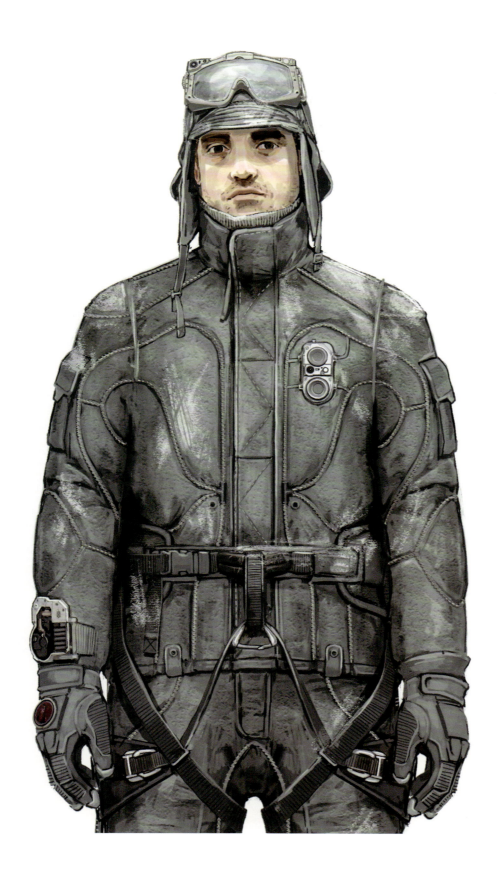

ABOVE: Gloves made by the costume department for when Mickey is on Niflheim.

LEFT AND THIS PAGE: Costume designs for Mickey's thermal suit when he is sent to explore where no one else dare go. And it doesn't matter if he ever returns.

THE SPACESUIT

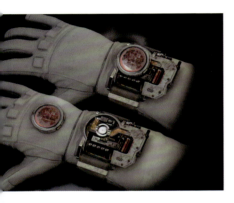

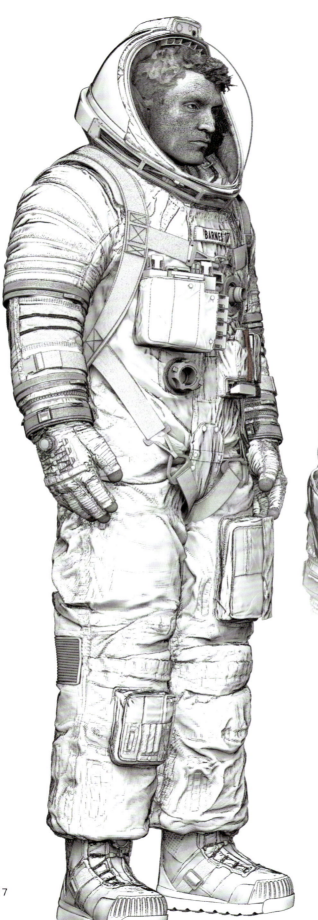

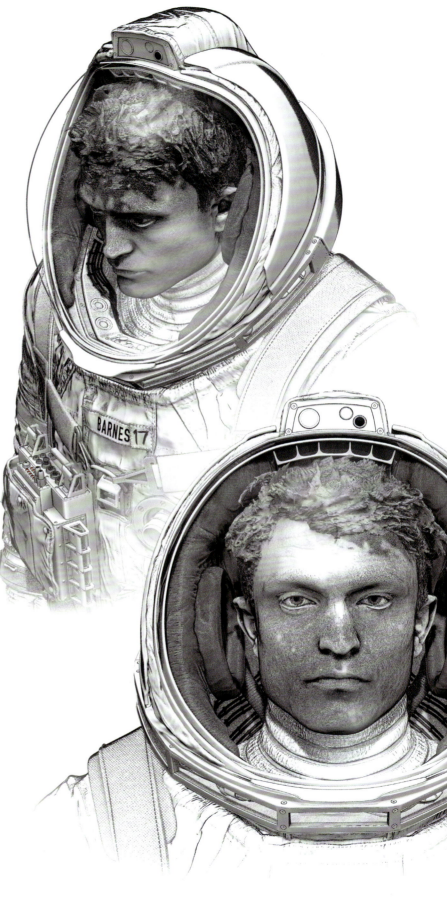

THIS SPREAD: Costume designs and actual props for Mickey's spacesuit. "Spacesuits get incredibly hot. On some movies, you can get this sort of cooling underwear to wear underneath. I think people use them on superhero movies and stuff. But on this one, we didn't need that. They didn't want Rob to overheat, but actually, we were up in Cardington, and it was freezing anyway." Catherine George, Costume Designer

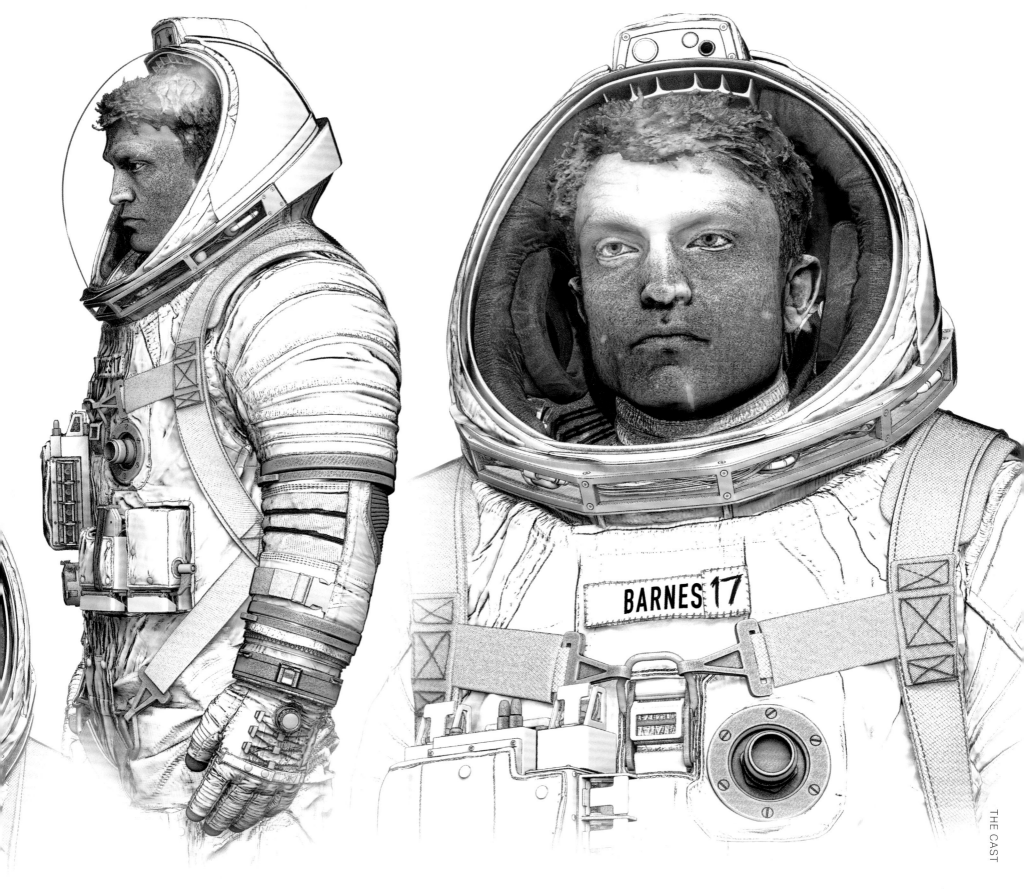

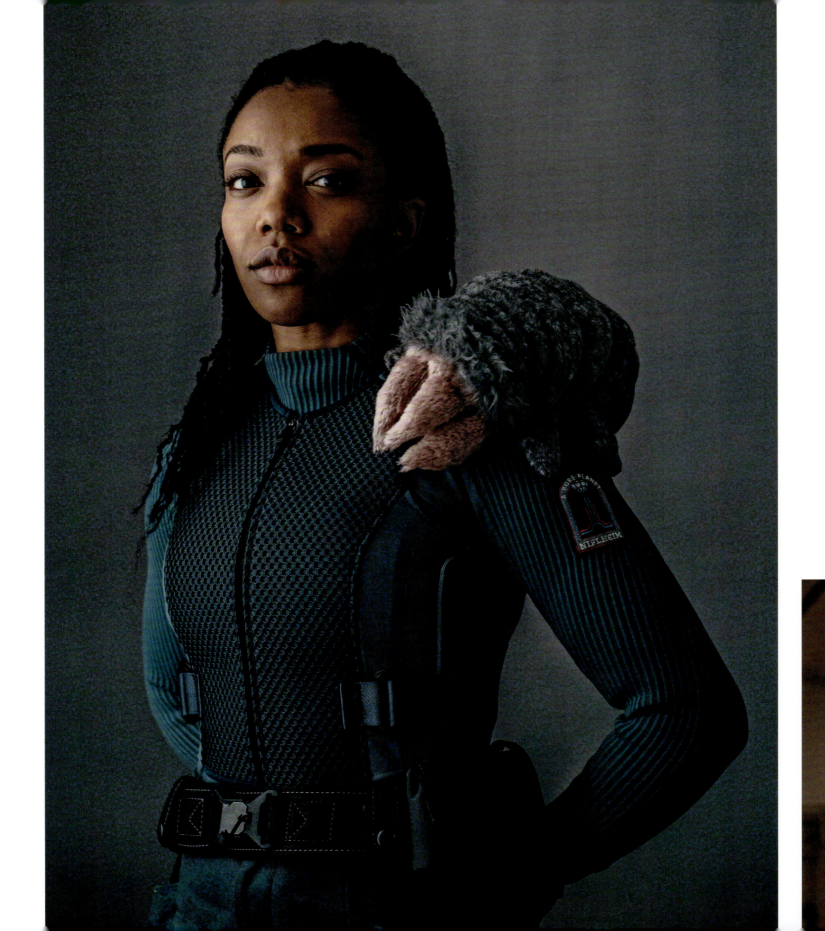

NASHA

Nasha Barridge is an elite agent. She is also the one ray of light in Mickey's gloomy, hopeless existence. As far as Nasha and Mickey are concerned, everyone else are "dickheads."

The journey to Niflheim comes with some strict rules on board, such as no sex. The act wastes precious calories. Mickey and Nasha meet on the journey, sensing a connection that makes them different to everyone else. Inevitably, and without wasting too much time (or calories), they sleep together, and their connection is solidified. Theirs is a bond that will be tested and challenged upon arrival at Niflheim and also with the arrival of Mickey 18.

Nasha is played by Naomi Ackie. The British actor said Director Bong gave her the choice of whether to have an accent or not. "I was like, I want to be British. I'm British. I want to see more British people speaking in their own accent onscreen, so this is a great opportunity to do that. I had just come off a movie where I was American, which I love, too, but it felt really cool to be able to speak in my own tongue," she says.

With her accent not an issue, Ackie turned her attention to the stunt work. The role of Nasha is a physical one, with some key set pieces requiring fighting skills and Ackie herself being in the fray.

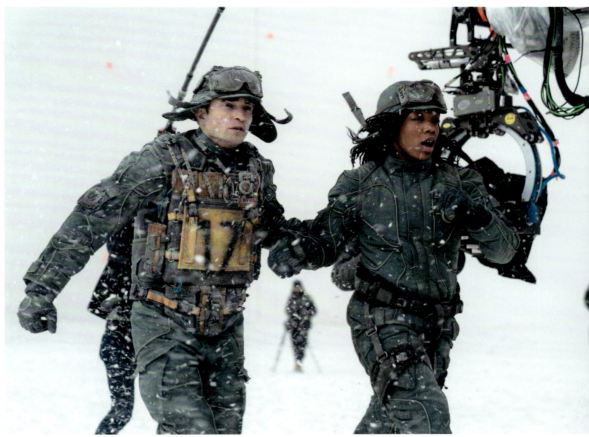

"The main thing was making sure that I knew the basics of fighting," she explains. "Working with the stunt team on how to use a gun and basic moves in jujitsu and judo. It was like mixing all of these martial arts techniques just in case we needed them. Nasha is not an action hero, but she is good at it. And she chooses her skills efficiently when she needs to. It all kind of seamlessly came together. And I had so much fun doing that. We did stuff around grappling holds and flipping people over. Man, I had a ball; I had such a good time.

"I even got a jujitsu suit afterwards because I had to use it for when I was training, and they gave it to me. I managed to do everything but one giant move, which even if I trained for a year, I wouldn't be able to do that. That was a stunt double, Zoe. She

handled that, as she works in circus training and is absolutely incredible. When you see this move, I wish it was me because *fucking hell*. But other than that, I was like a little spider monkey."

Nasha is fierce. She is driven. She is passionate and has a sense of right and wrong, which leads her to defend Mickey, to fight for the Creepers, and ultimately fulfill her destiny. Hair, makeup, and costume helped the actor find Nasha's movement and attitude. A few simple tricks went a long way to shaping the character's motives and values, Ackie recalls.

"We decided pretty early on that this was a braid situation," she says. "Because if I was going to say I'm bringing packs and packs of hair on this, then I'm braiding my hair, because it's the easiest thing to do. You just wake up in the morning, you don't have to style it. You just put it in a ponytail and go, so that was actually really fun to have that kind of same mindset, and Sharon the stylist was incredible at that.

"Director Bong loved the idea from the get-go, and it felt super easy. It also made my job easy every single day, as it wasn't a task to do my hair. In terms of costume, Nasha goes through about three, I would say. The one that we see the most is her kind of security costume. There's something about the bulletproof vest thing and the cargo pants and the boots and the holster to hold your gun that makes you walk in a different way. It makes you feel confident, and that is really cool to play with. Gives you a bit of swagger when you're walking through and other people aren't dressed like you."

It's true, the other people in the film aren't like Nasha. She has her own story on this ship and feels apart from everyone else, which helps her kinship with Mickey. "What I really liked about the script was her arc is really interesting," Ackie says. "She's kind of a floater. She loves Mickey and yet she wants to have fun. She came on this trip not necessarily running from anything, but also there's definitely stuff that she wasn't satisfied with back on Earth. But she's never thought of being a leader. She's got all the skills to be a leader; she's assertive, she's kind, passionate, she knows how to have fun. I love Nasha. I just think the way Director Bong has written her was so enticing for me and really fun. She's a fun character to play and hopefully she's a fun character to watch."

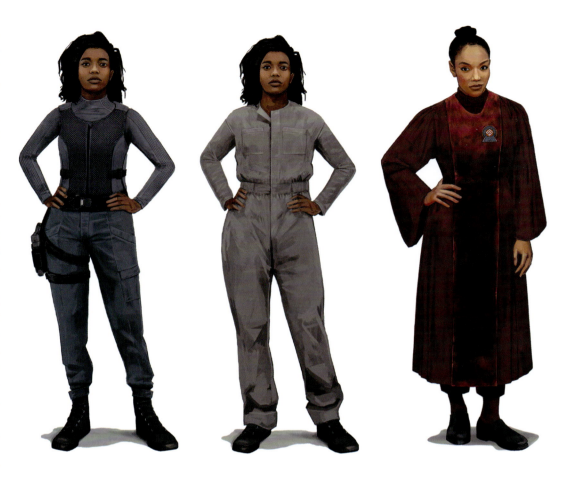

A great deal of Nasha's screen time is spent with Mickey. So, Ackie and Pattinson spent a lot of time filming together, including many intimate and emotionally challenging scenes—right from the very start.

"The first thing I ever did was kind of the whole point of Nasha, which was that she fights for Mickey, and I was comforting Mickey while he died. I came in, screaming in a lab, rip the hazmat suit off of him, climb into this weird glass chamber with Rob, then comforted him while he pretended to die," Ackie says, laughing, and then adds, "I love my job!"

The arrival of the eighteenth iteration of Mickey is not only the inciting incident for the whole plot and for Mickey's arc, but it takes Nasha and Mickey's relationship to an unexpected, but perhaps not so unexpected, place. "Obviously, there's a scene where she's trying to try to get freaky with two different versions of Mickey. She's a loose woman! It kind of makes logical sense. You have two partners, and you cannot lie and say that has not crossed your mind," Ackie says. "Wouldn't it cross your mind at all?"

THIS SPREAD: Costume designs showing the evolution of Nasha's final outfit, which mirrors the evolution of her character, as Naomi Ackie explains: "She's never kind of pushed herself. And it's amazing. She doesn't even realize it, but it just makes quite logical sense that she should be the, kind of, new leader of Niflheim and step into that responsibility. In terms of costume, she's moving forward: Her hair is like tied up and she looks a little bit more professional, but she still carries that same energy that she had. The arc felt strong."

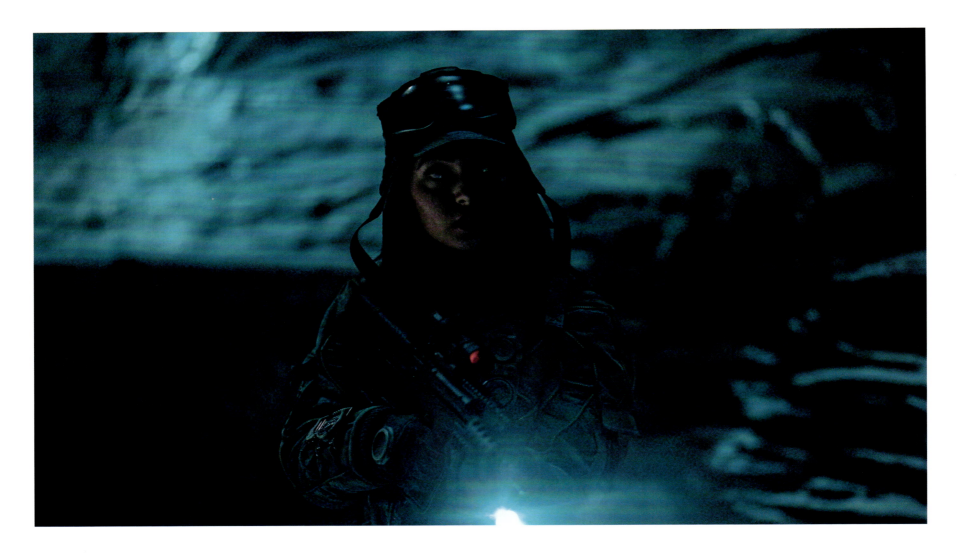

KAI

As with any character in a Bong Joon Ho film, Kai is not just one thing. She is an intelligence agent first and foremost in service of the mission. And at the same time, she seems sympathetic to Mickey. She is capable of love and trust yet betrays Nasha at a key moment. Marshall describes her in the film as "refined breeding. Impeccable genetics. The most optimal physical specimen."

For the role of Kai, the filmmakers cast actor Anamaria Vartolomei, best known to US audiences for her breakthrough role in 2021's *Happening*. That film won the main prize, the Golden Lion, at the 2021 Venice Film Festival. The jury was headed up by none other than Director Bong, and it was at this festival where Director Bong and Vartolomei first met. "So, we kinda knew each other," she says. "Not very well, because we met once, but we had something in common. I was kind of afraid, because sometimes when you're impressed by some people or by directors, sometimes you're like, 'Oh, I want to be myself, but at the same time I don't want to say *shit* or I don't want to be too shy or I have to find a good balance.' He's really spontaneous, and he's very joyful, so it makes you feel comfortable. It's really playful. Everything around him is nice. For example, you can come on set and sing something to him, and he will laugh, and then he will hug you, and then he will propose a new idea or something, and that's really cool, you know?"

One of the great pleasures actors enjoy about working with a Bong Joon Ho script is getting to play all the different notes of a character. Vartolomei was drawn to her character's catchy, funny, intelligent, and questioning story. "What I liked about my character and what intrigued me in her, I think, is her mystery," she says. "She's a girl we don't know too much about, and she's quite different from the others, and I saw there an opportunity to nuance that, and I think that Director Bong is the best dream partner for it."

As well as being a master of staging, pace, tone, and mise-en-scène, Bong Joon Ho is also an actor's director. This was already evident in his character-led films but compounded when *Parasite* won the Screen Actors Guild prize for Outstanding Performance by a Cast in a Motion Picture—a first for a non-English-language film. Director Bong creates a family atmosphere on set, with his cast and crew all equally important and equally committed. The 2021 Venice Film Festival was one of the first steps in finding the family for *Mickey 17*, with the casting of not only Vartolomei but Anna Mouglalis, who also starred in *Happening*, which earmarked her for a very specific and crucial role in Director Bong's next film.

THIS SPREAD: Concept art and film stills of Kai. The big questions audiences will ask of her are: What does Kai want and can she be trusted?

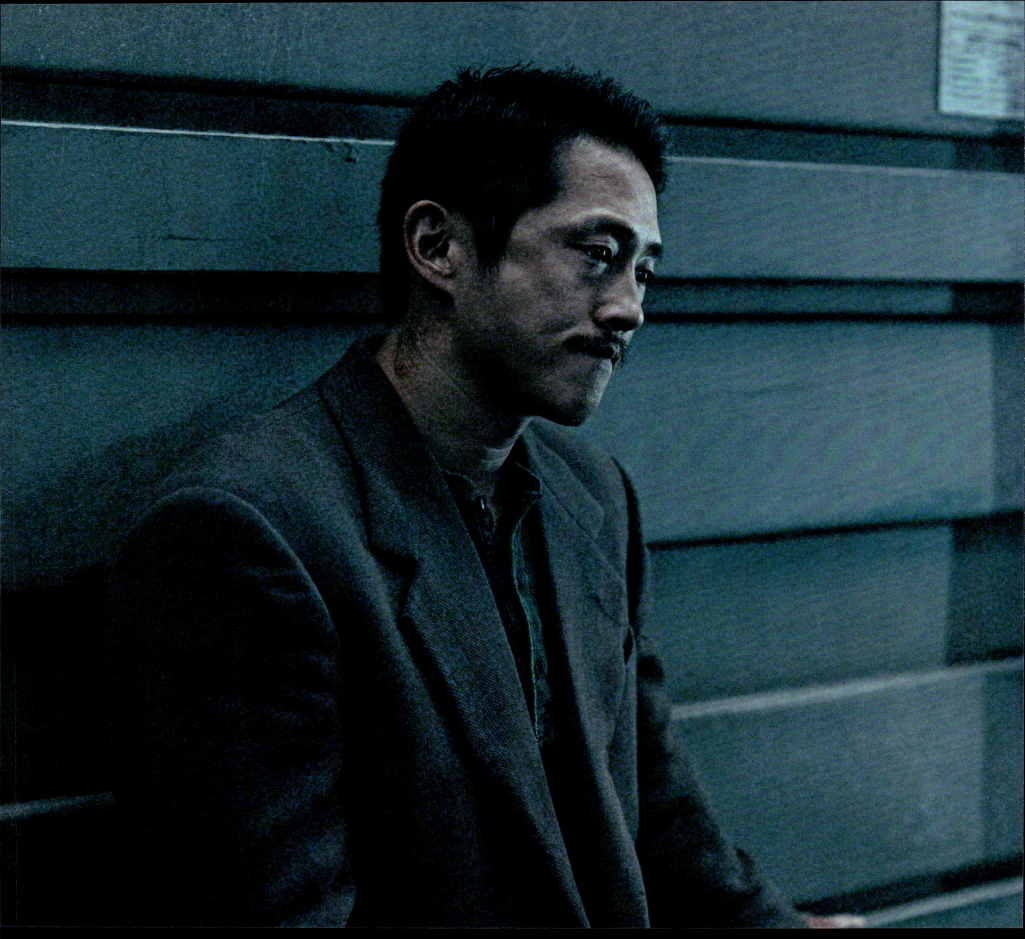

TIMO

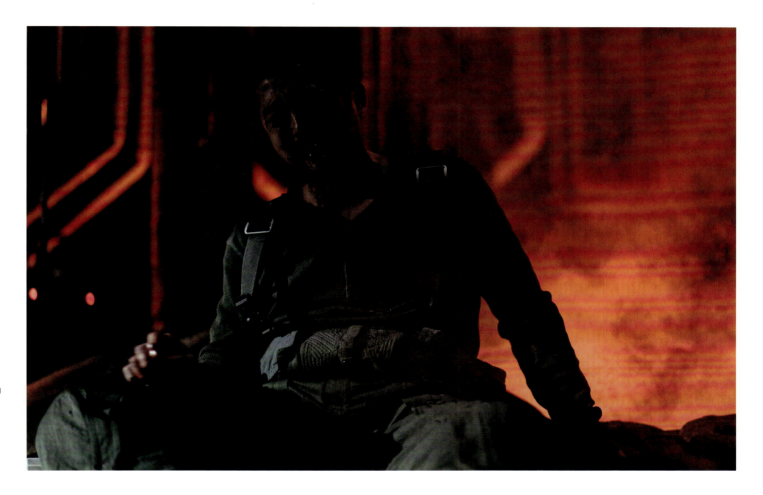

LEFT: A close-up of the award-winning actor Steven Yeun, whose character of Timo is a true survivor.
RIGHT: "Have a nice death! See ya tomorrow!" No matter the ups and downs—and the effect on those around him—Timo endures.

With a friend like Timo, who needs enemies?

When the story begins, Timo and Mickey owe money to a loan shark called Darius Blank. If they don't pay him, torture, mutilation, and death await. The two of them escape and head to the recruitment drive for the mission to Niflheim.

At first, Mickey and Timo seem like a team. But despite their time together, their adventures, and their familiarity, Timo is ultimately looking after one person: himself. In his mind, he is the one and only. Thanks to Timo's advice, Mickey puts himself forward for the ship's expendable program. A decision he will bitterly regret.

Once safely on board the ship, Timo reverts to his usual practice of finding a way to turn a situation to his own advantage. If there is an easy buck to be made, Timo will make it and deal with the consequences later.

The character is played by Steven Yeun, who describes Timo as a survivor. "He's an orphaned child that kinda, like, figured out life on his own, on his own terms," he says. "Maybe he learned a couple bad habits. He might be a survivalist over everything. He's someone that lives in the gaps of society. I think he's constantly gaming the system, trying to figure out how to live within it. He seems to have found a little bit of a cush position on the ship, but we'll see how long that lasts."

Yeun is a beloved Korean actor who balances mainstream projects with idiosyncratic projects. He is also an Oscar-nominated actor who had previously collaborated with Director Bong on *Okja*. Yeun's character in that film also makes some dubious choices to further his cause. When the chance came to reunite with Director Bong on another movie, Yeun did not hesitate. "I didn't have to think about it too hard," Yeun says. "I love Director Bong."

Mickey has several key relationships in the film: with Nasha, with Kai, and with himself. But the longest relationship has been with Timo. "Timo is like the older brother to Mickey," says Yeun. "They came up in the same orphanage, and I think Timo found in Mickey someone who he could feel connected to, perhaps not feel so alone. They have a very codependent relationship that doesn't necessarily look out for Mickey's best interests."

Case in point, when they join the Niflheim mission, Mickey is an expendable and Timo somehow becomes a pilot, or "weasels" his way into the job, as Yeun puts it.

Timo puts Timo first, and Yeun focused in on his character's own journey, finding notes of empathy and realism to play.

"He is the sum of what everybody thinks about him, but also he's not," he says. "To live in that gray area where you understand that you're being projected on in this particular way, but then also you could justify your own existence in a completely different way—that is so much to me about how reality works."

It so happens that Timo's time on the ship somewhat mirrored Steven Yeun's shoot on *Mickey 17*, as he explains. "I had maybe a very strange experience compared to others. I was shooting for two weeks and then gone a month and then gone another two weeks and then gone a month but then back for the last leg. It feels appropriately like Timo's life, a little bit of an outsider and a little bit isolated in his own world."

Timo is feeling his way through life as much as any other character. When he asks Mickey in the opening moments of the film, "What does it feel like to die?" he is really making light of Mickey's situation. According to Yeun, this question acknowledges Mickey's expendable nature, and it allows Timo to justify the way he behaves toward his friend. He's letting himself off the hook.

For Timo's styling, George describes the character as a playful schemer. "Steven was really committed to exploring this character, who's quite slippery and chameleonic," she explains. "He has several different looks, and designing his pilot uniform was challenging. We researched early flight gear and how the construction of the pilot's suits could retain heat."

"I get to wear some of the best stuff," Yeun confirms. "The pilot uniform Catherine made for me is so cool. Director Bong is all about attention to detail and a feeling of immersion, and so for me, I have been off and on [the shoot], in and out, but what's been

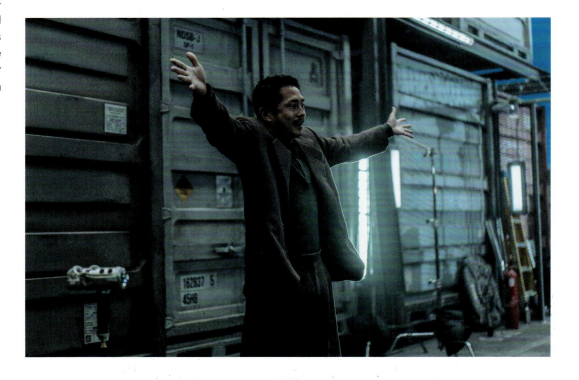

RIGHT: "My process isn't to necessarily craft every moment and make it very specific. The cool thing that [Director Bong does] is ask: What does this frame in this moment tell you about this person and this reality and what is happening? So I just express what's happening there. In that way I, like, surrender to it all; that's been nice." Steven Yeun
OPPOSITE: Look in your heart—the crux of the relationship between Timo and Mickey, with the former appealing to the latter but ultimately only for the good of Timo.

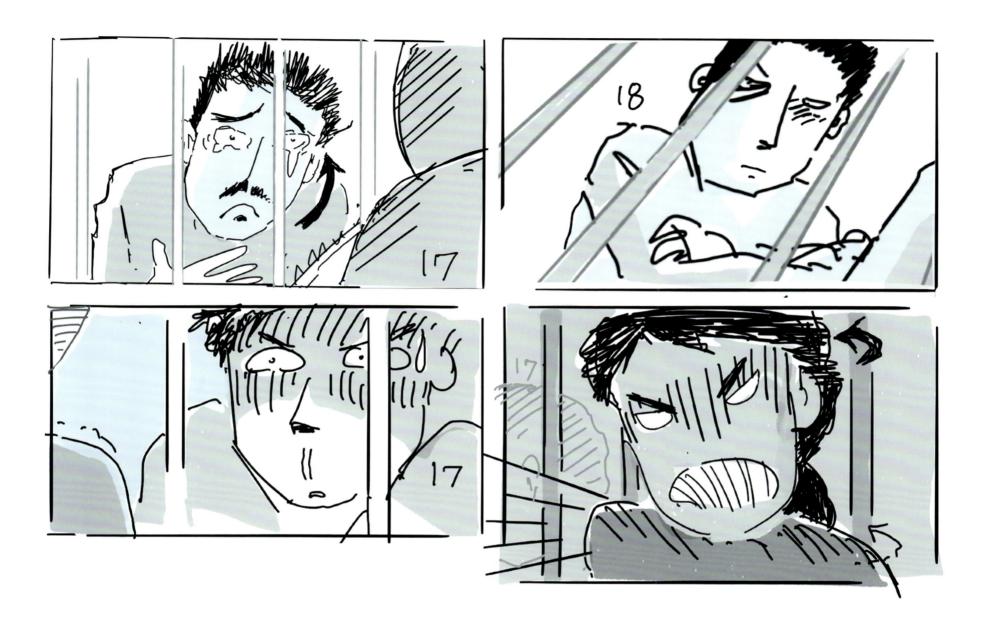

nice is like coming here and being on this set and you're kinda just like, 'Oh, I'm right back in.' It's not too hard to imagine, we're not on a green screen, so I appreciate that. With Timo, what's interesting is his pecking order belies his inherent real self too. He's always kind of in disguise. His flitter pilot suit is a disguise."

Mickey 17 also stars the veteran character actor Stephen Park. As Zeke, a member of the ship's security detail, the character is ostensibly aligned with Marshall. But throughout the film, he reveals himself as a character with heart and one of the few who see Mickey as a human being.

Park is an American-born actor of Korean heritage who has enjoyed a decades-long career across a wide range of film and TV, including working with such auteurs as Spike Lee, the Coen Brothers, and Wes Anderson. For Bong Joon Ho, he starred as Fuyu in *Snowpiercer*. Both Yeun and Park being cast in *Mickey 17* is a fun moment for two generations of acting talent—and the fans.

"They not only share a scene, but they are in the same shot together. It's a nice touch," says producer Dooho Choi.

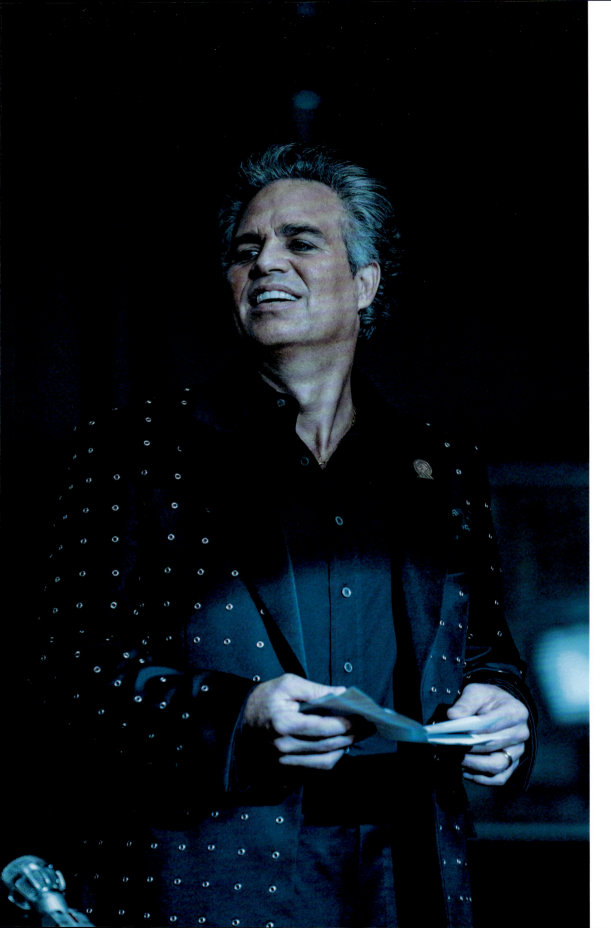

MARSHALL

In the film, Kenneth Marshall is a failed US congressman who believes he is a success and beloved despite all evidence to the contrary. The walking definition of an isolationist, Marshall has managed to drum up enough support from his fervent religious supporters to fund the mission into space. In his mind, he is the bold leader of a new world.

Mark Ruffalo plays Marshall, the fearless leader of the Niflheim expedition. The acclaimed actor is one of few performers to hold nominations (or awards) for the Emmys, Grammys, Oscars, and Tonys. He can switch comfortably between record-breaking blockbusters, such as his role as Bruce Banner in the Avengers movies, to adult dramas with the likes of David Fincher, Yorgos Lanthimos, Michael Mann, Lisa Cholodenko, and Martin Scorsese.

"I met Director Bong when he was doing the awards for *Parasite* in LA, and we just happened to be there at the same time," Ruffalo says. "I just loved his filmmaking, so I asked if we could have a general meeting, and I just told him how much I would love to work with him. And he was like, 'I like your work too.' A few years later, I got a call saying that he was interested in me for this film."

Ruffalo describes Marshall as a tyrant. "He's cruel. He's petty. He's exclusive. He's elitist. He's racist," he says. "The world does revolve around him. But why he's all those things is because inside he really feels like nothing."

It takes a man with a certain level of ego to assign themselves as the head of a mission across the galaxy. Where a whole colony of people are risking their lives for the mission and, once landed, he will be the self-appointed king. But Marshall has always had delusions of grandeur, according to Ruffalo.

"He is the son of a very successful American politician, a congressman or something," he says. "He's part of one of these dynasties, but he doesn't really have the talent and the appeal. He's like a Donald Trump, Jr.-type person who has been riding on the coattails of his father but has no real talent or gifts for it. But by bullshit, trickery, nepotism, he finds himself a commander on this colonizer ship that may or may not make it. When you see the ship, it's kind of a piece of shit. Everyone's living in squalor but him and his wife, Ylfa. They live in a totally gilded apartment—everything's gold or Rococo."

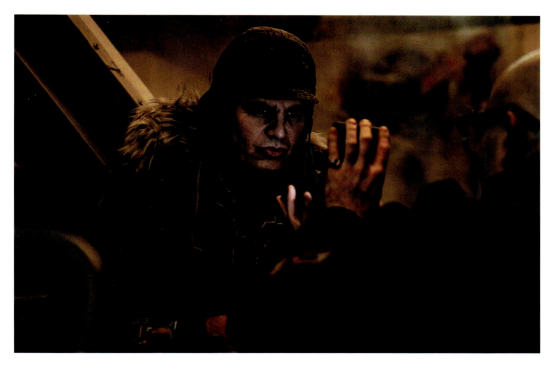

"In the original novel, his character is slightly different, but in the movie I needed a stronger villain. I amplified him. I wanted to make Marshall and Ylfa a unique couple."
—BONG JOON HO

But the glitz and glamor is all for show, as Marshall is a surface-level being. He is full of bluster and pretense, masking the emptiness and depthless insecurities beneath the impressive, attractive front he believes he is presenting. He is another in a long line of classic Bong Joon Ho characters who are playing a role or projecting a version of themselves to those around them and us the viewer. Marshall is in the same rogues' gallery as Ed Harris's self-proclaimed savior Wilford in *Snowpiercer*, Tilda Swinton's TV-ready Lucy Mirando in *Okja*, or the entire family assuming roles and personalities to fit in in *Parasite*.

Some would say that Marshall is a narcissist. The clinical definition of a narcissist is someone whose own self-worth is viewed as greater than others. They value their own significance above others, which actually speaks to a deep need for acceptance. "The narcissism comes across as supreme confidence," says Ruffalo. "But what's really happening is so much inner weakness and insecurity and a brokenness that is irreparable. If a narcissist had to actually look at themselves, I think they could have a psychotic break. Marshall at one point just loses it. I think he sort of has a psychotic break during the course of the movie."

A man like Marshall does not get to where he is without being enabled by those around him, and there is no one in his inner circle more important to him than his wife, Ylfa. They are a match made in heaven.

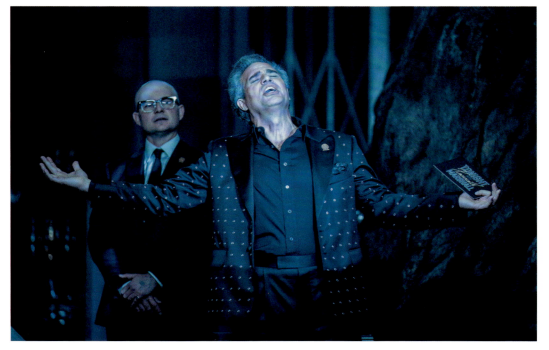

"It's a very strange relationship," Ruffalo says. "It's sort of like dominatrix/submissive. She's a little bit Lady Macbeth. She's very much in control of him. He keeps checking in with her. You'll see him constantly going to her, whispering to her, and her giving him words of encouragement or telling him what he needs to do. He's always checking in with her, secretly. I don't even know if you can hear a lot of it. But you do see him, in the middle of some crazy scene, turn to her and whisper something in her ear and her whisper something back to him and then him taking action. It happens quite a few times."

Catherine George worked closely with Ruffalo and Director Bong in getting the look of the character right, turning to a handy real-life source of inspiration. "For Marshall, we experimented with various suit silhouettes," George shares. "We determined which one best suited his character. Director Bong envisioned him as somewhat of a loser, referencing a Korean politician who was an almost-successful figure—there was just something off about him that was reflected in his body language and appearance. We aimed to incorporate that into Marshall's character.

"He has some power outfits, incorporating the colors of the 'one and only' symbol, and we had fun creating a tie with a repeat pattern of the symbol. Early on, Bong Joon Ho was particularly drawn to a swatch of fabric with tiny holes all over it. We spent some time creating that suit for his talk show, adding individual silver eyelets with our wonderful tailor Simone Feulner."

Marshall embodies many aspects and characteristics that go beyond being the mere "villain" of the piece. It is a role unlike any other that Ruffalo has previously taken on, something which initially played on his mind. "He's just a big personality. He's a psychopath. And I just had never played anything like that. And I didn't know if I could. I've never really played anything like that before. I thought, 'I can't do this.' I said to him, 'Director Bong, I don't know if I'll be good in this for you.' To which he said, 'What are you talking about? I wrote it for you!'"

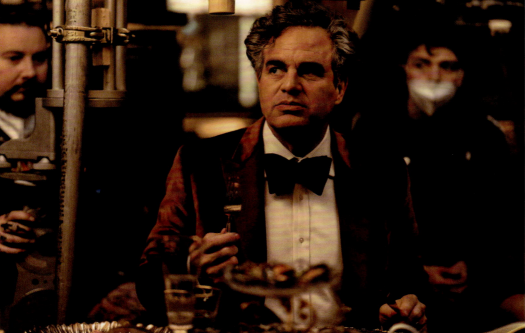

TOP LEFT: Marshall makes a fiery speech.
LEFT: Ruffalo poised and ready to shoot the dinner party scene.
RIGHT: Marshall is at his best—or what he see's as his best, with eyelet blazer and bouffant hair.

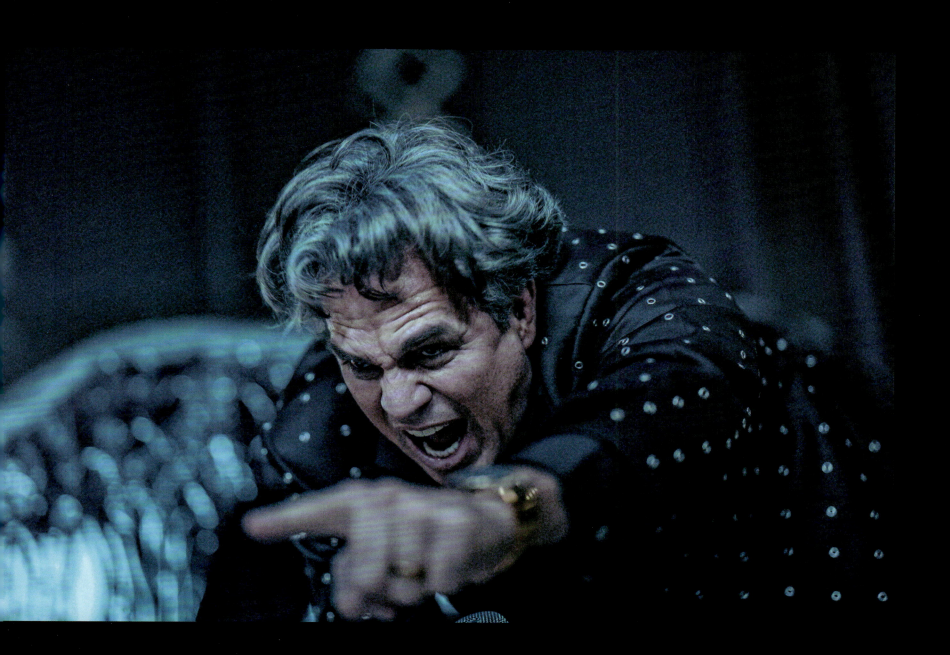

THIS SPREAD: Costume Designer Catherine George describes the styling of Ylfa: "I was free to be adventurous on colors with Ylfa as Director Bong was happy to have her stand out. When she and Marshall are in their suite her color choices make sense within that suite."

YLFA

If Marshall is the de facto president of this new colony, then Ylfa is the first lady. In their minds, they are impressive, powerful, attractive, and they are *always* right. The reality is otherwise.

Together, they make a garish pair. Their self-centered behavior, vanity, and delusions are obvious to all but them. They affect a cultured and sophisticated air, which clearly belies their failings. And these failings are severe: transporting an entire colony to a faraway planet as a vanity project-cum-master-race agenda.

Ylfa and Marshall join an established and celebrated rogues' gallery of the grotesque, as seen throughout Director Bong's filmography. These are people who seek positions of power and yearn to impose their will on others. They are creations who want to shape the world as they see it with no thought to others, and as in the case of *Parasite*, the lack of empathy for one another can be deadly.

"In some aspects, Ylfa is something more than Kenneth Marshall and also some kind of queen of this new version of racism," Director Bong says. "She is a mixture of historical political nightmares, of very bad political leaders and dictators and also dictators' wives. Ylfa has a great delicate and sophisticated manner. She tries to pretend to be politically correct but actually is not. Ylfa is quite a scary human being, I think. Of course, it is slightly exaggerated, but I think those kinds of characters actually exist in the real world."

Ylfa is played by Toni Collette. Collette has enjoyed a staggeringly varied career with a filmography encompassing everything from *Muriel's Wedding* (1994) and *The Sixth Sense* (1999) to *Hereditary* (2018) and *Knives Out* (2019). This ability to shift from project to project was one of the things that attracted her to *Mickey 17*.

"I had a Zoom meeting with Director Bong, and he told me in the Zoom, 'Toni, you and I have been doing this a long time. I just wanna be straight; I want you to be in my movie,'" Collette says. "And I swear to God, I could not stop smiling for weeks. I mean, it's a total dream.

"I really respect people who are willing to chop and change and mix things up and explore different worlds, and don't kind of stick to any particular genre. Within that he can kind of trick people into thinking he's working within a particular genre, but then it's all tonally bleeding out and becoming so many different things. And I just love that because life is like that, and I think

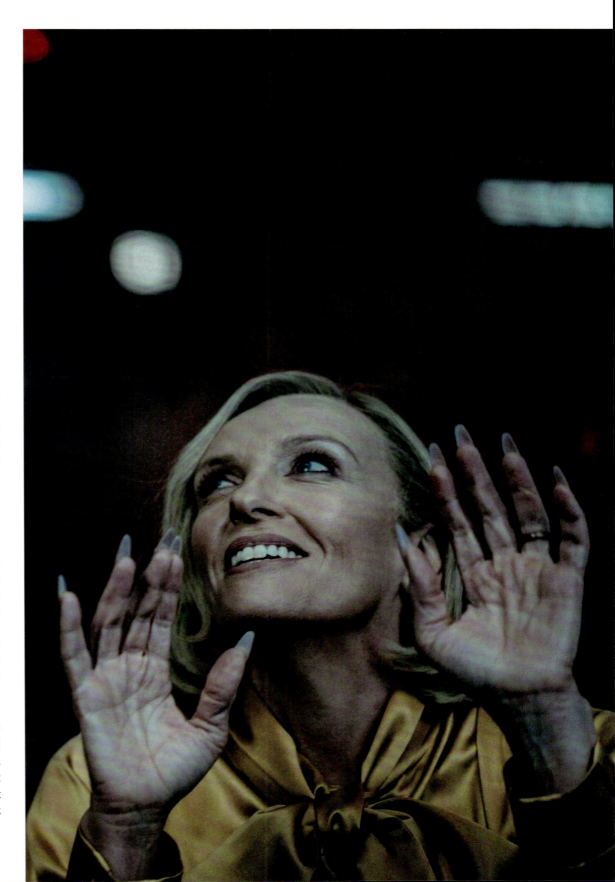

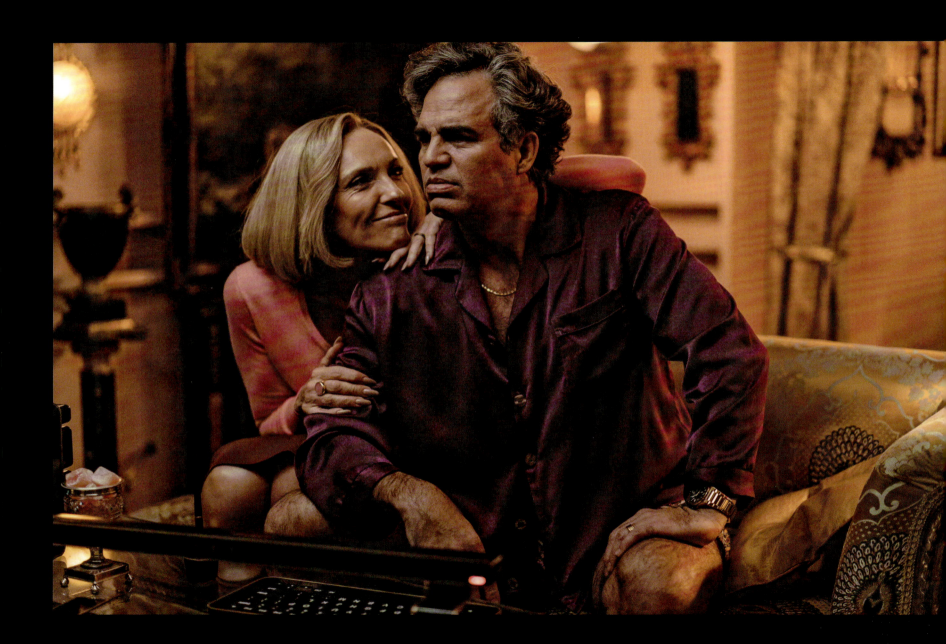

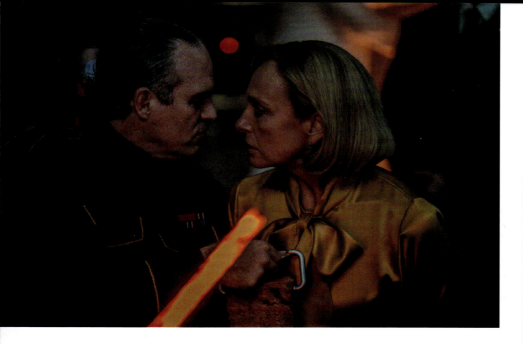

we as humans appreciate that in storytelling, that you can see how idiosyncratic it is, and how slippery it is, and how it's so changeable. We are so changeable."

People like Ylfa and Marshall live in a world where they envision themselves as main characters portrayed in a film. Also known as "main character syndrome," they see themselves as the protagonist in their own life story, with everyone else as supporting players. For the viewer, these abhorrent people are not the center of the narrative, despite what they think.

"They're a really narcissistic couple, and they are completely in love with each other and can't see how their decisions affect the rest of their community at all. They're just kind of blind to it, but they're also so sweet with each other that you almost forgive them. They're horrendous, actually."

Ylfa's specific oddity is food. She sees her kitchen as a place of refinery and culture, and Ylfa is desperate for the highest quality delicacies. Her hunt for food befitting a first lady leads her to sampling the blood of a Baby Creeper. It turns out to be the flavor she has been looking for. There is something phenomenally vampiric and shortsighted in the way she states in the movie, "A hundred tails will make enough sauce to last a couple years!"

The character is defined by her styling, George says. "There's a dream sequence where she wears a rich, blood-red outfit, connecting to the overall blood theme. Her wardrobe features luxurious fabrics with a feminine color palette of pinks, corals, and red in silk, satin, and velvets—very lush and lustrous. She revels in playing the role of the First Lady."

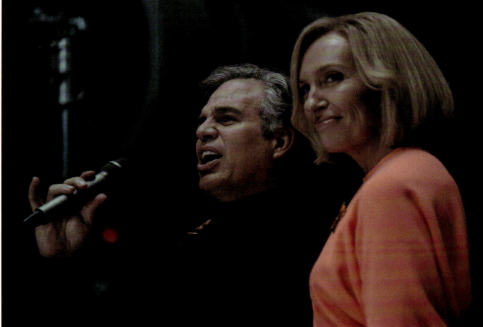

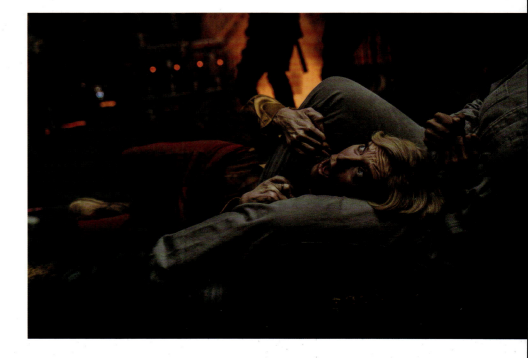

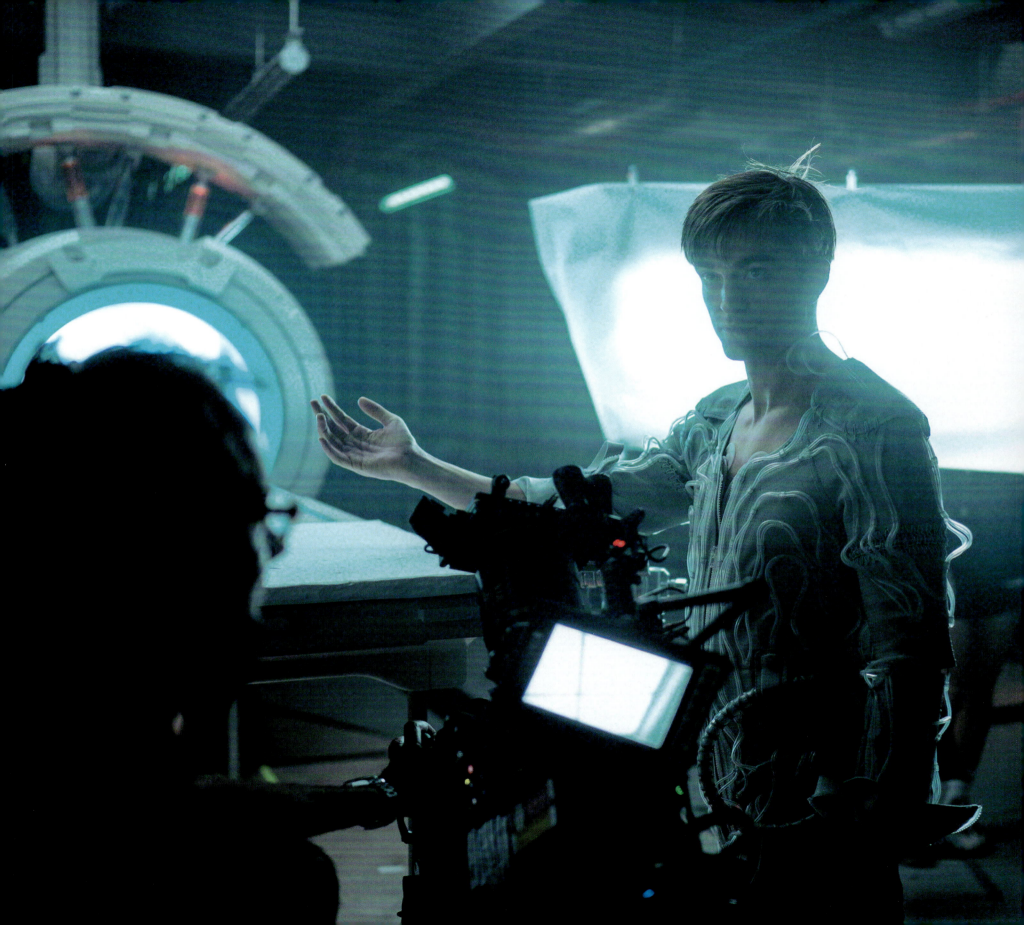

FILMING

Mickey 17 was primarily filmed on soundstages at the Warner Bros. Studios, Leavesden, outside of London, with a significant portion shot in a massive hangar at Cardington Studios, in Bedford. The filmmakers needed to create the "endless white" of Niflheim, an alien planet unlike anything on Earth. Although, perhaps, like one place on Earth.

"Obviously, there was a discussion about Iceland because the planet that they land on is a frozen planet. You know, you just go to Iceland for alien-looking places, right?" Dooho Choi says. "But I think we were also aware that Iceland was pretty exposed in terms of movies, whether it's *Prometheus* or *Oblivion*; they all shot in Iceland. Director Bong wanted a very specific look for the planet. There were some conversations with Darius about taking a unit to Iceland and shooting some stuff there, but it quickly became impractical not only for cost reasons, but in the time that we were shooting the movie, which would be early winter in Iceland; there's only four or five hours of daylight. Storms can come in and cause all kinds of delays."

In Cardington, they could create their own world, wholly within their control, without being dependent on the weather. Although inside the Cardington hangar they would be safe from the inevitable gray English skies and rain, they would not have what they needed the most: snow. For this, the filmmakers turned to Dom Tuohy. He and his team of SFX artists laid down almost 300 tons of magnesium salt to double as snow on the ground. "Ideal, because you can still see the treads of the tires from the flitter," he says. "But it doesn't stick to the tires, and it doesn't create a problem. It's got a little bit of sparkle to it, so that helps sell that fresh snow kind of look that you get."

Not only did Tuohy's crew lay the snow on the ground, but they also created a blizzard. "The blizzard was done with a combination of foam and plastics," Choi adds. "They have good and bad properties. The foam is really good because we put it through wind machines and it has this undulation, which gives a really nice, stormy look, but you've got to be really clever and careful because when it lands on the actor it looks like foam. We had an array of large wind machines down one side of the Cardington stage, and we were pumping in foam, and then the vehicles were driving through it, with the camera on the vehicle driving through with the actors. We just had to kind of take a chance that the foam didn't look like foam when it stuck to the costume."

Snowstorms can, of course, be created by digital effects, but the reality of the scene can be lost, not least in terms of the actors' interaction with the elements and the actual play of light in the frame. "This is where Darius's lighting department really did an incredible job," Choi says. "The lighting grid that our gaffer created was just unbelievable. He created these lighting grids all along the ceiling. One of the good things about Cardington was that the ceilings are really high because it's very important for Darius to have the lights as far away from the floor as possible, so you can have a really wide angle where the light would spread out, but he also had to have it really soft because we didn't want crazy shadows. We wanted it to feel like real daylight coming through a snowy atmosphere, and so he had these gigantic lights but through these silks, and so the whole entire space was evenly lit."

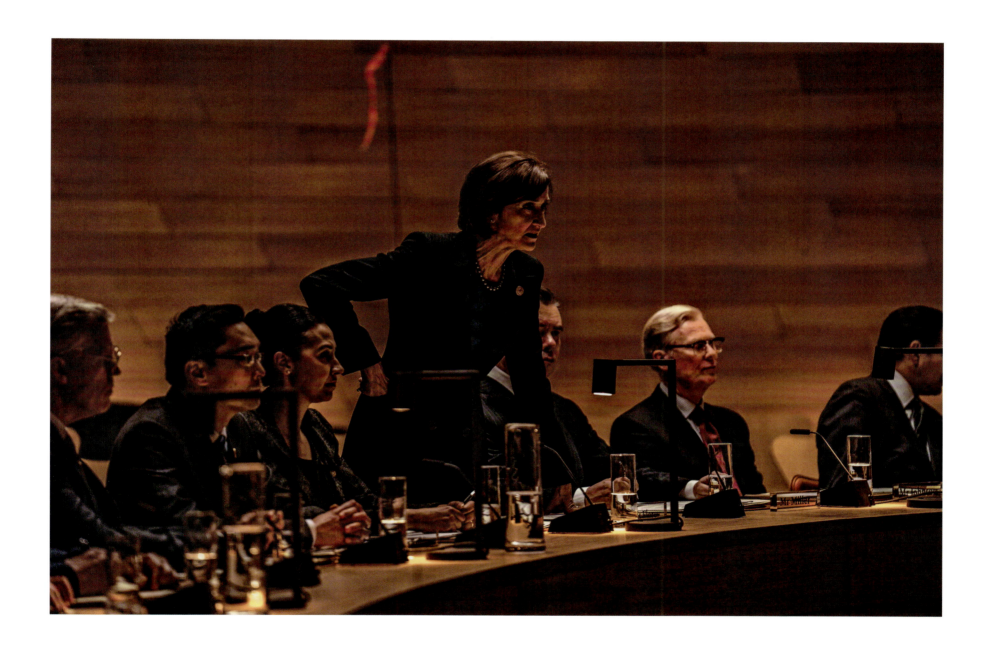

THE SHOOT

111

Cardington lists its available space as 146,000 square feet and 48 meters tall at its highest point, making it one of the biggest indoor shooting spaces in Europe. Still, there was concern it may not be big enough to communicate the idea of an entire planet.

"Dan Glass and I were always talking about the horizon," Khondji recalls. "Where the horizon is, where will it be with added visual effects beyond the snowstorm that we were actually photographing? Cardington is quite big, but Dan was doing an endless land of snow beyond that."

Glass was present throughout the shoot and considered different options for extending the expanse of Niflheim beyond the walls of Cardington. "I was actually weighing up using LED walls," he says. "When you are in a white environment, you have overcast snow coming in, and light is coming in and bouncing from everywhere. In a blue-screen stage, you cannot re-create that. You can't. You've got blue-screen light coming in, spilling onto people. You can replace the background nicely, but the skin is not receiving that light. It doesn't look like you're outside in a really wide, white environment. So, we went with white backgrounds. It's very, very painstaking work. You have to cut out the edges to replace what's there. But, really, the look of it is tremendous. Even when we were shooting, you felt like the actors were outside. You felt they were cold, and as it gets put together with all the CG in there, I'm very happy with how it looks."

The Cardington shoot was used for two key sequences, one early on where Mickey parachutes onto the surface before falling into a crevasse, which forms the catalyst for the story. Secondly, for the climax of the film. But in addition to Cardington, the filmmakers also shot on location in London, finding real streets and buildings that offered the ideal near-future world of *Mickey 17*. What they shot forms some of the earliest scenes in the movie.

"They were really very atmospheric locations," Fiona Crombie says. "They were well chosen because each of them has a very specific character. We've got two locations that are architecturally really fantastic. Visually, they look amazing. We went to the Strand and the Savoy. There's an alleyway next to

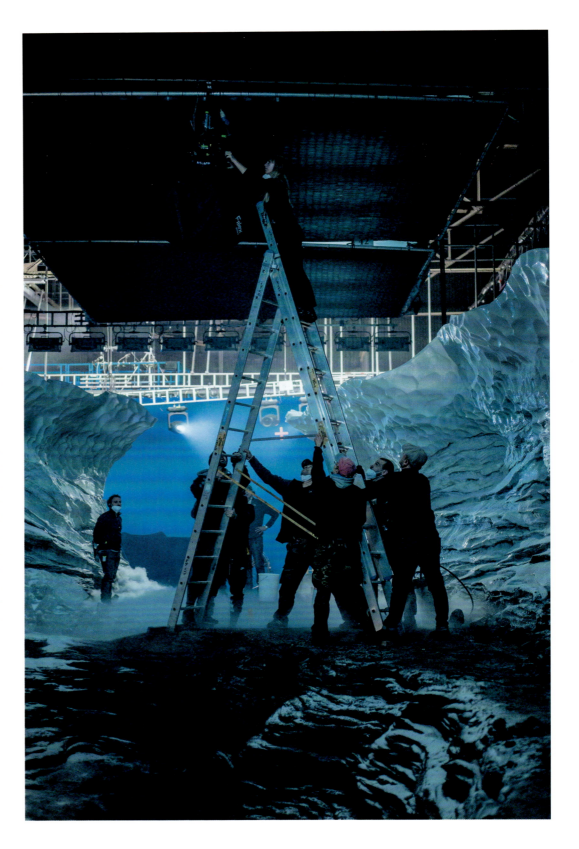

RIGHT: Constructing the ice cave set at Leavesden.
OPPOSITE RIGHT: Preparing for the sequence where a multitude of Creepers transport Mickey outside, back to the surface of Niflheim. "As fast as I could get it going," says Dan Glass, "I had teams using the models from [Creature Designer] Hee Chul, and we spoke with him about the Creepers. There were many questions going back and forth to understand why things were intended the way they were, getting his thoughts about how these creatures move."
FAR RIGHT: Bong Joon Ho at Cardington, alongside one of the working flitters, as he explains: "We had two very big flitters there. It's quite a huge place, but for the flitters, it is quite a small space because the vehicle is so big and we have to move it in many, many different ways."

112 THE ART AND MAKING OF MICKEY 17

> "The most complicated scene was actually the climactic sequence in the snowy field. Every shot of the sequence is in Cardington. All the things we shot in Cardington were physically demanding, complicated, and tricky."
> —BONG JOON HO

the Savoy, and behind the Savoy, there's that little zone there. We went to a place called French Ordinary Court, which is a tiny little underpass, where we did some alleyway work. And we went to the old City Hall in London. That's the big convention center where Mickey signs up for the mission. There's a whole lot of reasons why we liked that environment, but one of them is that you look out the windows and you can see the sandstorm. So that was a big consideration with that."

City Hall was designed by Norman Foster and sits on the south bank of the Thames. With its heavy use of glass on all sides, it may offer a great deal of natural light for filmmakers to work with, but the massive recruitment scene needed for *Mickey 17* posed its own issues.

"Shooting there was quite challenging," Darius Khondji remembers. "A lot of actors. A lot of characters. A lot of extras. That was lit mainly by natural light, and we were playing with the direction of the sun, of the natural light coming in, and how we're going to re-create the sandstorm, which will be added in after by visual effects. It was a beautiful building to photograph.

"The parts that I'm proud of, that I like, are the nights. I always love the nights. I always love night shoots. They're very small in the film. It's like a glimpse, a flashback of Earth, when you have the voice-over of Mickey talking about the life on Earth and what happened to him on Earth. Then you see a bit of those London night shoots; I actually loved doing it."

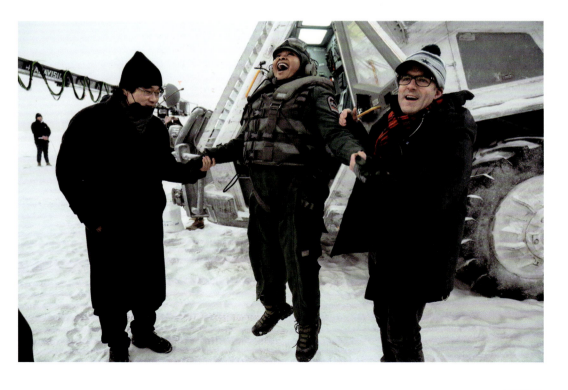

ON-SET STORIES

Principal photography began in August 2022.

With actor availability, utilizing the sets, weather conditions, and myriad other reasons, it is not often possible to shoot a movie in the chronological order of the script. But on *Mickey 17*, everything was planned in such a way as to feel seamless, sensible, and helpful to the cast and crew. Ackie confirms that the filmmakers were efficient, organized, and the feeling of the shoot mirrored the feeling of her character's journey. "For me, it was like the shoot was split into three parts; within section two there was medical stuff that got mixed in," she says. "And actually, even though I did some of the last scenes at the beginning, they held the same feeling at the beginning. It was more of a calmer kind of vibe."

Dom Tuohy agrees that the planning and preparation at every level of the production made all the difference. Not just for the schedule and budget but for the attitude and feeling of a film that is going smoothly. "I've got to say, this was one of the most organized films I've ever worked on. From day one of the introduction to Director Bong to the day that we left, the consistency of him and all of the production was unique. I've worked on many projects, and some projects you work on and they're great fun, the crew's really nice and you enjoy what you're doing, but the film doesn't come across well. And then I've worked on films where everything has been a real pain and it's been hard work, and every day is gritty and the films come across really good. People say, 'I like that film,' and you think, 'What a shame.' But this film was just a pleasure to work on, and it felt good when we were doing it. It felt structured."

The director, producers, and crew did everything they could to be as smart and economical as possible with the schedule, always ensuring they got what they needed but never at the expense of storytelling. Meaning they were able to start shooting before they had *really* started shooting.

"We did a 'pre-day' because there was a location that was a one-off," recalls Dooho Choi. "This was the bomb shelter in Clapham. It was like an unofficial first day, but it was really just three setups in a tunnel of Rob walking down to the launch site of where the spaceship takes off.

"It was really exciting. Finally, we're on set shooting. I think for a producer, that's always the moment: Now the baton has been passed. Obviously, you know, Director Bong was working on everything all the way through. But it's kind of like: Now it's your crew and your actors."

The Billy Wilder classic *Sunset Boulevard* starts with the protagonist and narrator dead, and the film is all about taking the viewer back through the events leading up to his death. Similarly, *It's a Wonderful Life* makes exposition part of the story by showing the hero's community and all those affected by his presence on Earth. By contrast, *Mickey 17* takes us on a whistle-stop tour through his life and how he got into the situation we find him in at the start of the film. But it emphasizes not how precious Mickey Barnes's life is but rather how cheap and disposable it is. His death is valuable—similar to Okja, Mickey is worth more dead than alive.

Mickey 17 opens with Mickey waiting to die in a crevasse on Niflheim. His best friend Timo looks down at him from the surface, bids him, "Have a nice death and see you tomorrow!" and leaves Mickey to the creatures he can hear approaching. As he lies on his back, awaiting the inevitable, Mickey's life does not so much pass before his eyes but pass before our eyes. We witness an extended introduction, which happens at a breakneck pace, of Mickey and Timo running from gangster Darius Blank back on Earth. It ends with them signing up for the Niflheim mission, with Mickey becoming an "expendable" on the spur of the moment and dealing with the fallout of that decision.

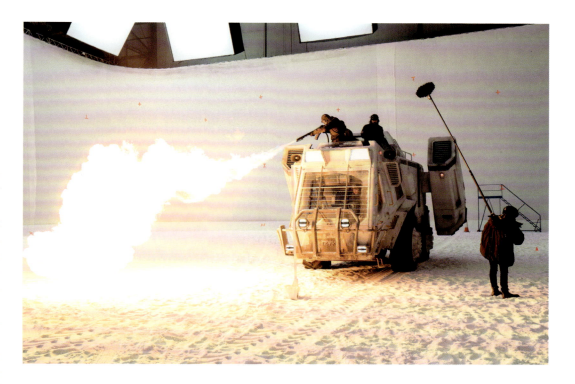

LEFT: "Director Bong has this incredibly specific tone, how he writes and directs. It's quite complex to get yourself to understand and to be a part of." Robert Pattinson
ABOVE: Set photo of Marshall's troops enacting their "scorched earth" policy.

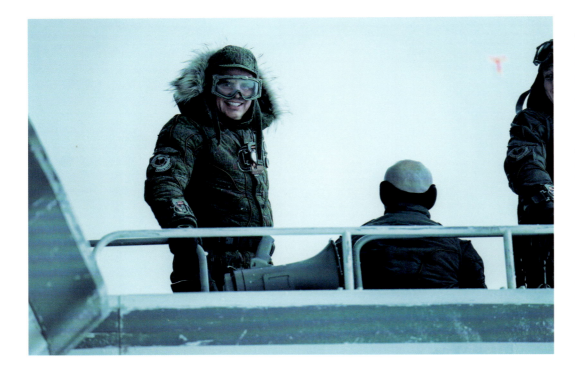

Mickey's relationship with Nasha and his so-called friendship with Timo is laid out. The audience also sees how Kai's girlfriend Jennifer dies on Niflheim, and that Marshall believes Mickey should have died instead. He punishes Mickey by halving his rations and sending him down to Niflheim seven days a week until he brings back a Creeper sample for the scientists on the ship to experiment on. It is during one of these recces that Mickey falls into the crevasse.

Mickey presumes he is as good as dead. Timo reports him as so, and a replacement, Mickey 18, is printed. The film has already twisted viewers' expectations of how a big-budget sci-fi operates, and now it twists it once again by playing with Mickey's own assumption of where his life, or his death, is leading. But Mickey doesn't die, creating the catalyst for the entire story. The Creepers drag him back to within reach of his ship. Mickey is then faced with rejoining the mission, picking his life back up with Mickey 18 already having taken his place.

Pattinson needed to be able to sell the emotional reality of Mickeys 17 and 18 talking, fighting, and relating to one another. As prepared as he could be in his own headspace and rehearsals, he had some help from costuming and hair and makeup.

"Director Bong was always quite clear that he wanted the tiniest difference between them, so it looks like nothing but there is something there," Hair and Makeup Supervisor Sharon Martin says. "I straightaway kind of thought of using cheek plumpers just to change the shape of the face. So we started off with several sets of plumpers, different sizes. So on the camera test we were testing plumper A, which was small, and plumper B, which was like medium, and plumper C, which was a little more. And they were giving us changes. One's at the front of the mouth, one's in the cheeks, and then we could just see where we wanted to go. This was for Mickey 17. Mickey 18, I offered up just a little tooth, a little snaggletooth. It's like Rob's own teeth, but one tooth slightly overlaps so you catch it just at different times. It's never there in your face. And in the end, we went with no plumpers for 17 and just a snaggletooth for 18, so that's really their difference."

"I think Rob's two different characters, Mickey 17 and Mickey 18, talk in quite different ways," Sound Mixer Stuart Wilson says. "Over time you start to recognize the different characters that he's developed for each personality, or each incarnation of himself. Mickey 17 has a higher pitch, and he doesn't enunciate so clearly. He runs things together and he has quite a goofy personality. Whereas Mickey 18 is much more no-nonsense. His voice is in a lower register, and he makes statements, and he just says what he needs to say."

When it came to framing Pattinson for almost three months, while playing two parts, Khondji had nothing but praise. The two had previously worked together on James Gray's *The Lost City of Z*. "It didn't feel like a long process," Darius Khondji says. "They did it quite quickly. We did a lot of rehearsal. And we ended up doing the scenes quite quickly. It was fun. And Rob always made everything fun and very easy. So there was never any melodrama coming from him or coming from anyone; he was setting the tone. When you have a director like Director Bong and an actor like Pattinson, what's great is that no one is trying to be a prima donna or giving problems. You know what I mean? It was a good spirit, you know, which is very nice. I really enjoyed it, the fact that the director and a big star have this attitude—a very nice attitude. It really sets the tone for me on a big movie like that.

"I love photographing Rob. He's a very, very charismatic, interesting actor, you know. He can change very easily into different faces, you know? Sometimes it looks like an actor from the beginning of cinema at the beginning of the 20th century. You know, he looks like a silent actor, someone from an expressionist film. I was looking at him and I was thinking, 'Oh, wow, Fritz Lang would have loved casting him in a movie.'"

A key scene in *Mickey 17* is not a huge special effects piece and is unlikely to be a sequence that gets cut into a trailer. It's a dinner scene all about character interaction and dynamics. It also happened to be Director Bong's favorite.

ABOVE: Ruffalo breaking character on set, in between shooting the big finale.
TOP RIGHT: Steven Yeun makes the best of a bad situation for Timo.
FAR RIGHT: Director Bong and Robert Pattinson conversing on the surface of Niflheim with the Mama puppet in the background.

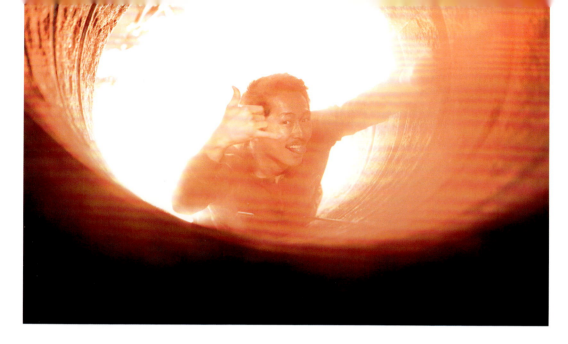

were just doing a sixth of a scene, sometimes out of order, but you just got to learn to go with the flow.

"It's all about the camera movement and your movement within the frame. A huge part of the blocking is done for you. You've still got to do all the pacing, and you've got to make sure that you're hitting the right emotion at the right time, but you know that the blocking is not your responsibility. And also, what happens is that the movement of the camera or how close the camera is, or how far away, really helps you decide how you're going to place yourself. I can look at the storyboard and I can see in one shot, it's a real close-up on Nasha's eyes, and they look very intense. So, I'm like, 'Okay, cool, that's my starting point,' without even needing to

"When I was writing the screenplay, I was obsessed with the dinner sequence," he says. "I was very excited by it. Marshall invites Mickey to dinner, and he is so happy. His food has been so limited and then halved, and when the dinner turns out to be just another excuse for medical trials, it's so sad. That dinner scene is really something for Mickey, Marshall, and Ylfa. The situation is so twisted in that scene, and the audience actually understands what kind of people they are, Marshall and Ylfa. Through that sequence the audience finally understands how terrible they are, in a very crazy and funny way. The audience also can actually physically experience what kind of job Mickey is doing now, in that even in the dinner he is in that kind of very harsh lab situation. All the dialogue and suddenly the song they are singing during the dinner; it's all crazy. So many crazy details. From the very early stage of screenwriting, I loved that scene so much and I was quite obsessed with it. Scene 68."

One of the most distinctive features of a Bong Joon Ho movie is his actual shooting method. Most filmmakers run scenes all the way through and shoot from multiple angles, giving themselves different options when it comes to editing. Director Bong does not work that way. He meticulously plans his movies frame by frame and knows exactly which angle he wants to shoot. He does not shoot anything he does not think he'll use in the editing room. He also communicates this to the cast and crew via the storyboards he designs. For many of his actors, this was an entirely new way of working.

"I remember him saying like, 'Okay, guys, by the way, we're going to shoot this frame by frame,'" Ackie says. "Me and Rob freaked out a little: What does that mean, to not go through the scene, ever, all the way through? Director Bong said give it five days and we'll get used to it, and he was so right. By the end we

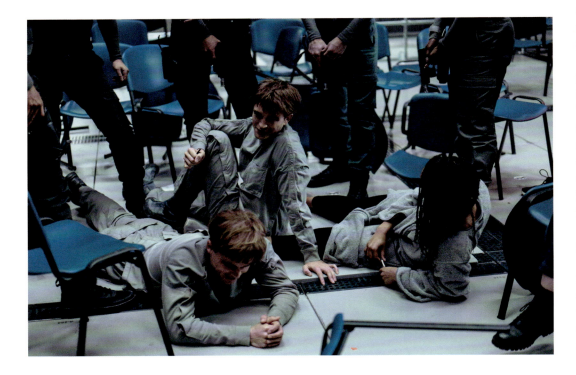

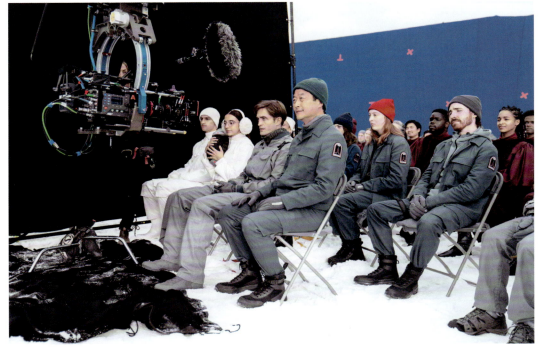

really talk to Director Bong about it. You're literally every day walking in with this snippet of this storyboard comic book and you're re-creating the comic book. It just broke it down into the simplest form, and I thank Director Bong for taking that on because a lot of that stuff is usually done on the day. But I think everyone was allowed to relax, and we stepped into just concentrating on that one thing because he held that burden himself.

"The biggest lesson I learned from Director Bong in this environment was about relinquishing control. I think it's so special that he allows actors to be contradictory within the same scene. There's something great in going from one person to the next and always moving, and there's never a master shot, so you don't have to follow a linear line of emotion. It kind of makes everyone seem a bit crazy. In one scene Nasha is being super quiet and intense, and literally in the next frame I'm like screaming at someone at the top of my lungs. You don't know how I got there, but she's there!"

The screaming really starts once the film reaches its centerpiece: the canteen fight. Until this point, Mickey 17 and Mickey 18 have reached an accord. They are sharing their life, their rations with the help of Nasha. But it cannot go on forever. After a dinner party at Marshall and Ylfa's, the film takes a dramatic turn. Mickey 18 sets his sights on ending Marshall. It all reaches a head in the canteen when Marshall summons everyone for a ceremonial moment: He cuts open a Niflheim rock and a Baby Creeper emerges from it. Followed by another. Two Baby Creepers and two Mickeys. That's when all hell breaks loose.

Almost every principal actor was involved in the sequence, which also required the stunt team and VFX team to work in harmony. For Khondji it was one of the most demanding sections of the shoot. "It took a week or more," he says. "There was so much going on. First, you've got Marshall's crazy ceremony and *then* the fight."

In the iconic "axe fight" in *Snowpiercer,* Director Bong created several minutes of thrilling, devastating action where the viewer never loses sight of the goal, the characters in the heart of the melee. The same goes for the *Mickey 17* canteen scene. Consider it orchestrated chaos. In some ways it's like a riot breaking out in a school cafeteria, with an increasingly unhinged principal, Marshall, watching over. The least threatening elements—the Baby Creepers—send everyone into a frenzy. What unfolds is a wonderful satire of a typical sci-fi movie moment when the monster is normally revealed.

The geography and choreography of the fight is so finely tuned as to have us rooting for Mickey 18 to shoot Marshall, while being acutely aware of the stakes and fallout if he misses and it is discovered that he and 17 are both alive at the same time.

Stunt Coordinator Paul Lowe had to make sure everything happened convincingly and safely. "This film was challenging because sometimes Director Bong is just very specific on what he wants," Lowe says. "Everything he wants like no 'crash bang wallop' stunts. He wants things to look real. So, if Naomi as Nasha has got to fight someone or punch someone, he wants it to look like it would in real life, not like a big movie fight, or something ridiculous.

"[For the canteen fight,] I think we had maybe twenty stuntmen, and there were lots of supporting artists around. Then we had to get the artist there. A lot going on. You also really have got to create chaos, but the chaos has got to be safe. So, we would rehearse in our area first, and we'd have bits of action that we can maybe set on the table there or someone else going over the table. And then, you know, it's a process; we come onto the stage. We deal with the actors first, and we go onto the stage and then we do it slowly with the actors. You make sure all that we've set can work in that position. You've got to perform and do something cool. And then, hopefully, you can watch the playback or watch it on the big screen, and it looks good. We had Naomi doing a whole piece with a gun and wrapping this guy's arm and putting him onto the table. That was a big day for stunts. Not a crazy stunt day, but like a lot of stuntmen and a lot of action going on in different areas."

This was meant to be Marshall's big moment. He is splitting the rock on a live stream, broadcasting back to Earth so his devotees can witness the event. "That's him at his best—what he would think is his best," Ruffalo says. "That's a high spot. That's Marshall probably most in control. There's a weird relationship with his wife; he's very submissive with her. That's a really wild relationship that we have together. But the cafeteria scene is the one moment where he's not with her. Whenever he's around her he feels insecure, but whenever he's not with her he's more in control and feels better about himself as a leader."

That feeling of confidence does not last long. What started as a showcase for Marshall's conquering of space and Niflheim descends into madness and embarrassment. Mickeys 17 and 18 are imprisoned, along with Nasha. One of the Baby Creepers is shot. The other, Zoco, is taken away to be experimented on. Zoco screams in fear, and at that precise moment on Niflheim, Mama Creeper and her hordes of babies look up at the sound. It is clear that Mama wants her baby back—and is going to do whatever it takes to get it.

It is during the prison scene that Timo really comes into his own. Blank sent one of his goons on the spaceship to kill Timo and Mickey, but Timo has made a deal to sacrifice Mickey and save his own skin. It's here that Mickey 17, 18, and Nasha start working as a team and manage to escape.

They all come together once again in the cycler room for what is perhaps the darkest stretch of the movie. Marshall is adopting a scorched-earth policy: He wants both Mickeys gone, dead, and has deleted the memory files for Mickey. After these two die, no other versions will be made.

"We were in this really smoky, steamy set," Ruffalo recalls. "They were using steam for smoke, so it was just very sticky. There were very intricate camera moves and there was a lot of dialogue, and Marshall's raging. And all the characters are assembled there. That was hard. That whole sequence in the cycler was particularly tough. That was probably the hardest thing because we were in that space for probably eight or ten days. It was very intricate, and there's a lot of choreography and movement in there. The shots were very specific. You had to modulate yourself to make sure that you were in sync with the camera, and it was a lot of working parts because all the actors were together there at one time. We were doing, you know, both Mickey 17 and Mickey 18 together in those shots. There was physical interaction, so everything had to be just perfect. So that was probably the hardest period for me to shoot."

TOP LEFT: Robert Pattinson, Naomi Ackie, and Sam Woodhams in between filming the moment when Nasha and the Mickeys are discovered and surrounded after the cafeteria fight.
LEFT: The final moments of the film. Robert Pattinson sits in between Stephen Park and Patsy Ferran.
ABOVE: From left to right: Darius Khondji, Mark Ruffalo, and Dooho Choi.

It is an intense, moody sequence, boasting a different color palette from the rest of the film, with the orange and reds from the furnaces lending the moment a hellish tint. "I remember this was a very difficult, challenging scene that took us a very long time to do because it kept on getting longer," Khondji says. "The scene had a lot of shots. It was a long, complicated, challenging one."

In the meantime, Ylfa has discovered that the blood from the Baby Creeper is a wonderful new culinary ingredient and is determined to get as much of it as she can. Turns out thousands of Creepers have congregated outside the ship after hearing the Baby Creeper cry. Her want plays perfectly into Marshall's frame of mind. He hatches a plan. Mickeys 17 and 18 will descend to Niflheim with one objective: The first one to collect a hundred Creeper tails for Ylfa will live. To give them an added incentive, remotely controlled bomb vests are strapped to their chests.

The two Mickeys are sent out into the snow to face the mass of Creepers who have come for Zoco. It is the climax of the film, with an enormous battle sequence unlike anything previously attempted in a Bong Joon Ho movie.

"We prepared that scene from the beginning of pre-production," Director Bong says. "At that time, we already knew that sequence would really be quite challenging, so me; our production designer; Dan Glass, our VFX supervisor; and our first AD, Ben Howard; and our line producer; we were all very concerned about the sequence, and from the beginning we did so many discussions and meetings. We prepared quite obsessively. It was quite intense."

Choi explains that they were able to create a Niflheim that would look real for the actors. "The walls are all like white curtains, and then in post, Dan Glass is putting, say, a spaceship or like a little mountain range in the background. And then obviously the Creepers will be inserted digitally, but pulling that off was challenging. Director Bong was very meticulous; it's just things like coordinating vehicles in that space, resetting, getting everything to look right."

The big battle scene in the snow was quite challenging, Khondji confirms. "We did a bit of a snowstorm," he says. "Dom Tuohy was absolutely another great person on set. He was very, very good at doing these large amounts of sections of snow, then Dan Glass was going to add the rest. We did some snow actually going onto the actors and the camera, and then Dan was going to enhance the rest."

With much of the movie set within a very restricted and restrictive environment, the climactic battle takes place on an immense snow field. In many ways, the scene opens up the film, spilling out into this massive cathartic expulsion. Yet, despite the vast number of Creepers, the carnage, the blizzard, and spaceships in the background, Director Bong and Khondji keep the stakes and the emotion of the film centered on Mickey.

"There was a lot," continues Khondji. "There was fire, explosions, a lot of creatures all around. There were three cameras shooting. It was a lot going on at the same time in Cardington. Everything is around Mickey. Mickey is the one. It was fantastic, the way we worked with shooting Mickey 17 and 18. I loved it because I thought it was going to be so much more technical and boring and annoying and very slow. And Dan Glass made us shoot it in a very nice way, so it was never very long to shoot. We went through it quite quickly considering the difficulty of the twinning, and from what I saw it is very successful. The twinning is very good."

Nasha and Mickey 17 manage to get Zoco back to the Mama Creeper. Mickey 18, on the other hand, captures Marshall, and makes the ultimate sacrifice. He presses the detonator to activate his own bomb vest. In the last second of his short life, this more confident, brasher Mickey briefly resembles his meeker predecessor. Then he is gone, and Marshall is gone. The humans and Creepers can now begin to start building a peaceful coexistence.

Mickey 17 is filmmaking on a grand scale, but the storytelling is as intimate as anything Director Bong had made before. It was the largest crew he'd worked with yet, but only what was needed to tell Mickey's story.

LEFT: "Any creature has its own challenges, of course, because you inherently know it's not real. You've sort of got an uphill battle from the get go." Dan Glass, VFX Supervisor

EDITING

Editor Jinmo Yang is one of Director Bong's closest collaborators. He was the on-set editor on *Snowpiercer* and then the editor on *Okja*. Their next project was *Parasite*. It was here that they refined and perfected their process.

The shooting and editing system Director Bong and Yang have created is extremely rare in filmmaking and all but unheard of in Hollywood. It is well known that Director Bong storyboards every frame of his movies, and he gives these to the cast and crew to work from. Yang knows what he will have to work with because it is planned in advance, as the storyboards directly inform the dailies.

During shooting, Yang sits at his monitor with Director Bong's storyboards in front of him. He cuts and edits in real time, composites overnight, and the next morning presents a rough assembly of the previous day's footage. To serve the evolving movie even more, Yang even puts music where necessary to the rough cuts. The goal is to enable him and Director Bong to find the pacing and tone at such an early stage. For the *Mickey 17* "sneak peek" teaser that went online in early 2023, Yang chose the music. It was initially something different chosen by the film's marketing division, but Yang wanted something that better suited Director Bong's style; in his words, "Classical, but felt intimate and personal. Beautiful and different."

Bong Joon Ho and Yang's efficient style and creative shorthand resulted in *Parasite* being nominated for Best Editing at the 2020 Academy Awards, in addition to the four Oscars the film took home that night. The pair's meticulous organization gives them the ability to show the team how everything is working in real time and that all is going according to plan. This process was eye-opening to new members of the troupe.

"We're just shooting the storyboard. And we never really run the whole scene, not even for coverage," Ruffalo explains. "I've never worked on a movie that did that. It was actually an interesting way to work, and once I understood how it worked, I really kind of enjoyed it. You're really focusing on one moment, and he'll have a very complicated shot within three lines that you just have to nail, and there's no other way to do that except by just shooting the panel, the one panel on the storyboard. When you get your sides in the morning, it's the storyboards with your lines on them. You're actually given a movement instruction and you understand how the scene physically plays out, not just from the stage direction and the lines you have but also you understand what the camera's doing. You can get very specific and crafty with your interpretation of it.

"Generally, I don't look at stuff I've shot," Ruffalo continues. "I mean, I did a couple of times because Director Bong asked me to, but I generally don't like to look at stuff just because I could get too self-conscious. But I would look at other stuff. I saw everything they'd shot up until the moment my character shows up, which was about probably 40 minutes into the film. They'll cut it down, but they had a 40-minute assembly or maybe 30-minute assembly. By the end of the day, they've cut whatever you shot. And that's it, you know? They'll tighten it and do everything they need to do later, but what you shoot that day is what is gonna end up in the movie."

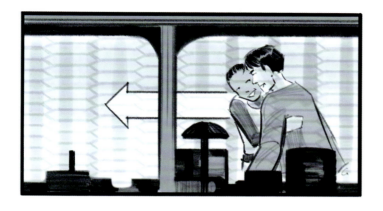
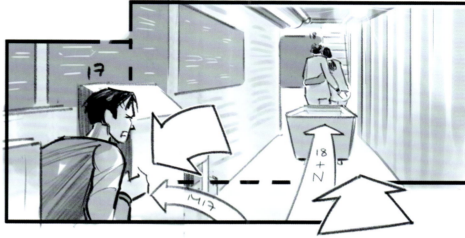

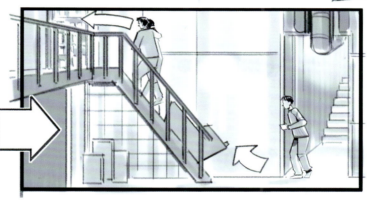
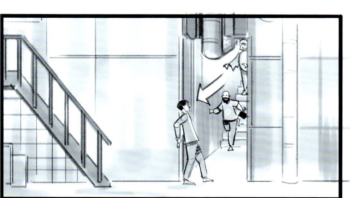

THIS PAGE: Storyboards and concept art showing the set titled "Hallway Staircase Corner." The film features many staircases, hallways, and corners, and this was an important example of all three. Dooho Choi explains how this set was constructed in a particular way: "We didn't want it to seem like we were reusing the same sets over and over."
BELOW: Visual render of the hallway featured in the above storyboard.

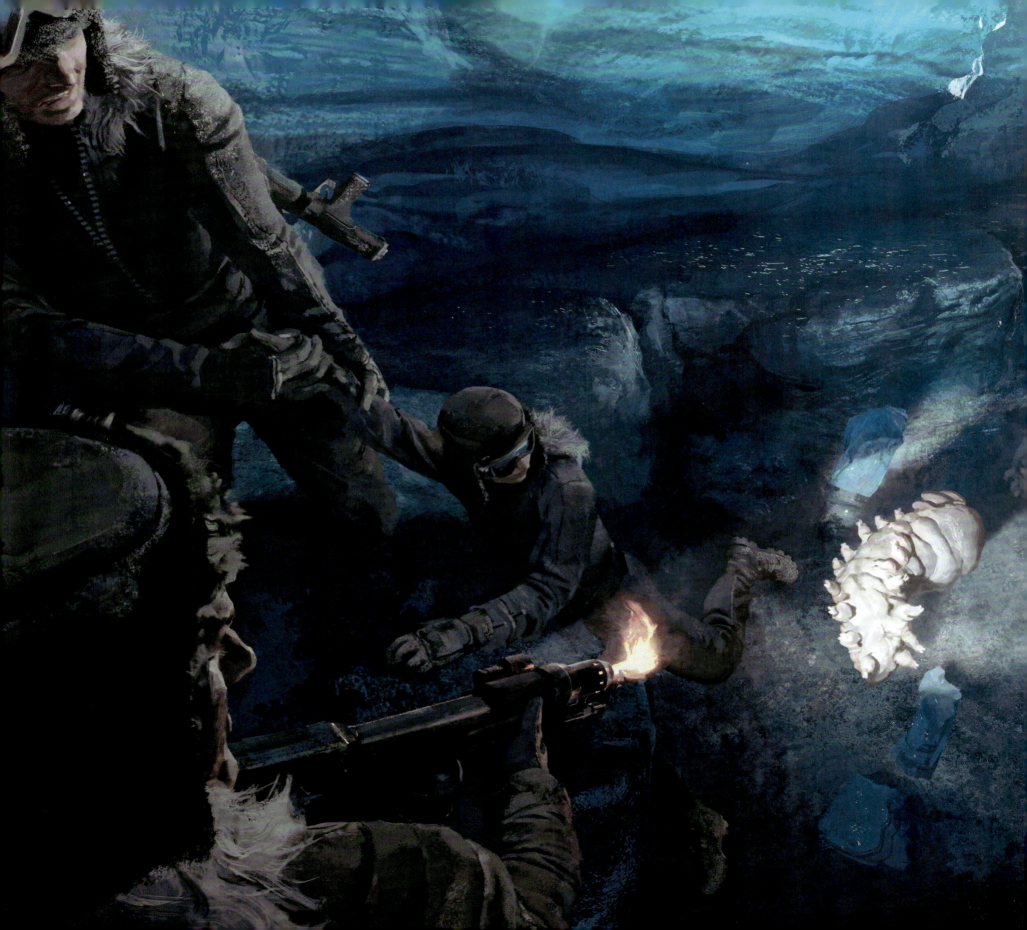

VISUAL EFFECTS 5

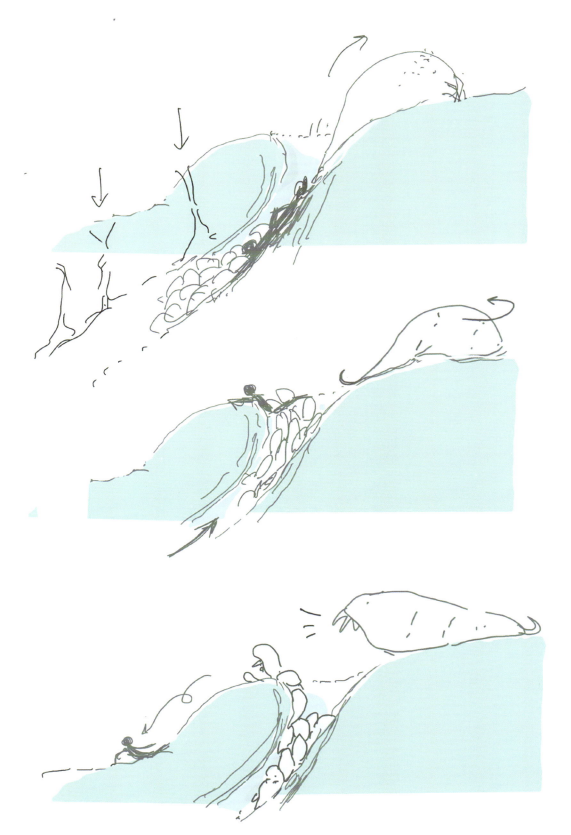

THE CREEPERS

When it comes to depicting the native species on Niflheim and their role not only in the story but the entire production process, it is necessary to go right back to the beginning.

Mickey 17 is lying in a crevasse on Niflheim, the alien planet they have not long ago reached. This is a hostile place filled with unknown dangers. Known dangers also lurk, such as the creatures approaching him while he lies powerless to defend himself. He knows he is about to die.

The audience knows this too. We have been conditioned by a long list of science-fiction films, books, and stories to fear strange creatures on distant planets. But this is not a straightforward science-fiction film. This is a Bong Joon Ho film.

The bizarre creatures—dubbed Creepers—do drag Mickey away. But then they deposit him on a snow field, from where he can safely return to his ship. This unexpected act, among other experiences, helps Mickey reach new understandings throughout the film, about himself, about life—and about the Creepers. Subverting the audience's expectation, by having bizarre, native species perform an act of kindness, was present in Edward Ashton's original source novel.

"Ordinarily, in a movie like this, such as *Starship Troopers* or something like this, you have these sort of horrifying insectile monsters," Ashton says. "They're soulless, godless killing machines. They're coming to destroy us all. I wanted a species that looked like that, that looked horrifying. I think as humans, we have a natural sort of aversion to things the further away from us they get in terms of appearance. So, mammals, we think are cute most of the time; even dangerous mammals like a tiger [are seen as] beautiful, majestic. You know, nobody thinks a scorpion is majestic. The more unlike us things become, the more frightening they become, and so I wanted something that was very unlike us and very frightening, but something that was not actually a danger, something that was in fact intelligent, something that perhaps wanted to coexist with us. Then obviously the task of the book is to learn how to do that."

This also becomes a beautiful dynamic for the movie. It is easier for Mickey to find commonality and rapport with weird insectoid beings—the Creepers—across the universe than reach that same understanding with some of his own kind.

126 THE ART AND MAKING OF MICKEY 17

In the script, the Creepers are described as having "croissant-shaped bodies with legs on every segment like centipedes." Throughout the adaptation process, Director Bong had been refining how the creatures (not monsters) would be visualized onscreen.

"In the original book, the description of the Creeper is kind of a centipede," Director Bong says. "But my imagination was slightly different. My approach was a moving croissant. The croissant shape—I don't know why, but I love croissants so much, and from the very beginning that was the starting point of the creature design."

Storyboard Artist Alex Clark was brought in to help develop the concept. "Doing all of this stuff with the Creepers, I really enjoyed doing that," he says. "I found it quite fun working out how all the creatures moved, trying to incorporate some of the personalities of how they move and interact with Mickey, drawing inspiration from puppies, or croissants, and things like this. That was a lot of fun, and there's a lot of sort of humorous moments in there as well. Mickey doesn't know what's going on; he's being sort of dragged around by these big, fluffy, weird alien things."

For that moment of Mickey being pulled away to unknown doom, which turned out to be his salvation, Dominic Tuohy and his team came up with a handy, practical solution. "We made a rig that went on a tracker," he explains. "I think it was a 22-degree ramp and it was undulated, as if the Creepers were underneath. So, we did this puppeteered rig on servo motors that gave us this kind of movement as we pulled it up a track, and CG will put the Creepers underneath, kind of pushing them. Robert Pattinson rode that rig. He was happy to do that."

THIS SPREAD: Sketches and designs for the Creepers and one of Mickey's early interactions with them. Bong Joon Ho worked with artists and the VFX department throughout pre-production, into the shoot, and beyond into post-production to bring them perfectly to life.

VISUAL EFFECTS

127

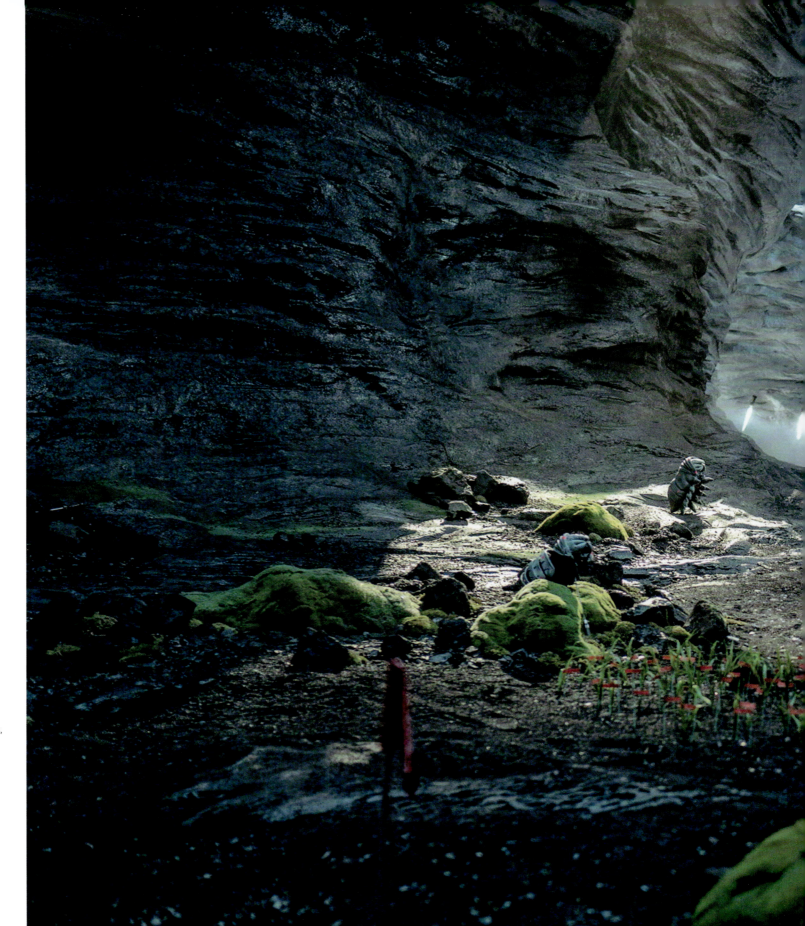

RIGHT: Filming the scene where Robert Pattinson converses with Mama Creeper. This was shot late in the schedule and, Pattinson explains, he was still exploring the character even in these latter stages: "The script is very specific. I was still just bringing up questions like: Who is Mickey? I think it's what attracts me to a lot of these parts. I was still trying to define exactly who Mickey was, even when we were doing ADR (automated dialogue replacement) now."

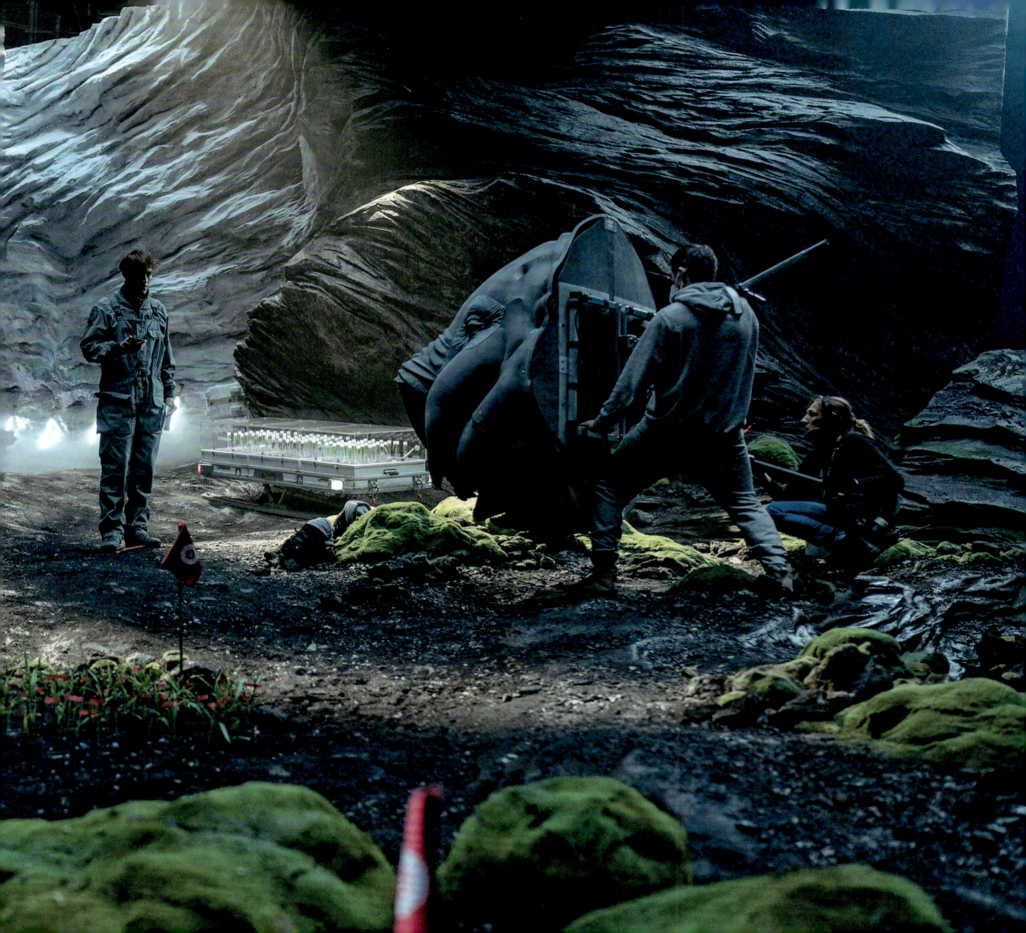

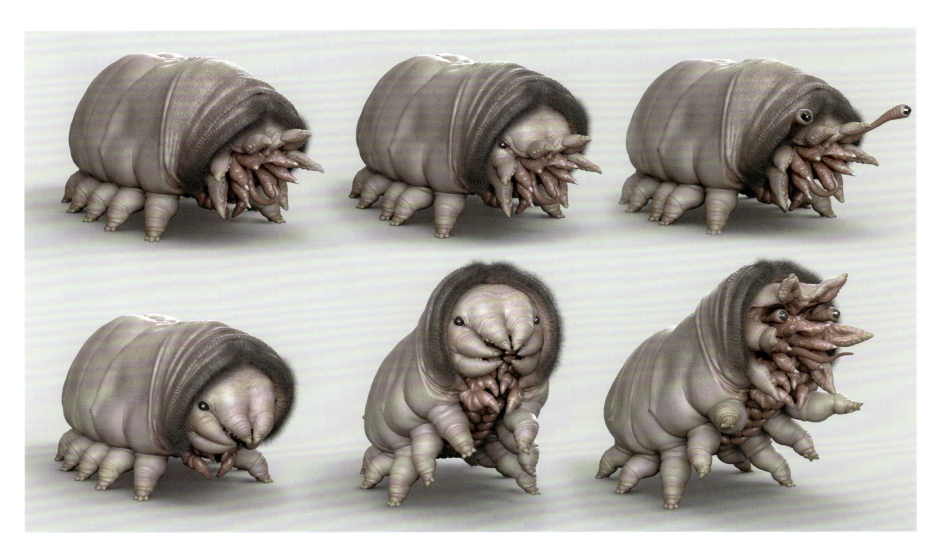

The creatures in Bong Joon Ho's films are unique. The giant, mutated fish that emerges from the Han River in *The Host* is not evil but rather a product of its circumstances. The genetically modified super pig Okja is by no stretch of the imagination a "monster" but lives and dies at the behest of the humans around it. Onscreen, both of these creatures are extraordinary to behold, with a character of their own, a personality and quirks that only Director Bong would bestow upon an imaginary being.

"How do you sell something to people that they know is a CG creation?" Glass asks. "There are various things that help a lot toward that goal. Part of it is Director Bong's process: He loves his creatures. He wants to understand them. They're part of his acting crew, you know? They're there. They become, in a way, real in his mind."

To help design the Creepers, Director Bong called on the same artist who visualized the Host and Okja, Designer Jang Heechul. "I sent the very simple drawing of the croissant to Hee Chul," Director Bong says. "We have three different kinds of Creeper in the movie: Baby, Junior, and Mama Creeper. Junior and Mama are quite similar to the croissant shape, but Baby Creeper is slightly different because it's a baby. Baby Creeper is very lovely, adorable, cute, and looks like a small kid wearing a very hairy and furry coat and hood, which is very lovely. It is invented and made by Hee Chul. His idea and approach is so great. It's very nice, very unique, and strange. Strange but in some aspects the design is very lovely. It was quite a challenging job because in the beginning part of the movie, the Creeper looks creepy and disgusting and scary. But in the middle or later part of the movie, it must look quite lovely, friendly, intimate. The Creeper must have those kinds of two different qualities, and Hee Chul did it so well. He never makes me disappointed."

ABOVE: Concept art showing Creeper movement. Dan Glass explains how the Creepers can rise up to vocalize and then fully rise up onto their back legs for their screaming "ululation."

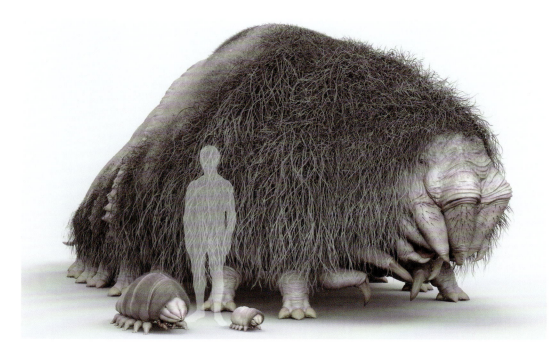

"In February or March 2022, we already had a basic design of the Creeper, which is a very, very important character in the film, and very important to design given the challenging look of the creature."
—BONG JOON HO

TOP: An early concept from Jang Heechul showing potential relative sizes of Mama Creeper, a human character, a Junior Creeper, and a Baby Creeper. In the finished film, the Junior Creeper was actually larger than pictured here.
RIGHT: Storyboard art for Mickey among the Creepers—Bong Joon Ho's beloved and inspiring croissant shape never more evident.

Glass describes the artist as an amazing one-man band who constructs in 3D, along with rendering and adding details and textures. "But beyond that, Hee Chul also thinks about how this creature came to be, how it eats, shits, etc. Through this, they have a sort of backstory. When I came aboard, the designs were very advanced already. Hee Chul doesn't do them in 3D, but they are almost like sculptures. They've kind of built us 3D sculptures and had photographs taken from that. Director Bong had worked with him, and they'd been able to understand the proportions not just of the Creepers themselves to each other but also to humans. They had suggestions of how they move, and that's really where the first part of my process with any creature comes in. To say, okay, that's beautiful, awesome, but there are often things that you learn as you start to move the creature—having it emote, walk, run, whatever—that can lead you to other input on the design. The actual evolution of the design isn't complete until it's in motion. And we call that an R&D process or 'look development.'"

When it comes to movement, the Creepers do indeed have a signature way of expressing themselves. The digital effects team explored and experimented with many options and still made sure to keep intact the logic of the movement.

"The most fantastical is the moment of ululation, where they actually open up," Glass explains. "The ululation is its own kind of special thing: They go into this terrifying, screaming pose, opened up, with legs and tongues flailing in the air. These creatures are almost like giant mealy bugs, where they kind of have an outer shell. It's not as rigid as an exoskeleton, but it's more like a rhino. The young ones are a bit more flexible. But it's this kind of outer, toughened shell and then multiple legs. But that thing can all open up and expose this inner set of teeth and claws. That is quite horrific.

"There's a lot of figuring out how that really works. You pose the creature and then say, 'Okay, but now how did that actually happen?' We got into doing a lot of movement studies and animation studies to understand that. How does the thing run? Because when you've got that many legs in the game, they get in the way of each other very quickly."

One of the defining, and often praised, characteristics of both the Host and Okja is the perceived weight of the creatures. Onscreen, they lumber or stagger, they tumble into things and have a "real," authentic interaction with their surroundings. For example, Okja the pig leaps into a lagoon, or the Host rampages through the citizens of Seoul on the banks of the Han River. The digital effects team on *Mickey 17* strived to sell that same type of physicality for the Creepers in a world covered in snow and ice.

"That's actually a really interesting part of it," Glass says. "In Hee Chul's mind, these creatures were very light. The closest kind of origin comparison for him is insects, perhaps aspects of birds, in terms of their lightness, but they don't really have a skeleton, in theory. So, they're really hollow inside and light. The problem is that if you then animate them to be that light it looks like bad animation. Ultimately, we've had to convey them as heavier than Hee Chul intended. They kind of need to feel the mass that you picture. They're in snow, so you need to film them sinking in the snow."

The believability of these creatures is fundamental for the film to work. And that starts with the actors. Audiences must buy into the notion that the actors are interacting with a real creature. There is a misconception that digital effects only join a film during post-production. For *Mickey 17*, Glass worked on the Creepers from the beginning, getting them as prepped as possible before the shoot.

"I love that part of the process because I feel it's like really getting to know your character, and I think it's so important to get done early, so that you can at least show people what they're going to be looking at when they're acting against it. If you can actually do some little tests of these moments, they can understand that particular beat of what's happening."

When it came to the shoot, it was decided the best way to have an actual embodiment of the Creepers on set would be to use tricks that the team had experience with in the past. For Okja, segments of the super pig were built as substantial but lightweight "stuffies" that could be on set, on location, on camera, doing an approximation of whatever the script said Okja was doing, as well as—vitally—giving the actors something to play off.

The team constructed similar systems to create the Creepers, Glass says. "We built some physical puppets to kind of work within sections as eyelines. We built the head of Mama — Mama's enormous—and we built her head and we put it on a stick, and we approached some puppeteers in London. They do a lot of the Fantastic Beasts movies, and this team can come in and puppet stuff around, so people have an eyeline to work with the camera. Talking to them off the bat, they said that the gold standard they use for how to do this is Okja, so that was cool."

THIS SPREAD: Tests for Mama Creeper. The challenge for this creation was twisting expectations: something that can look scary and also cuddly and approachable—and believable.

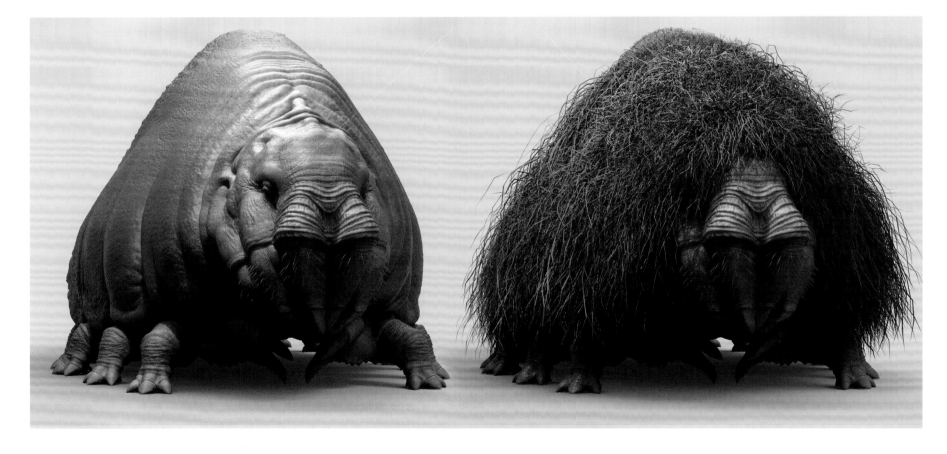

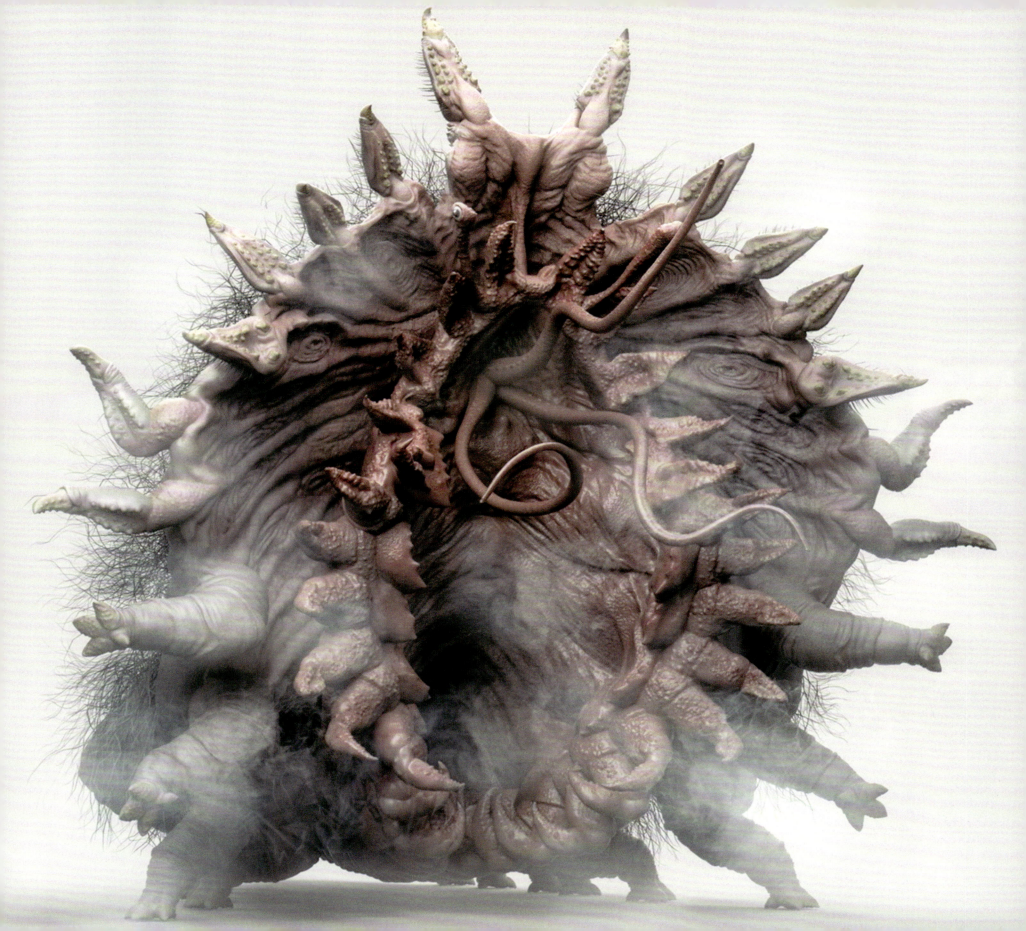

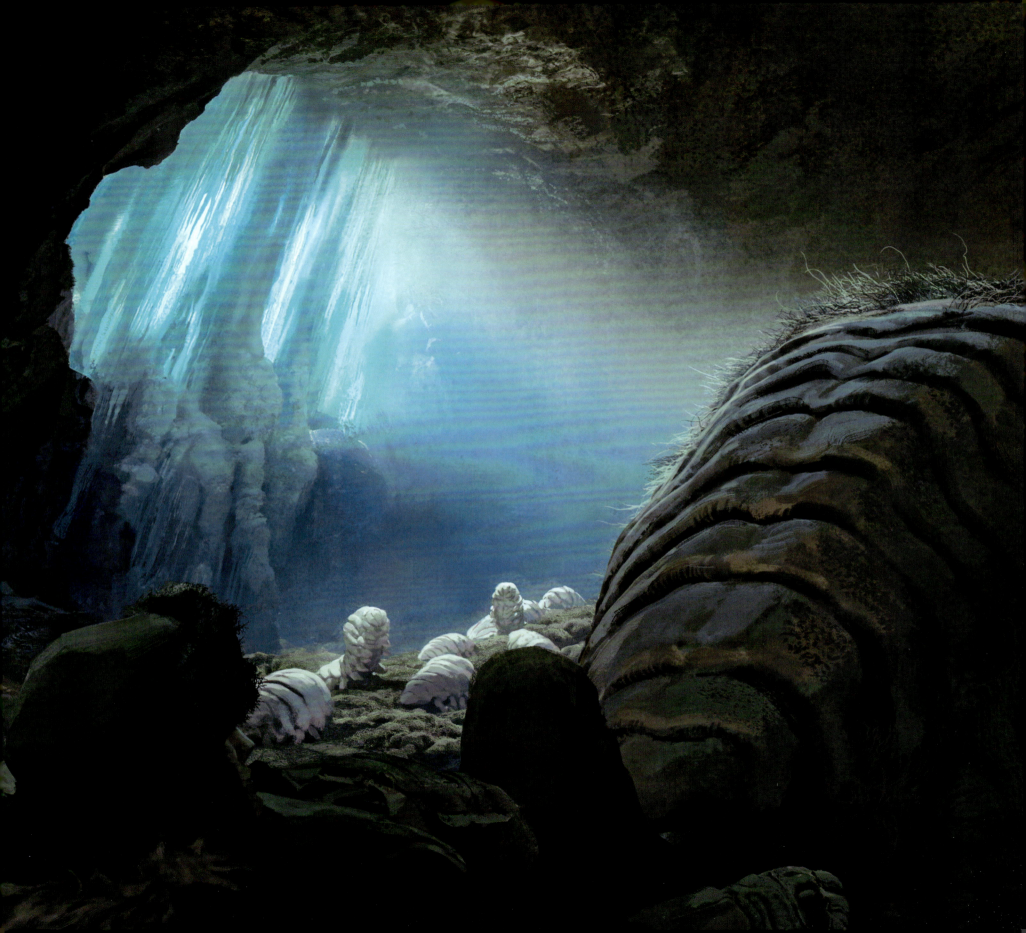

MAMA CREEPER

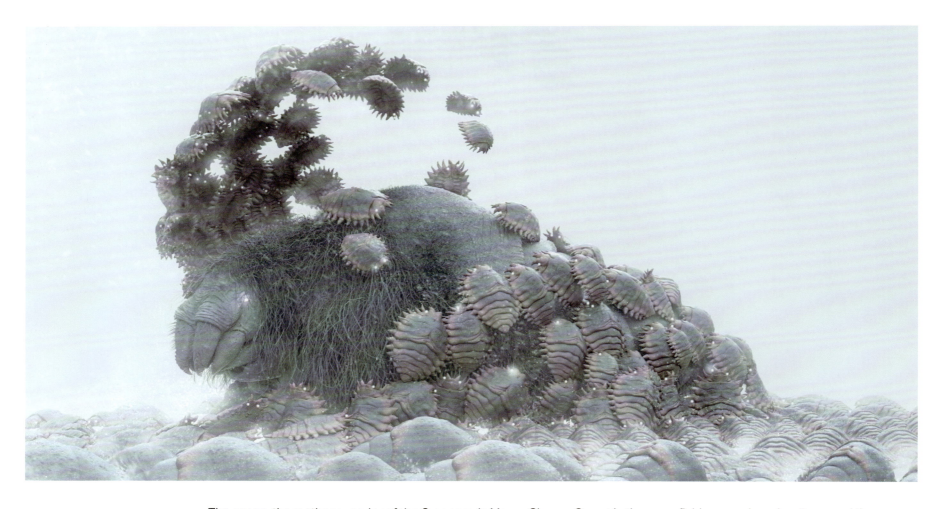

ABOVE: "I really want to see how the Creepers turned out. I actually got given one little kind of Baby Creeper puppet. We obviously saw incredible, like, drawings of them and artwork, but to actually see them and interact was really weird. They're pretty cute—they're a little bit cute. And they're a little bit gross." Naomi Ackie

The queen, the mother superior of the Creepers, is Mama. She looks formidable, she sounds formidable, but any fan of Bong Joon Ho's movies should know better than to judge a character purely on first impressions. The most important aspect of Mama's character is that she is a parent, a loving one—a universal trait. This gave the filmmakers, voice actor, and visual effects team a challenge: how to make a so-called alien creature emotionally relatable.

"For our Mama Creeper, we had three puppeteers," explains Dan Glass. "One was holding the head and two for the kind of frame that went off the back. And they were awesome because they really got into the movement, the weight, and how she kind of walked along. So out in the snow field, we can have her there, and the camera knew what to frame for and the actors knew where to look."

To further communicate the reality of any digital effect onscreen, there needed to be an authenticity in how they inhabit the world they're in. This includes weather and the light, something the filmmakers had to consider in the imagined world of Niflheim they were creating.

"What we did there is basically build a section of hide," Glass continues. "We built a patch of Mama's skin that was rubber polyurethane and painted, then we added some hair in certain places. We would literally carry out this hide with us, and when we do our visual effects balls and spheres for lighting reference, we

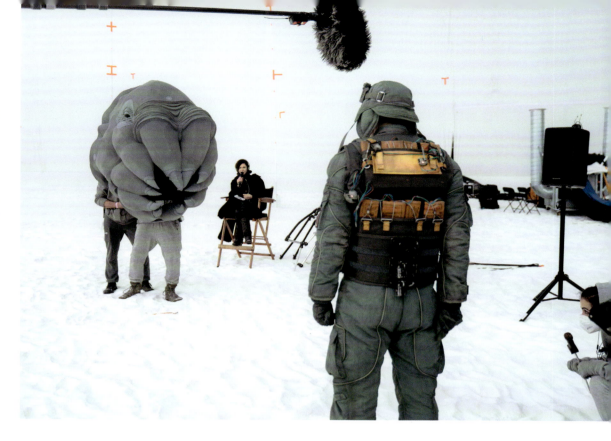

can have the hide there and hold that in and give an effect for lighting. Those things are super, super important. I think even the most skilled lighting artists in the world need a reference; it gives you something to dial up to. Importantly, it's when everybody's looking at it after the fact that these things can be a bit subjective, but you can say: Here's what it actually looked like in the light."

The final flourish needed to bring Mama Creeper to life was the voice. The Creepers are sentient beings that talk to one another and, eventually, with Mickey. The tech team on board the ship creates a transmitter that takes the sounds emitted by the Mama Creeper and translates them into English. As well as being a key plot point, it is a necessary way of underlining the film's themes of communication and understanding.

"In the later part of the film, there is a conversation between the protagonist Mickey and Mama Creeper, which is very, very important in the movie, and very significant," Director Bong reveals. "Almost everything is there in that conversation. The implications are quite menacing. I really enjoyed writing their dialogue. It's a very short dialogue but simple, short, and very strong, I think. The Creepers are the so-called natives to the planet. But from the point of view of Kenneth Marshall and Ylfa, they despise that creature so much. They call it this dirty, creepy insect, but actually they are very advanced and very profound, even very diplomatic. Diplomatic creatures being native to the planet, that concept makes me excited."

With this dialogue between Mickey and Mama Creeper so crucial to the film, finding the right actor to bring a croissant-shaped alien species to life was key, Director Bong says. "Mama Creeper's voice is very, very important. I was so lucky. When I did the jury job on the 2021 Venice Film Festival, *Happening* won the Golden Lion, and Anna Mouglalis was the abortionist in the movie. She did such impactful, very, very impressive work. We brought her in to be the voice of Mama Creeper. Anna does such a great job. Our sound crew members were so shocked when they heard her voice for the very first time. There was no effect or filter. Her voice was already kind of very hard to believe."

"I had planned to have this sound booth on set for when we shot," says Sound Mixer Stuart Wilson. "But the first scene Anna did, they wanted to have her in the place where the Creeper would be for Rob's eyeline. He would be interacting with her, although there was a model of the Creeper that he would be looking at, so that was interesting to start with. This was the two characters interacting. And this was what we wanted to be in the movie. This wasn't just a temporary thing. I had to insist that Anna would go into the sound booth, so we brought it in on a forklift and put it right close to where the director could go between the two actors and give notes and discuss. And then Anna would be in there, and we could capture her performance because the performance she was doing at the time was the real deal. She has a lower, rich voice anyway, but for this character she brought it down even more. That was amazing. I mean, I've never heard a voice like it. It sounds like she's already been through some kind of processing in post-production, but she's just for real. She has an extraordinary voice. For her position on set, we brought in a speaker, which had a good low-end response, to give Rob that dimension of the sound that he was interacting with. But at the same time, we were recording her in a clean way that would be usable in post-production."

ABOVE: Filming Mickey conversing on the surface of Niflheim with Mama Creeper. Beyond the Mama puppet is seated Anna Mouglalis, performing the dialogue on set in Cardington in order to aid interactions with the other actors.
LEFT: This is the translator device, created to enable communication between the Creepers and the ship's crew. It is used by Mickey to talk with Mama Creeper—this bridges their understanding of one another.

ZOCO

Life is disposable in Mickey's world. His life hasn't mattered, and for Marshall and Ylfa, people and the Creepers are valued only by their usefulness. And yet the story comes to hinge on the importance of one life: Zoco's. The difference between Zoco's living and dying is the difference between war and peace. And by saving Zoco's life, Mickey has finally given his own life meaning.

Dan Glass explains the physical props they used for Zoco. "They're all really interesting creatures to work with, but the Baby especially was," he says. "From the outset, we knew we needed it to be both terrifying at moments, and you can understand why Marshall and others want to eradicate the species, but then there had to be a way that these things can also be appealing and cute, and the babies are key to that. They are definitely the cutest of the bunch, and you kind of want to coddle them. They're designed to be the size and weight of a small child. That was Director Bong's thought process. So, I felt that we really needed a really good prop, not just a 3D-printed solid shape. I

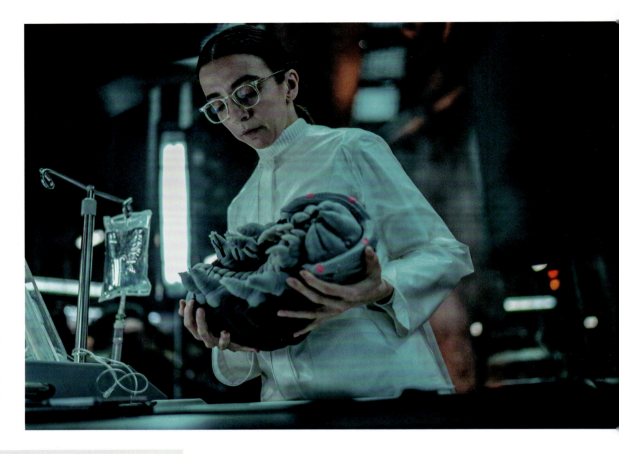

said I needed something that was articulated and weighted. It had to be the real weight, the three and a half kilos or whatever it was. This amazing company built us the Baby Creeper.

"The face—the mandible at the front—is solid, it doesn't animate, but the body is just literally a kind of a sack that was weighted, with little legs that float. The actors could carry it, and it was heavy. They would be shooting a take, and I could tell it was the wrong one. They'd have the light one, just for practicing with, and it doesn't look right. So, we'd swap it out, and you feel the actor adjusting to this real weighted prop. That's what it has to be. If you're holding this thing and there's no reaction, it doesn't look right. So, the weight was very important and the ability for it to flop. I think it's really helped us as we put in the digital one. We feel like it was there."

LEFT: A test of how a Baby Creeper could be rendered onscreen. Famed VFX house Framestore did crucial work on Zoco, under guidance from Dan Glass and his team.
ABOVE: A final film still showing Dorothy (Patsy Ferran) cradling Zoco. Dorothy becomes one of Mickey's allies on the ship and understands the importance of coexistence with the Creepers.
RIGHT: A Creeper made by the VFX department, on set and ready for action.

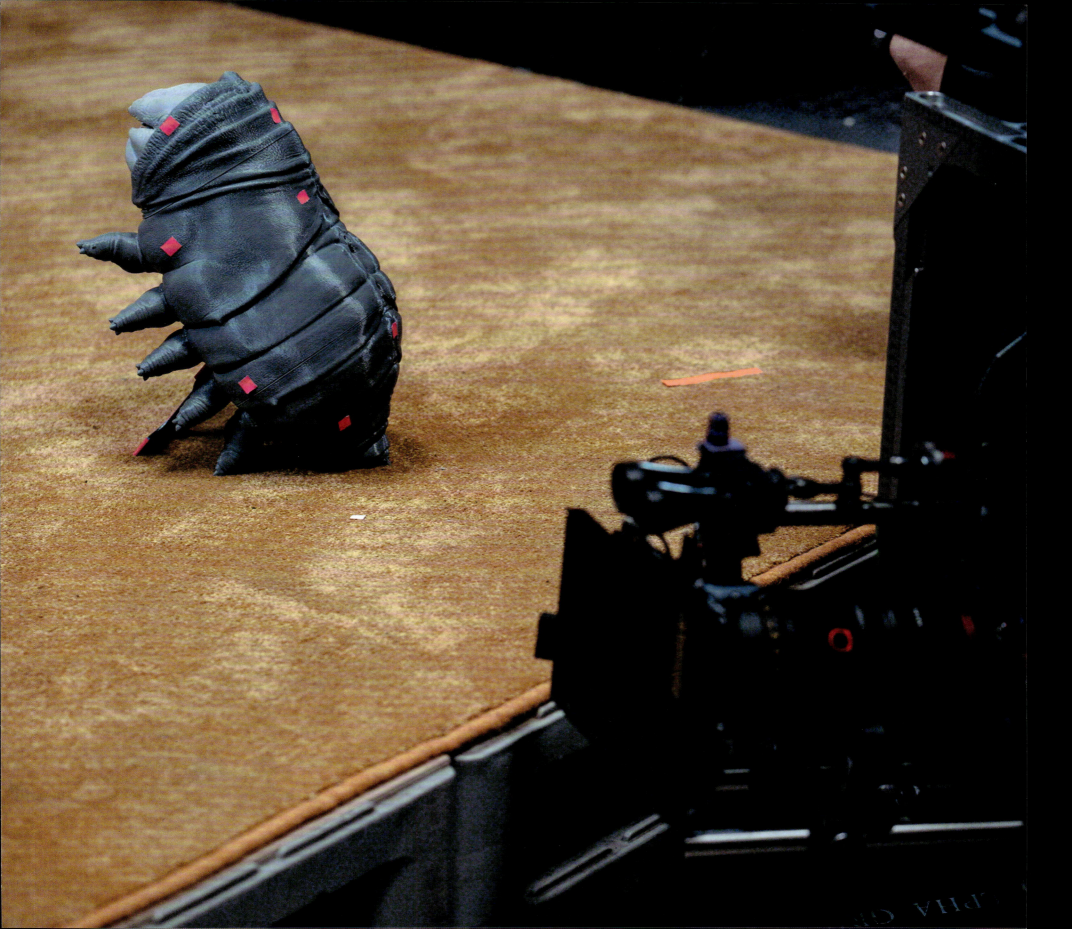

POST-PRODUCTION

Filming two Pattinsons posed challenges for the crew and Robert Pattinson himself. The technical artistry of two Roberts, two Mickeys, interacting within the same frame needs to be exact. For this, the digital effects team used a combination of tried and tested methods for "twinning" as well as utilizing the bleeding-edge technological advancements at their disposal.

Even though this is a long post-production process, a lot of the work was done during the shoot, Glass explains. "They've made a lot of movies that have done identical characters playing against each other. The really simple version is: You lock off your camera, shoot one actor, then move the actor over to the other side. It can become pretty evident how you've done the trick very quickly. But I would say that Director Bong's style of shooting is not far from that. We've done plenty of those in the film—split screens—and I don't think it pops out as much. But there are moments where something more sophisticated was definitely going to be needed. That's where we looked into a technology that was really complex and impressive.

"What we've done a lot on this movie is that there are actually multiple solutions within a shot. Sometimes it's a bit of split screen. Sometimes it's a bit of CG bodywork. There's a whole mixture of ingredients going into pulling it off. I personally love approaching things like that because I think it makes it much harder to figure out if there's no obvious thing coming to mind of how it was done. I think hopefully it helps you forget about it and you kind of just accept it.

"The CG human is the most flexible in terms of you being able to move your camera. You can have them do what you want; they can even interact with somebody. You can have a real actor but then replace the head or face with CG, for example. But I think it is so phenomenally hard, if not impossible, to really re-create all it is to be human. It's like the way that light kind of travels and bounces through underneath your skin, like the way that all the subtle muscles move in the skin. The blood flow changes as you do different expressions. The amount of stuff that you have to kind of factor in there to really sell it. . . it's really, really hard. It's really looking at something and trying to understand, What is it that makes that look like and behave like and feel like somebody or something? It's my job every day to look and say, 'Okay, what is it that doesn't feel right? Is it because the texture of the jacket doesn't feel right?' I'm analyzing in my own head.

"What that kind of led me to do—and luckily Director Bong and Rob and the first AD, Ben, got very much behind it—was that we made sure that Rob did the second performance every time. We basically shot twice or more. Because we would get him to do the scene and we'd have to choose which was the lead performance. Basically, the performance that drives the camera and the main interaction in the scene is the one that you do first, and then you have to swap into the second position. Sam was our acting double cast to be Rob. This was also a really, really important role as Sam had to learn to be Rob. He needed to be very close in stature and body structure and appearance. A lot of times, what you're hoping to do is keep the body of the double and just replace the face. But we would still always swap them and have Rob do both parts.

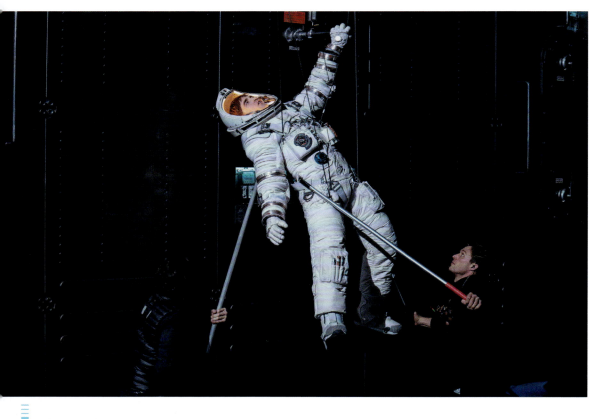

140 THE ART AND MAKING OF MICKEY 17

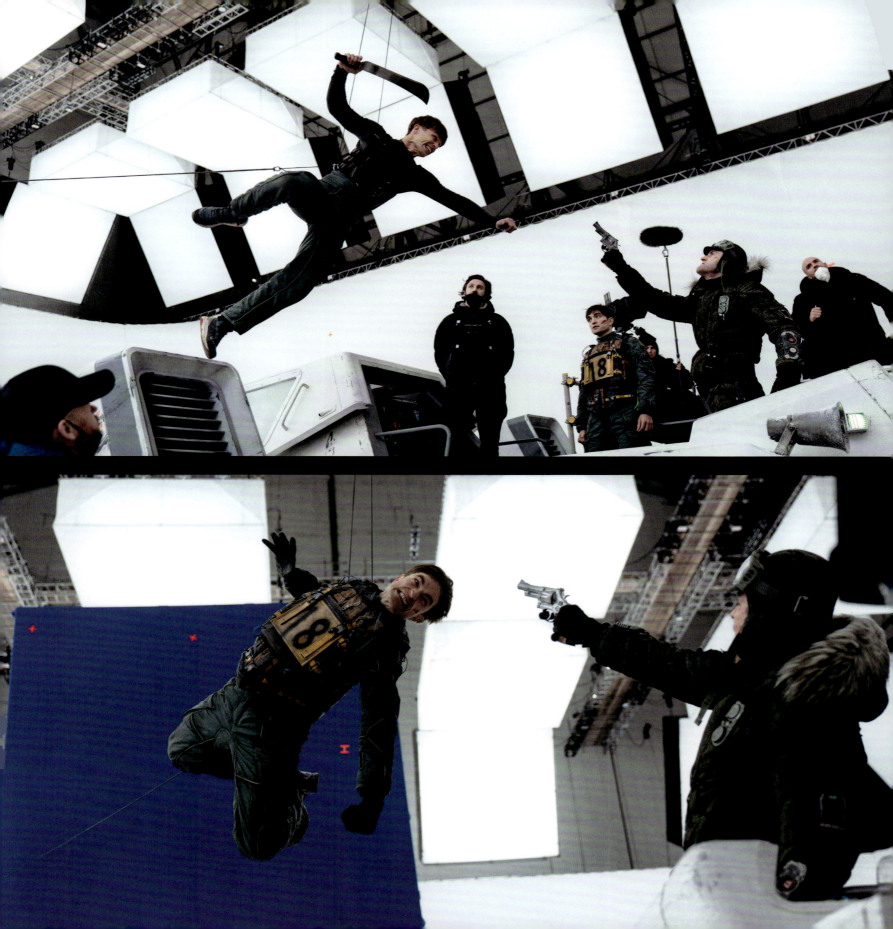

"Additionally, we bought a specialized rig from Germany that I had been developing and used on *The Matrix Resurrections* for different purposes. This grew out of the single volume capture technology where they basically put cameras all around, and then they film somebody doing something and you can create a version of your subject matter in 3D, but it's not really 3D. You don't necessarily get geometry. You're like a shaper. It's basically looking at pictures when it's got enough cameras around and it can interpolate between them. That's what volume capture is—it captures the volume. We took a rig on *Matrix* that pared that way down. We had to be very nimble on that show and not get in the way of anything during the normal procedure of shooting.

"We built it with like eight or ten cameras, and I thought if we brought that rig over then whenever we were in a given scene, like Mickey's bedroom or in the cafeteria, when we were going to need this twinning work, we bring the rig in and we shoot Rob doing the expressions and doing the performances with that rig. You suddenly get eight or ten different angles of that performance in the lighting at the time. We've got all the information and references we need.

"The biggest thing is I didn't want to restrict the way Director Bong wanted to shoot, as well as his blocking and his actors. That's why we had to research to figure out what was in our toolbox. We actually set it up that way with the crew as well. We went through with them these four or five different approaches for twinning, saying, 'We're typically going to tell you which one it is for any moment, but if the setup needs something different, we can switch. What we're not going to do here is saying don't do this or that.' It's a question of just really trying to respond in the moment and let them continue to film a movie they wanted to make."

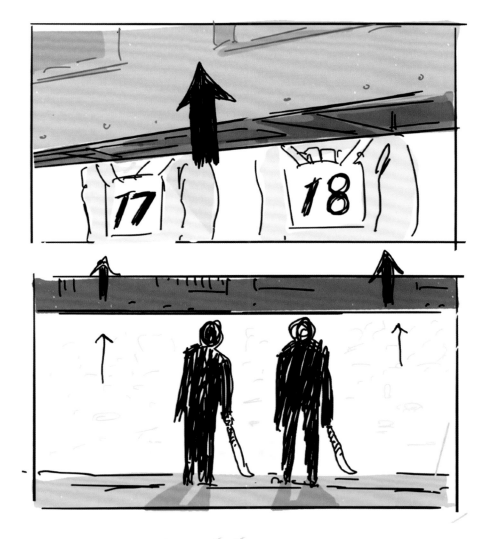

LEFT: The full-scale Mama Creeper maquette. This is a 1:1 ratio for Mama herself.
THIS PAGE: Bong Joon Ho's simple, soulful storyboards showing Mickeys 17 and 18 finally having become something like brothers.
OVERLEAF: Another of the Jaime Jones concept designs, this one showcasing a bound Mickey as the crew observes Niflheim, covered in Creepers as far as the eye can see. "They are watching outside the window and the world looks huge," remembers Bong Joon Ho.

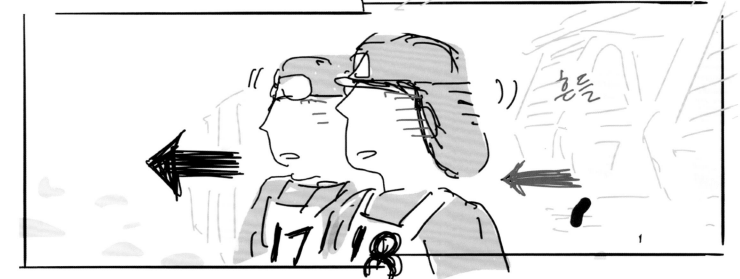

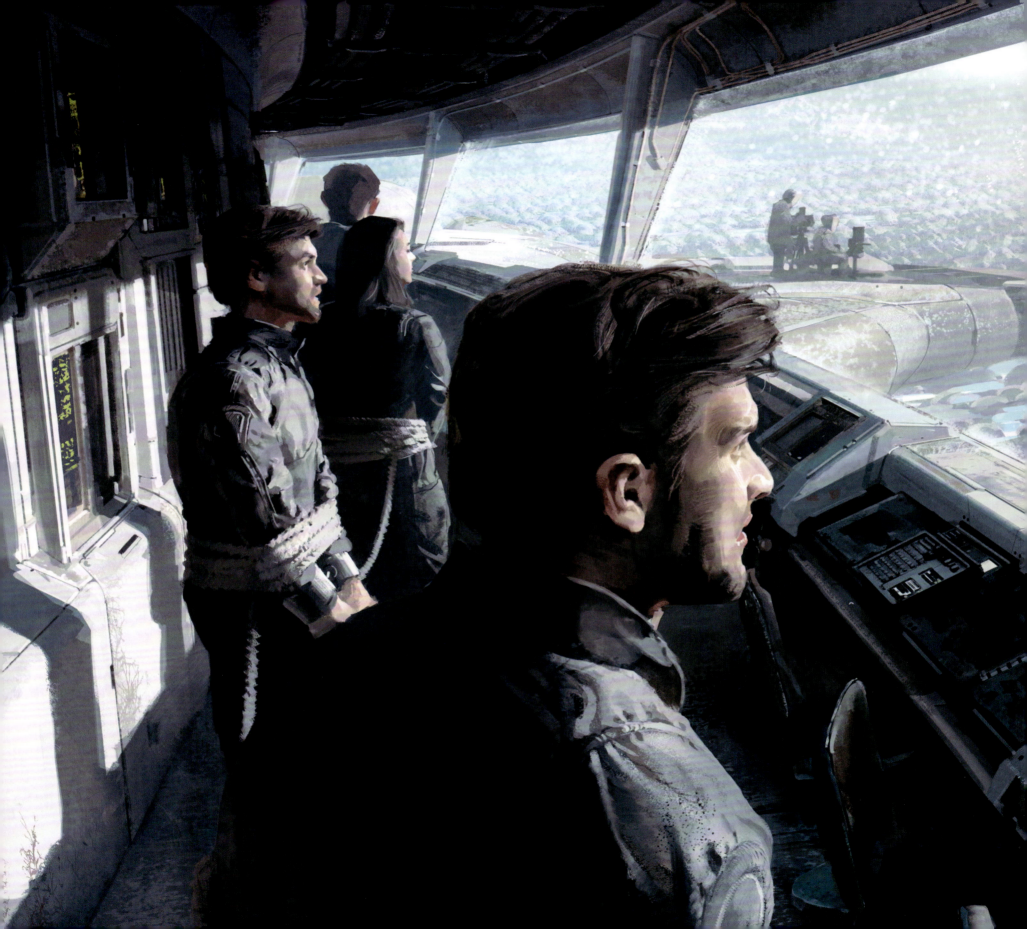

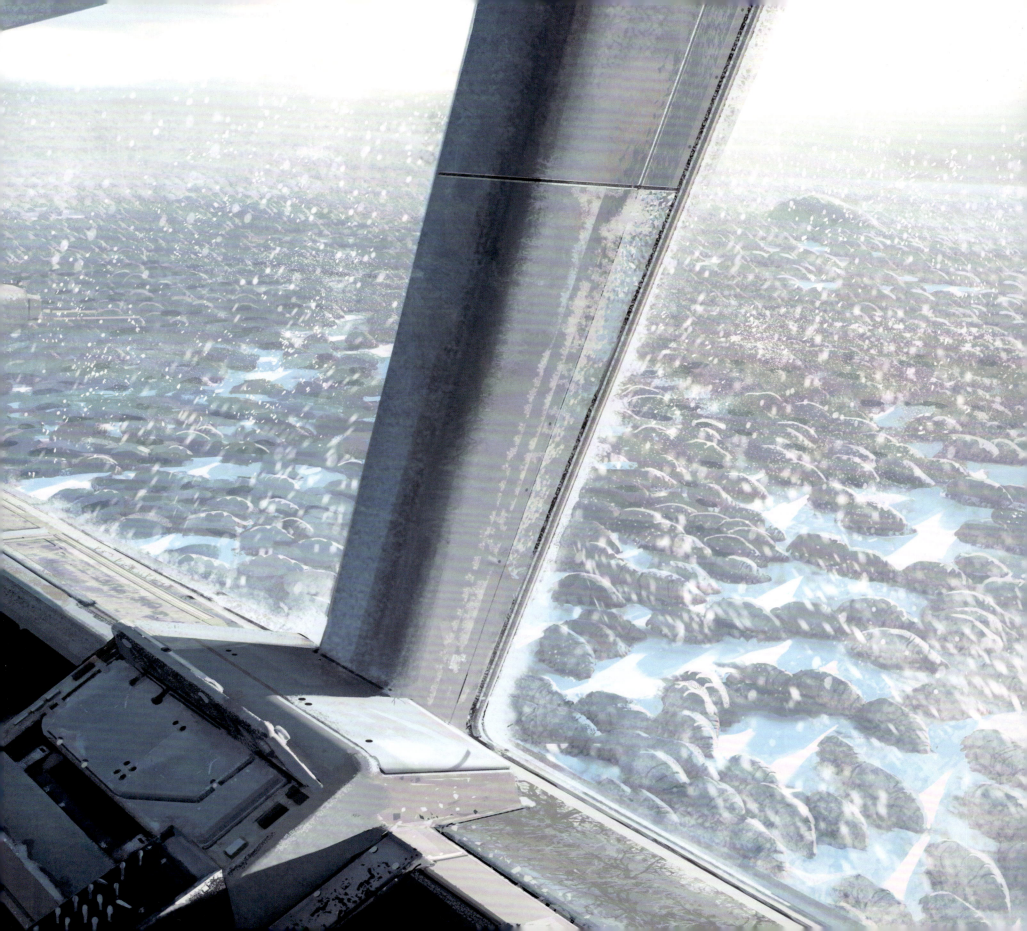

AFTERWORD

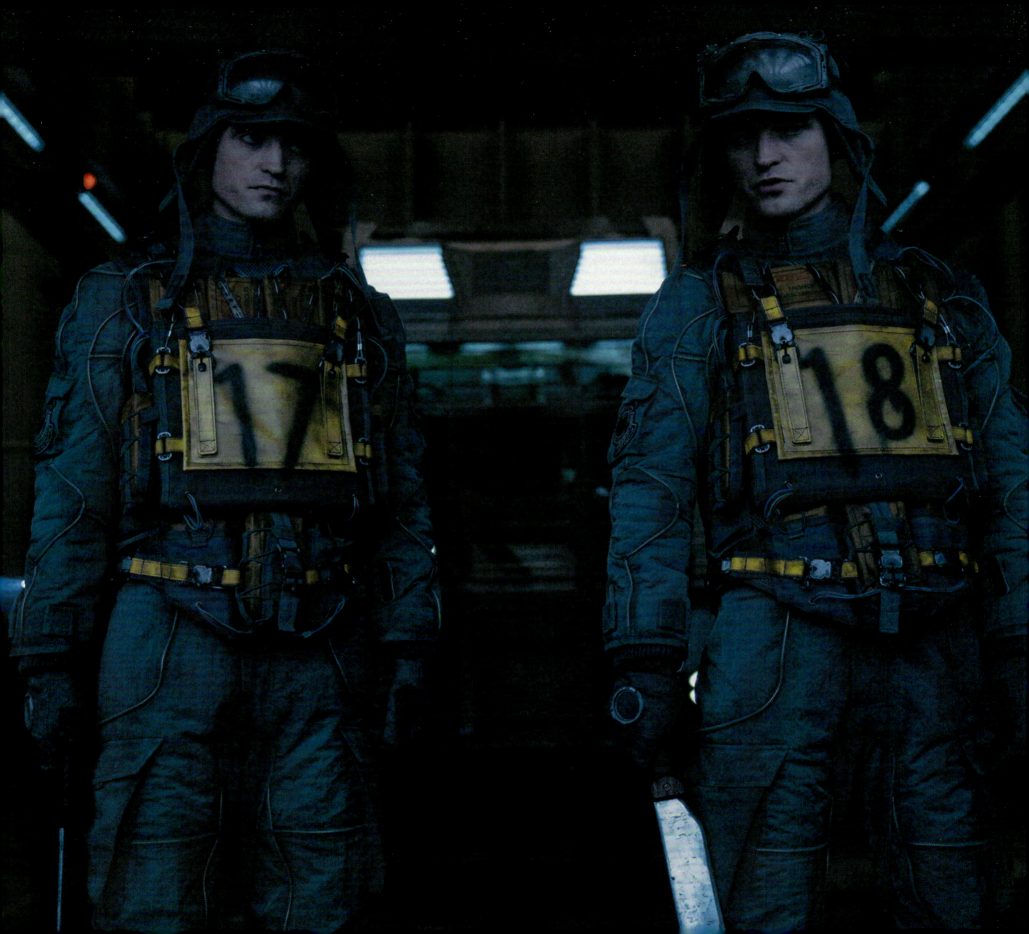

FINAL THOUGHTS

"There's a scene talking to the Mama Creeper when I'm imitating her language. It was on this absolutely enormous set with a huge snowstorm effect, really kind of grandiose, a proper Hollywood sci-fi movie, and I'm making these kind of absolutely ridiculous gargling sounds to a green tennis ball thing. I remember when it was a close-up, just wondering, 'What on Earth is happening?' It's one of the most bizarre and fun experiences I've ever had. And seeing it in the movie, I'm like, 'Wow, you're not gonna see that moment in another movie for a long time, probably ever.'"

—ROBERT PATTINSON

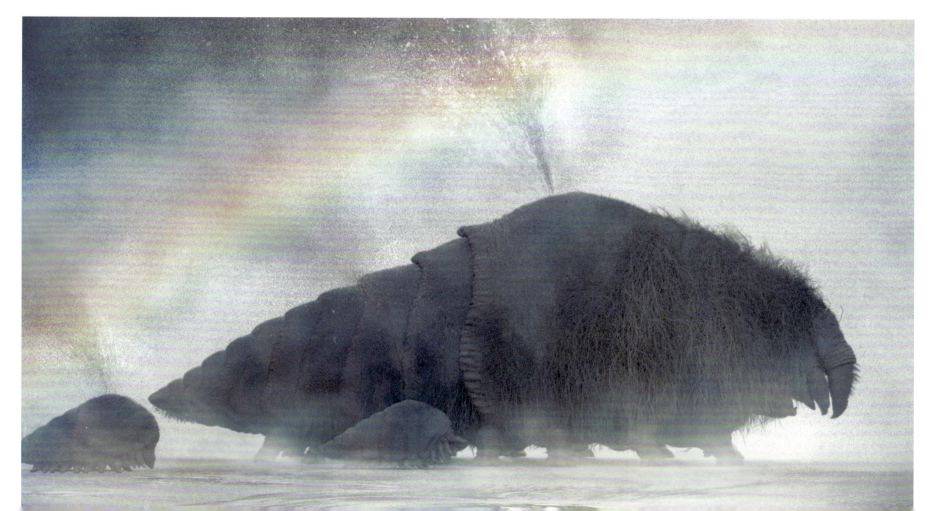

"There was no day where I left frustrated. That's normal and that's okay—there's a lot of passion in this job and there's a lot of moving parts, and everyone's wanting to evolve their craft and they want to defend their craft. A set should be a safe place to do that. But there wasn't even any need for that. It was just like a really joyful space to be a little bit crazy."
—NAOMI ACKIE

"Working with people like that, who are that creative, it lends a sense of honesty that really is helpful. I think that probably comes from Director Bong."
—MARK RUFFALO

"I did love collaborating with Director Bong and just having the calm, quiet conversations, a little cup of coffee, just bouncing ideas around. That was a pleasure for me. And it's the humor. He's so funny. He has such a fantastic, fresh eye on humanity, and he's a great storyteller for pulling us all apart in a unique way."
—FIONA CROMBIE

"I just want to work with nice, talented people. I think this industry is a huge learning curve that we can all learn from, and I want to learn—and I did learn from Director Bong. That to me is invaluable."
—DOMINIC TUOHY

"I felt greatly honored they thought I was a good person to approach to kind of figure out how to do what we've done on this."
—DAN GLASS

"I believe that everyone on set aims to do their best because Director Bong truly appreciates the contributions of every department. When I present him with something he really likes and it makes him chuckle, it feels like a big win."
—CATHERINE GEORGE

"My idea was: What is really a sci-fi? I imagined in my head the world at the end of everything, somewhere in the future, where things don't improve and it's kind of a wrong aspect of human beings. The human beings are still the same people, as bad as they were years back on Earth, but still hoping you can find humanity. The character of Mickey, even though he comes out of a machine, he's actually a real human being—the only real human being on the spaceship. For me it was like a story that Kafka could have written, but like upside down, you know? If you take Kafka and put it completely upside down."

—DARIUS KHONDJI

"The character of Ylfa was not in the original novel. I needed her for making the dark side of the story and the bad side of the story. That's the reason she appears in the very last moment of the movie. Without her and without that nightmare scene, all the epilogue is very peaceful, just a so-called happy ending. But with the existence of that traumatic, strong nightmare scene, the ending can be different, I think. Of course, we can still say it's a happy ending because Mickey pushed the button and the human printer exploded. It's a very clear liberation from a horrible system. But that impression of nightmare is quite strong, and I hope that impression still remains even after the immediate happy ending; that that traumatic moment very strongly remains in the body of the audience even after they leave the theater and arrive at their home—Ylfa keeps following them to their house."

—BONG JOON HO

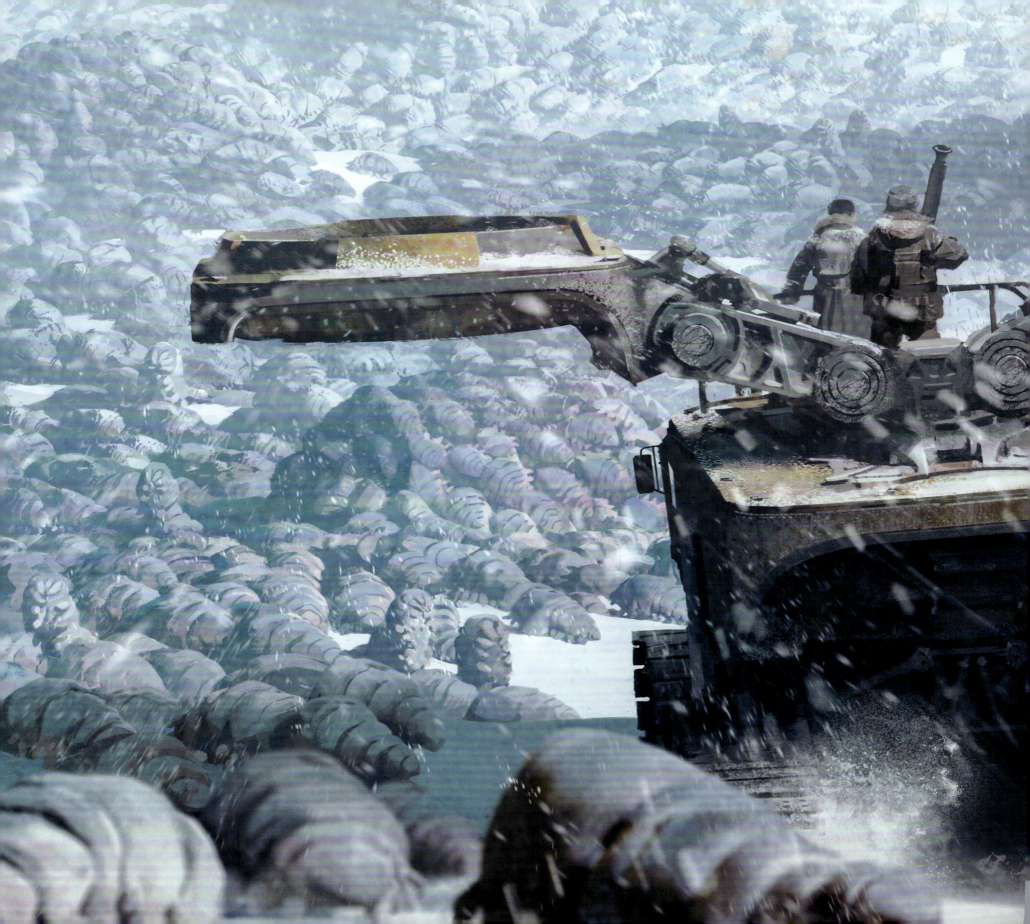

ACKNOWLEDGMENTS

The author would like to thank Bong Joon Ho, Dooho Choi, and everyone in the cast and crew who generously gave up their time for this project. It is a privilege to see how this film was made. This book would not have happened were it not for the belief and effort of Angeline Rodriguez, Raoul Goff, Lia Brown, Alecsander Zapata, Vanessa Lopez, Stephen Fall, Lola Villanueva, Matt Girard, and the entire team at Insight Editions.

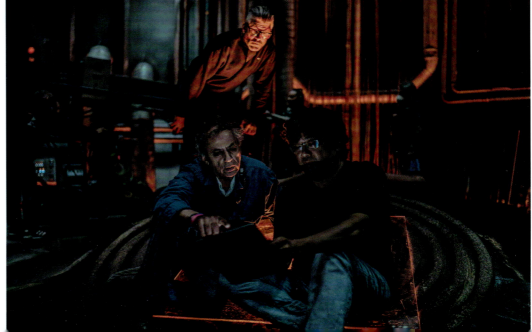

THIS SPREAD: Moments from the shoot, filled with old collaborators and new friends. As Bong Joon Ho recalls, "All those crazy situations and so many people..."

Special thanks to the artists and photographers whose work is included in this book: Max Berman, Alex Clark, Chelsea Davison, Jang Heechul, Jaime Jones, Jason Knox-Johnston, Jonathan Olley, Robert Rowley, Aleksander Stojanov, Georji Tanev, Sam Williams, and Katren Wood.

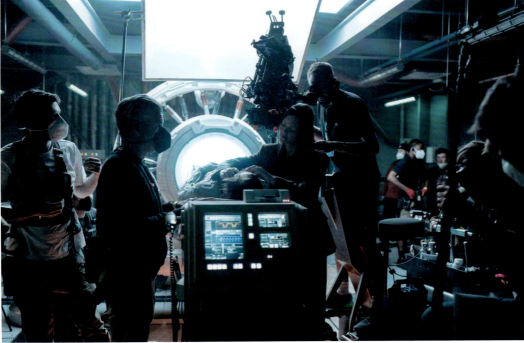